YAVUZ SULTAN SELIM BRIDGE

The New Gateway between East and West

Art Director and Design
Stefano Frattini
with the collaboration of **Lilia Di Bella**

Edited by
Lida Castelli
Maria Vittoria Capitanucci

Editorial Coordination
Giovanna Crespi
Sara Maestro

Translation
Joan Clayton
Sara Maestro

Editing
Sylvia Notini
with the collaboration of **Laura Guidetti**

First published in the United States of America in 2017 by
Rizzoli International Publications, Inc.
300 Park Avenue South
New York, NY 10010
www.rizzoliusa.com

Originally published in Italian in 2017 by
Libri Illustrati Rizzoli
© 2017 Mondadori Electa S.p.A., Milano
© 2017 BWS - Balich Worldwide Shows S.r.l.
© 2017 IC İbrahim Çeçen Foundation
© 2017 ICA IC İçtaş Astaldi
© 2017 Astaldi S.p.A.

2017 2018 2019 2020 / 10 9 8 7 6 5 4 3 2 1

ISBN: 978-0-8478-6078-4

Library of Congress Control Number: 2017941554

Printed in Italy

YAVUZ SULTAN SELIM BRIDGE
The New Gateway between East and West

Edited by

Lida Castelli
Maria Vittoria Capitanucci

RIZZOLI
NEW YORK

New York · Paris · London · Milan

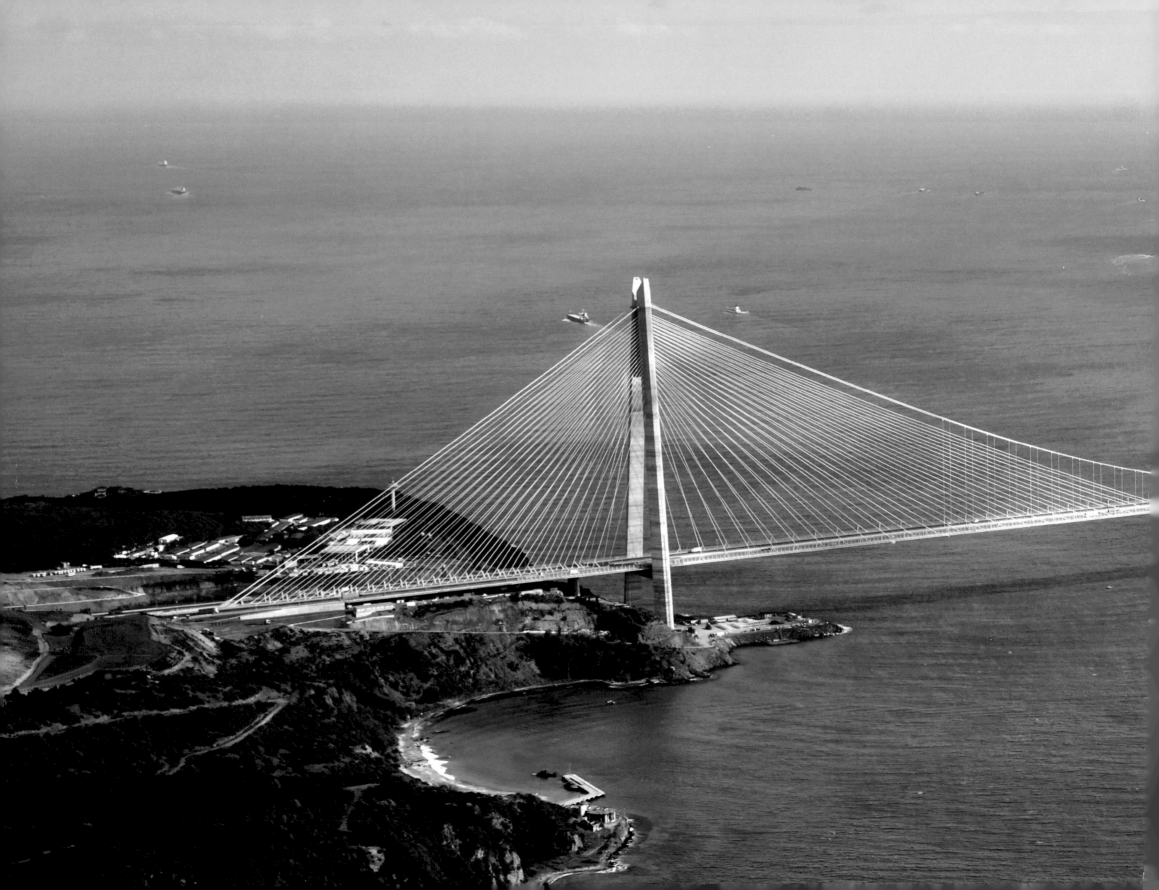

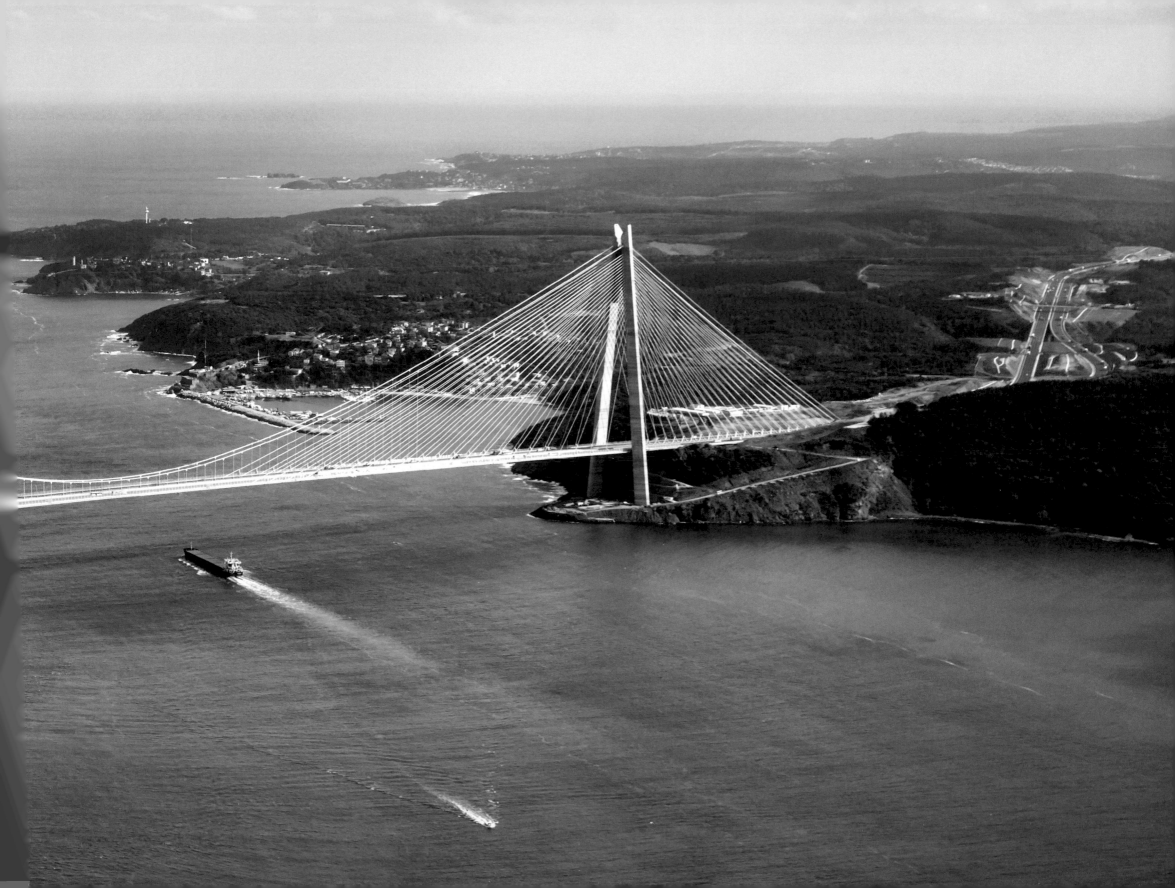

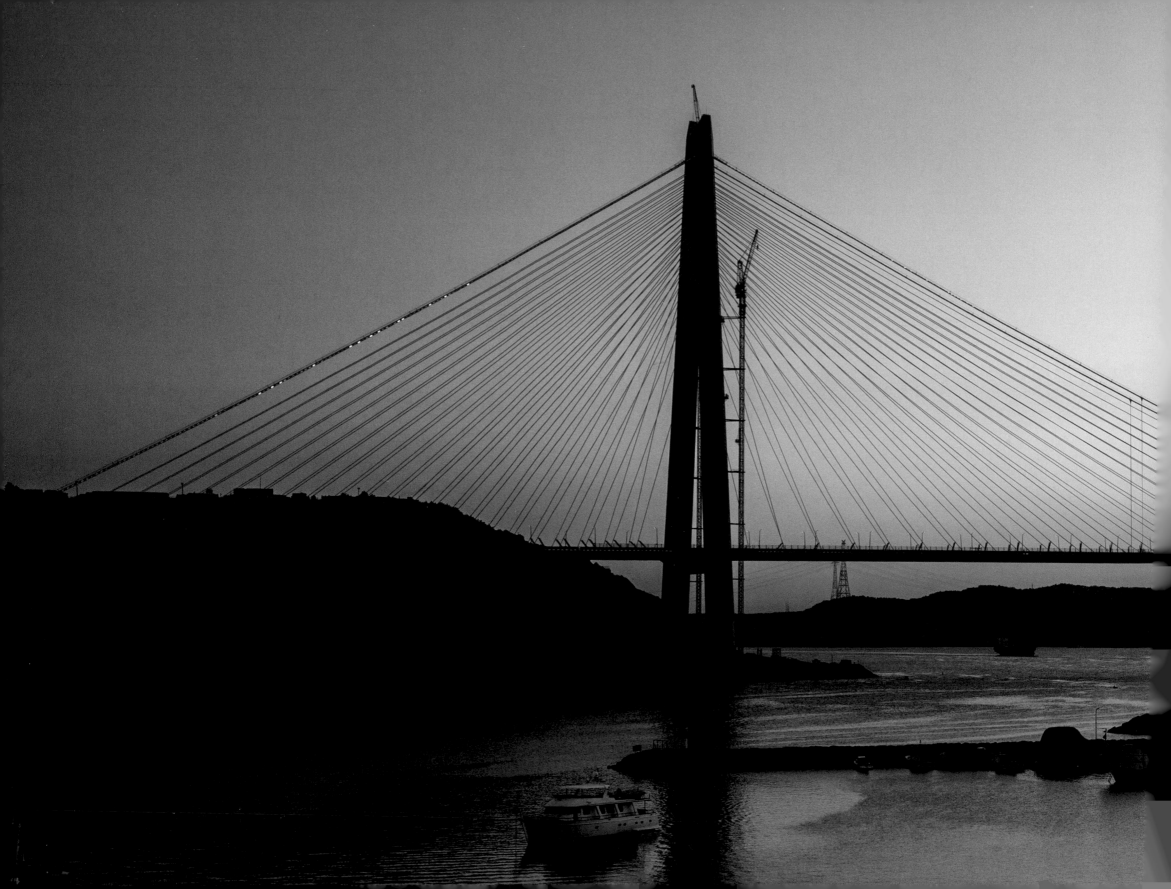

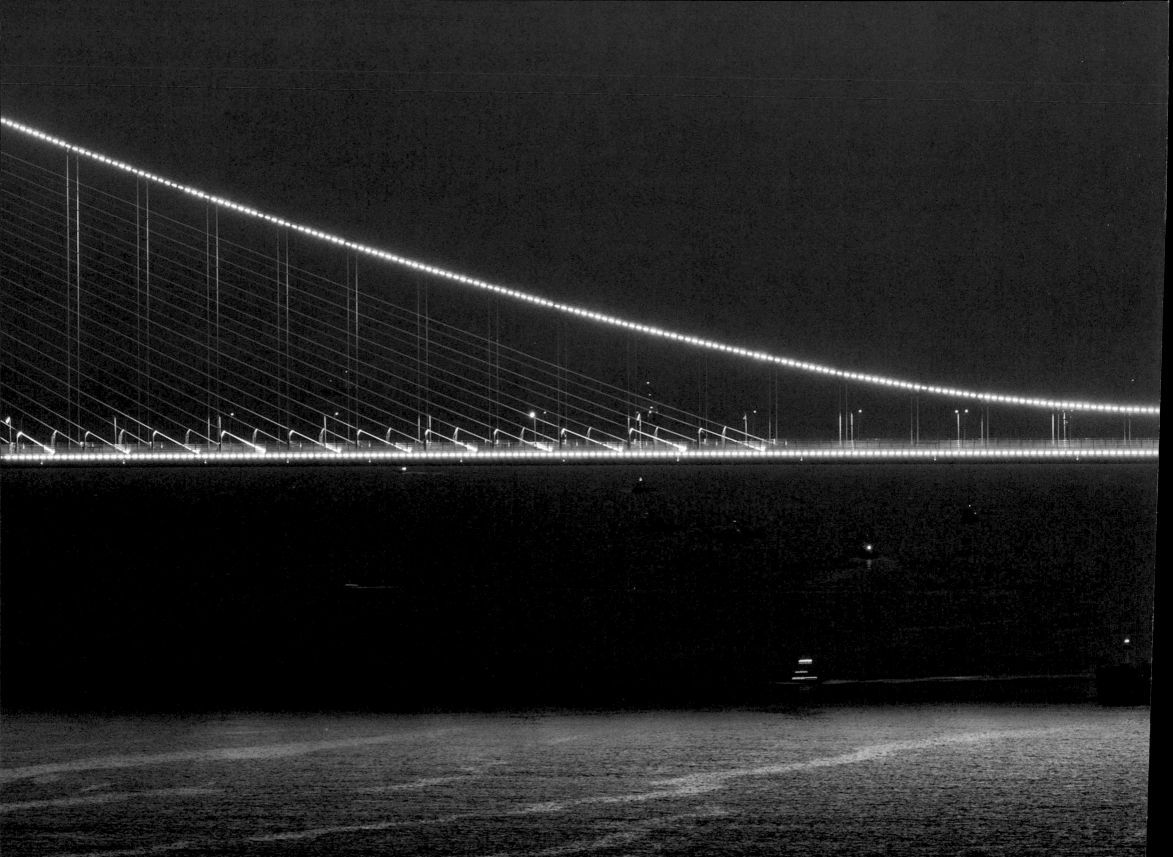

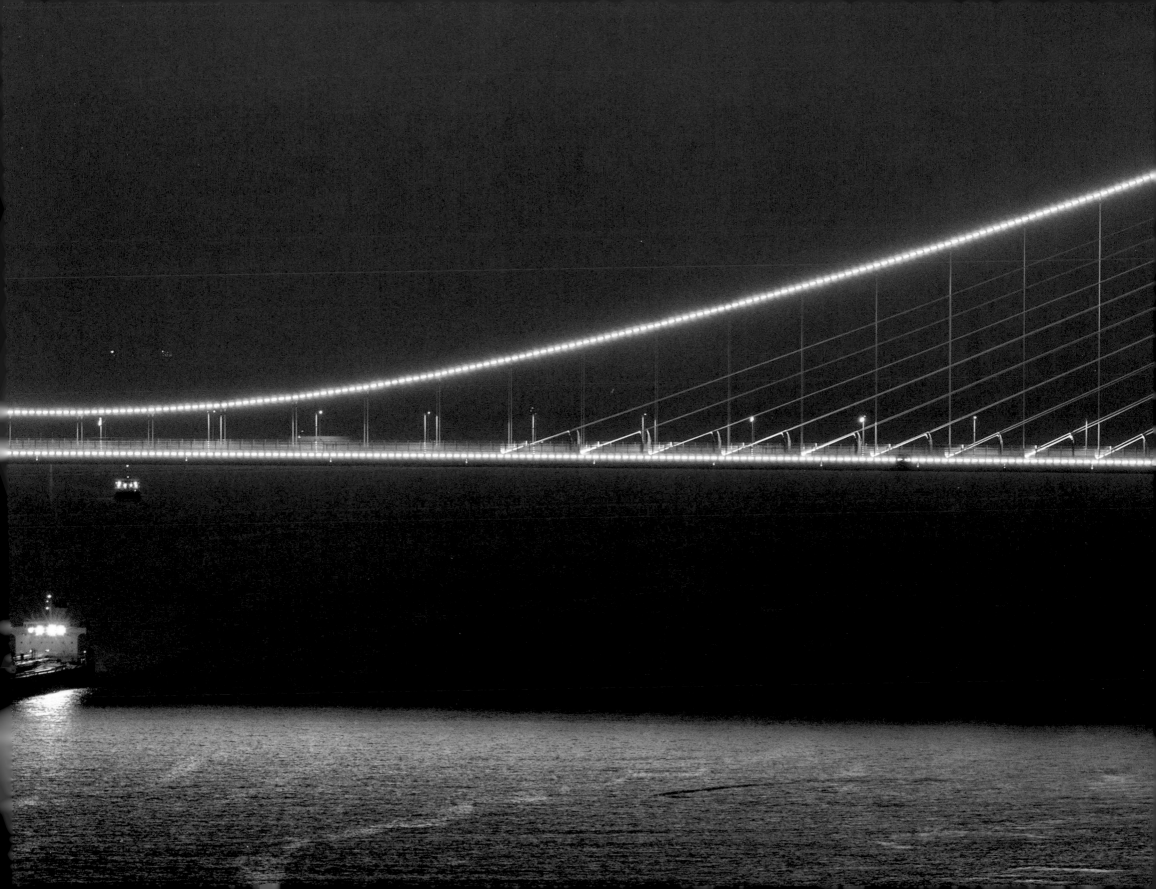

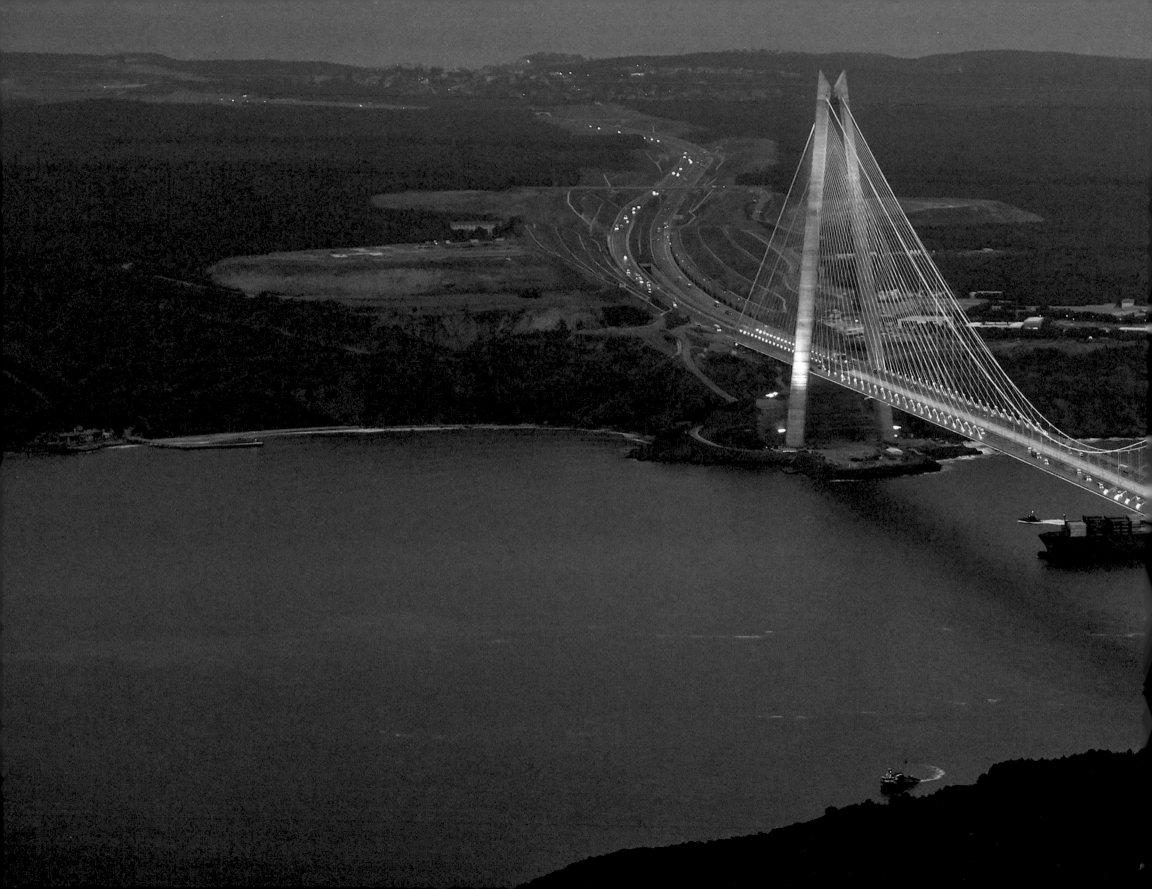

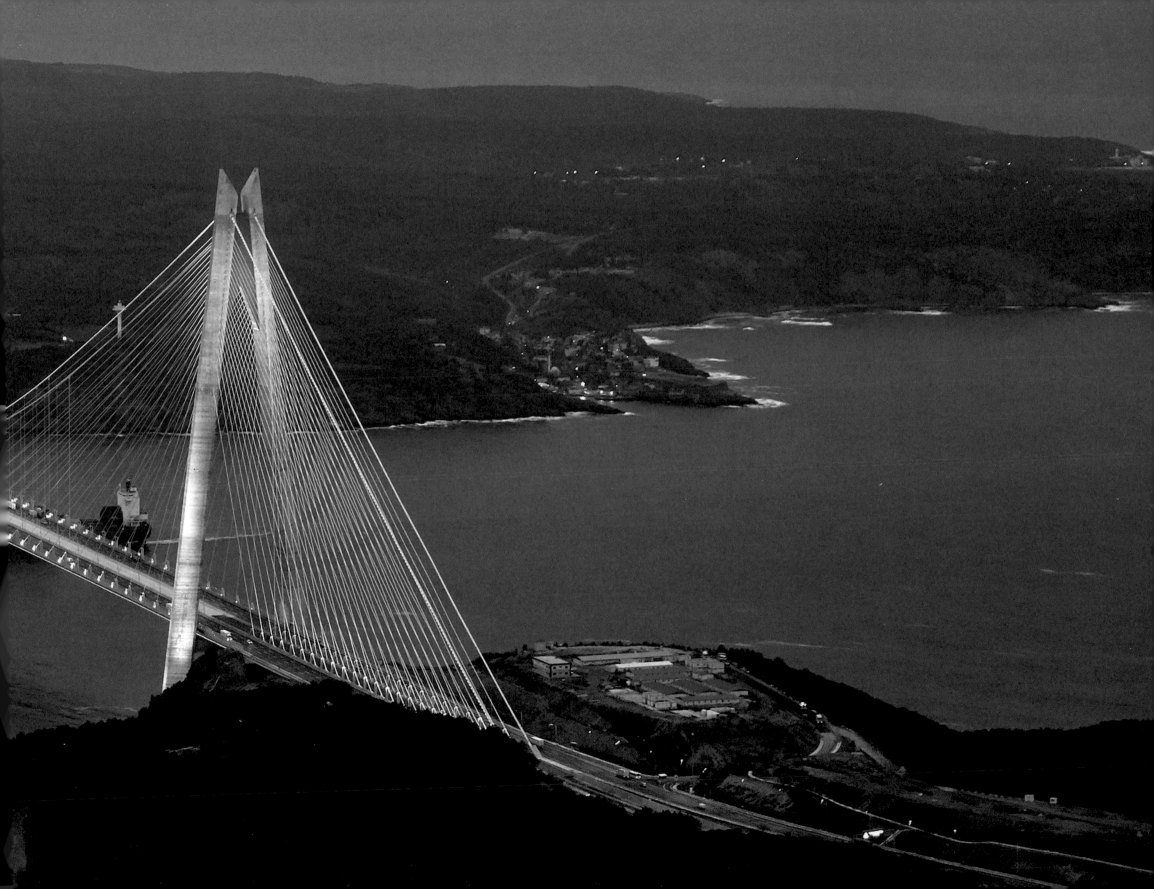

CONTENTS

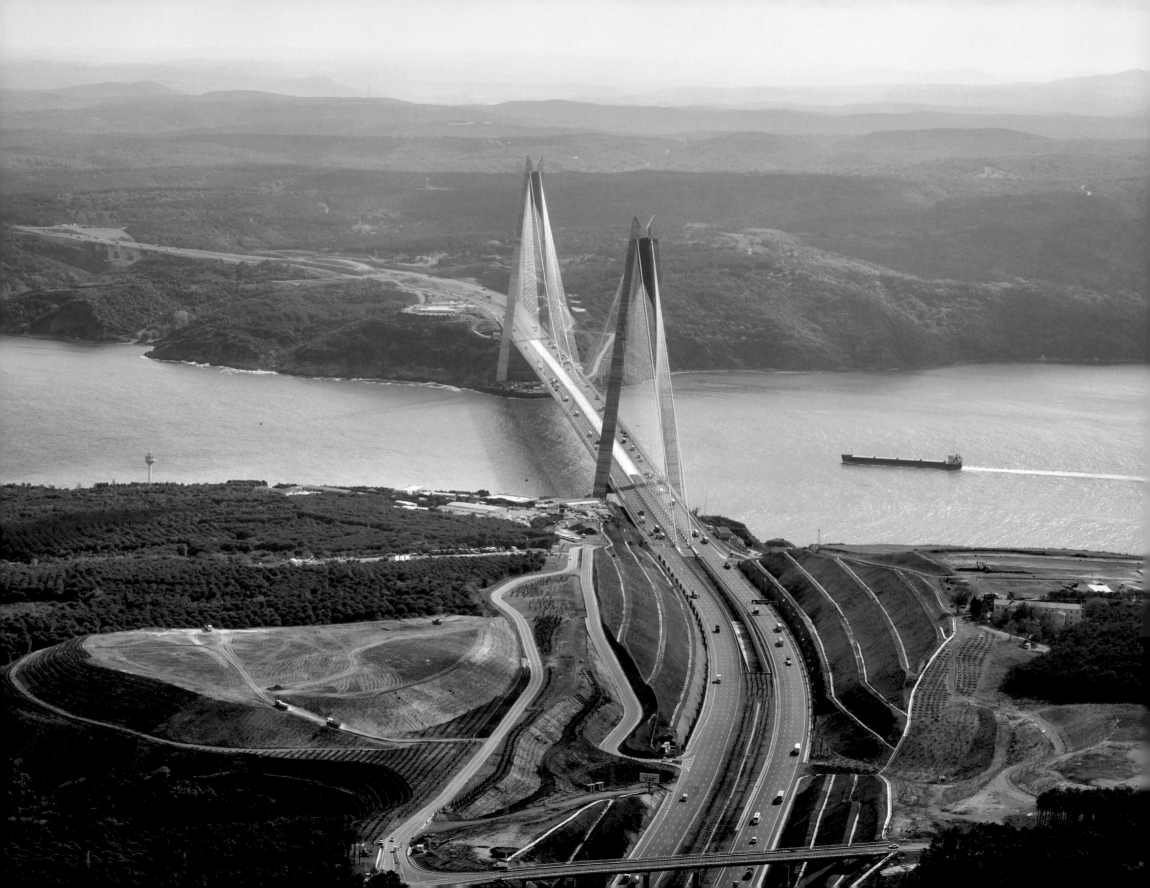

A HYBRID DREAM
Maria Vittoria Capitanucci

Something new has appeared in the fascinating landscape of the Bosphorus Strait. Slender, soaring while at the same time powerful, contemporary, reaching out to the future, this is the Yavuz Sultan Selim Bridge, the new landmark of modernity connecting Europe and Asia. A sophisticated and highly technological structure, a display of sculptural engineering, a combination of a suspension and a cable-stayed bridge, spectacular and conceived not only as a structure functional for crossing the water and connecting the districts of Poyrazköy, on the Asian shore, and Garipçe, on the European side, but as an element representing a complex infrastructure system. During the day, its appearance is that of a megastructure worthy of a work of Land Art, while at dusk it resembles a space station that has landed masterfully and with considerable engineering and structural effort between the two shores of the huge estuary, in a rocky point where the hilly terrain advances, creating a narrowing of the stretch of water between the two opposing coastlines. A bridge, dedicated to the ninth Ottoman emperor, which certainly serves the area and the city, but which aims to reach out well beyond the region, projecting itself toward both continents with a dual motorway and high-speed railway connection. A functional plurality that allows the Yavuz Sultan Selim Bridge, the third Bosphorus bridge, to be considered the only suspension bridge in the world, housing on its deck, all on the same level, an eight-lane motorway and two railway lines, with an incredibly shallow maximum height of 5.50 metres. A specificity that has also earned it the record as the widest suspension bridge on the international scene, with a width of 58.50 metres. A result achieved partly due to the decision to conceive it as a hybrid cable-stayed, suspension bridge supported by two A-shaped pylons soaring to 322 metres in height, another record that overshadows even the iconic Tour Eiffel

in Paris. Therefore, it is a structure that, in its various constructional elements, has far outstripped recent major projects around the globe. Furthermore, it took an incredibly short time to build: 39 months from the laying of the foundation stone, thanks to the efforts of up to ten thousand people on a site that required organisation akin to that of town planning on the two shores involved as areas of operations, in full compliance with the planned timing and budget. A financial plan backed by the involvement of the major Turkish banking groups that supported this project, in which the Yavuz Sultan Selim Bridge is a substantial part of a broader infrastructure scheme entrusted to the major Turkish group IC İçtaş (in a specially set up consortium with the Italian company, Astaldi, holders of a 33.33% share in the formula of the ICA joint venture) but which also includes the building of no less than 150 kilometres of the Northern Ring Motorway (from Odayeri to Paşaköy), with an awe-inspiring system of viaducts measuring 25.40 kilometres and underground tunnels designed to link the European and Asian railway lines. The consortium also has the task of subsequently managing the whole infrastructure project, as a concession holder. It is therefore an extremely wide-ranging operation of which the impressive Yavuz Sultan Selim Bridge is certainly the iconic element, standing at the far northern end of the Bosphorus, just before it flows into the Black Sea. A landmark that takes its place, ideally and functionally, alongside the previous two suspension bridges connecting Europe and Asia, both built in the last century: the 15 Temmuz Şehitler Bridge, formerly known as Boğaziçi Köprüsü, the first bridge over the strait dating from the seventies, and the second, Fatih Sultan Mehmet, built at the end of the eighties. Bridges that, despite their soaring structural lines and functional value, compared to the recently built third bridge, now appear to be from an earlier generation both with regard to size and design. The first bridge over the Bosphorus, inaugurated on 30 October 1973, stretches between the Ortaköy and Beylerbeyi districts. Designed to connect the two halves of the city, it was the first permanent bridge uniting the two continents; it was made by a British company, which enlisted the services of the engineers Gilbert Roberts and William

ICA is carrying out a large reforestation project in the building site area, organised in three different phases, after a trilateral protocol was signed by ICA, the General Directorate of Highways and the Regional Directorate of Forestry. As part of the project, an area of 1,400 hectares will be turned into forest in three years. Reforestation operations are being held in the Çatalca, Riva, Kanlıca, Karaağaç and Şile districts.

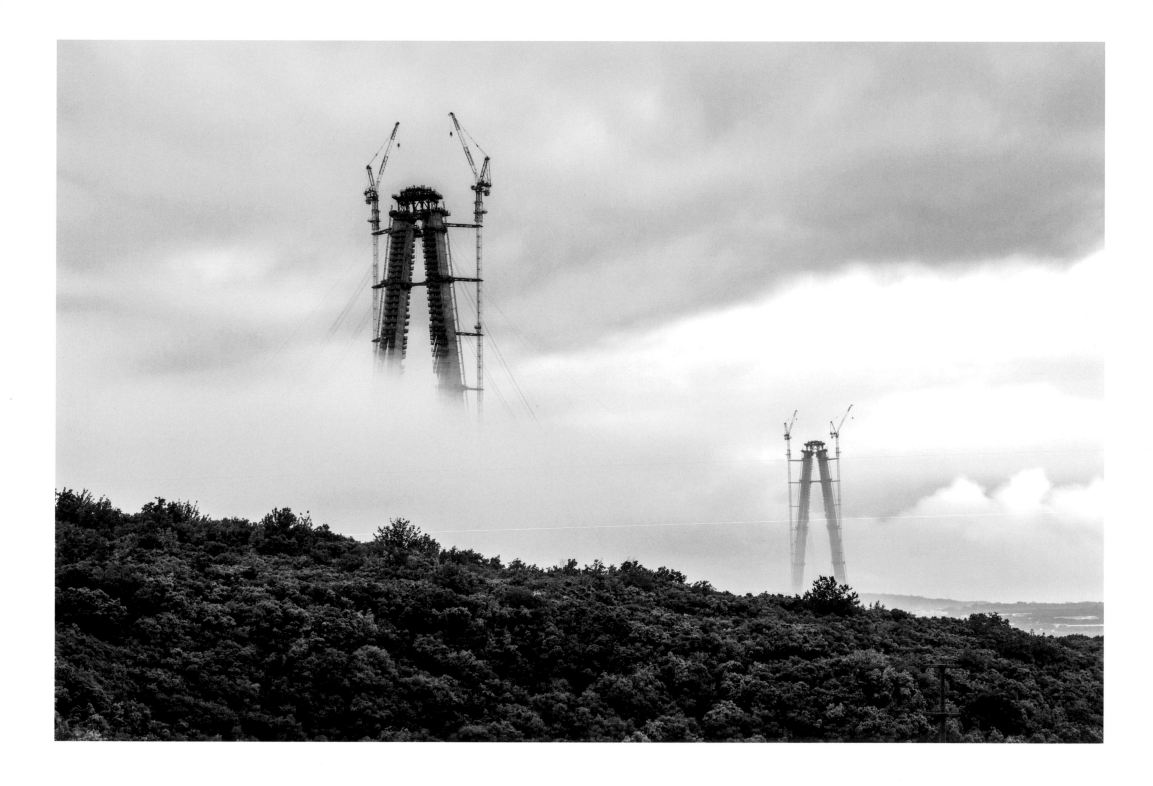

A nighttime image of the three bridges on the Bosphorus; in the foreground, the Yavuz Sultan Selim Bridge lit in red.

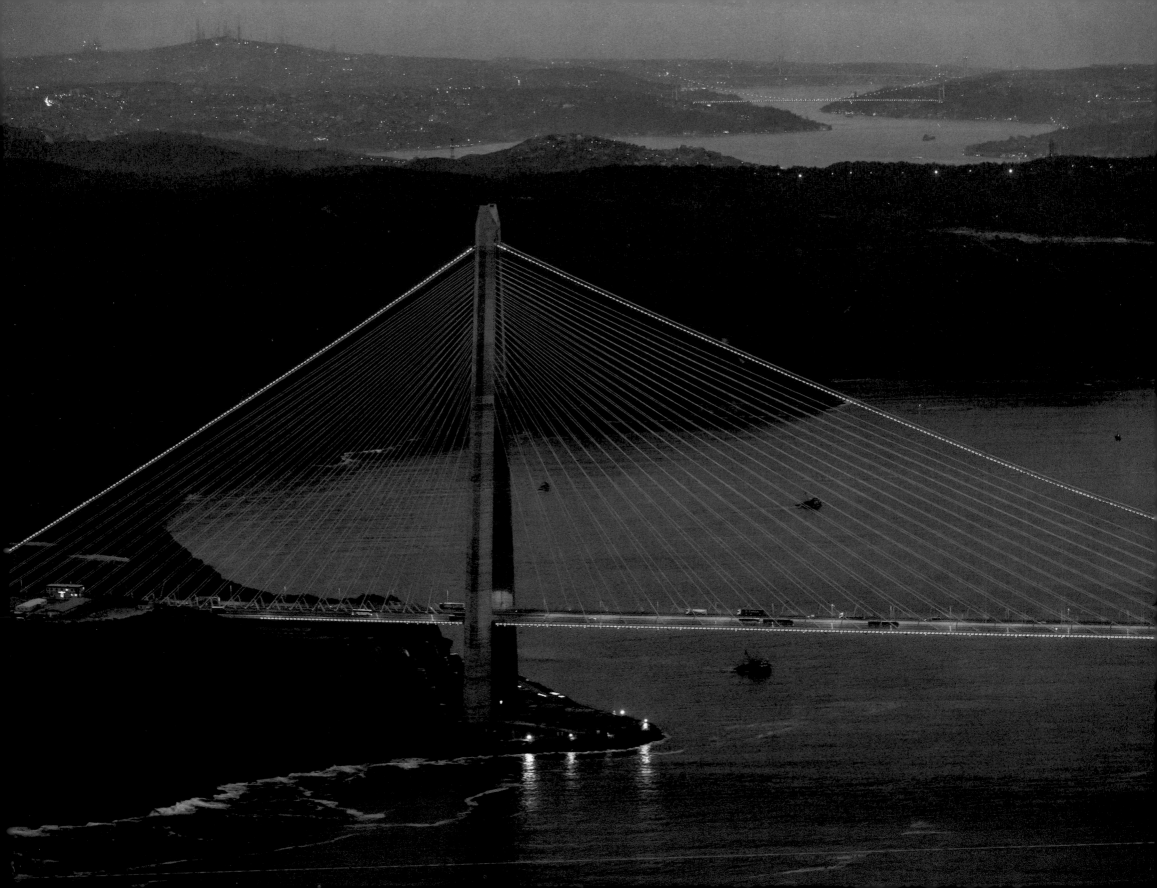

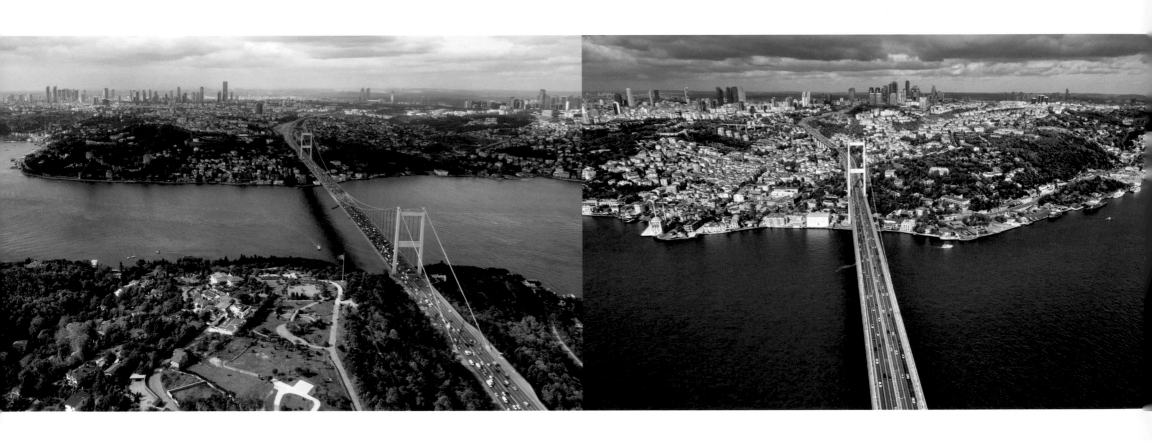

Brown with the collaboration of the Italian Almerico Meomartini. In the period in which this major bridge was constructed there was also a huge increase in the population of Istanbul (now a city with almost 16 million inhabitants) which, due to high immigration, began to change its urban layout in relation to its two different areas of development, with an expansion of the Asian area. In support of the need to build a third bridge, one only has to consider that at present the 15 Temmuz Şehitler Bridge is crossed each day in both directions by 180,000 vehicles, a considerable figure comparable only to a few bridges in the United States. Standing just 5 kilometres north of the previous bridge and connecting the Rumelihisarı and Anadoluhisarı districts, where there are very fine Ottoman fortresses, is the second bridge, the Fatih Sultan Mehmet, dedicated to the 15th-century Ottoman Sultan who conquered Constantinople in 1453. Designed by the London firm Freeman Fox & Partners, and completed in 1988 by a Japanese company, this suspension bridge has similar characteristics to the first. Consequently, in order to reorganise the flow of car traffic between the metropolis and its territory, also bearing in mind its exponential growth over the past ten years, the decision to expand the railway and motorway systems converging upon a third bridge now appears even more necessary.

The idea of a bridge over the Bosphorus dates from truly ancient times. According to the Greek historian Herodotus, the Persian Emperor Darius the Great created a temporary crossing using hundreds of ships placed one beside the other to build a passage between the two shores of the estuary, so that the areas of his huge empire could be easily reached. After him, another Persian king, Xerxes, used the same ploy to reach Greece and invade it. The place chosen then was much further south, across the Dardanelles, beyond the Sea of Marmara, in the point where the two straits divide the Black Sea from the Mediterranean Sea. Since then, a great deal of time has gone by, and there have been other bridges, too. But then the fabric of the splendid city of Istanbul is uniquely stratified, varying between heights and hollows—today we could call it "layered"—where suspended crossings, vi-

The two Bosphorus bridges, the 15 Temmuz Şehitler Bridge, and the Fatih Sultan Mehmet Bridge.

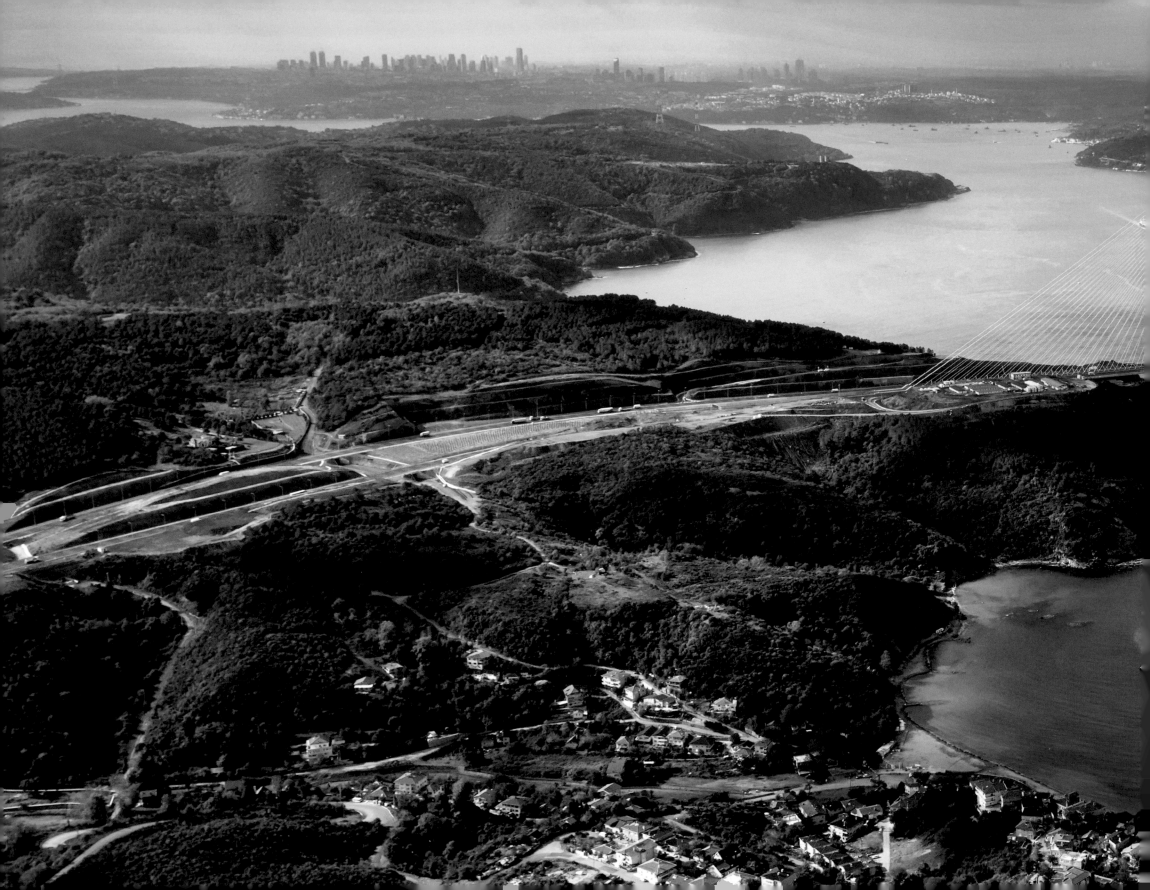

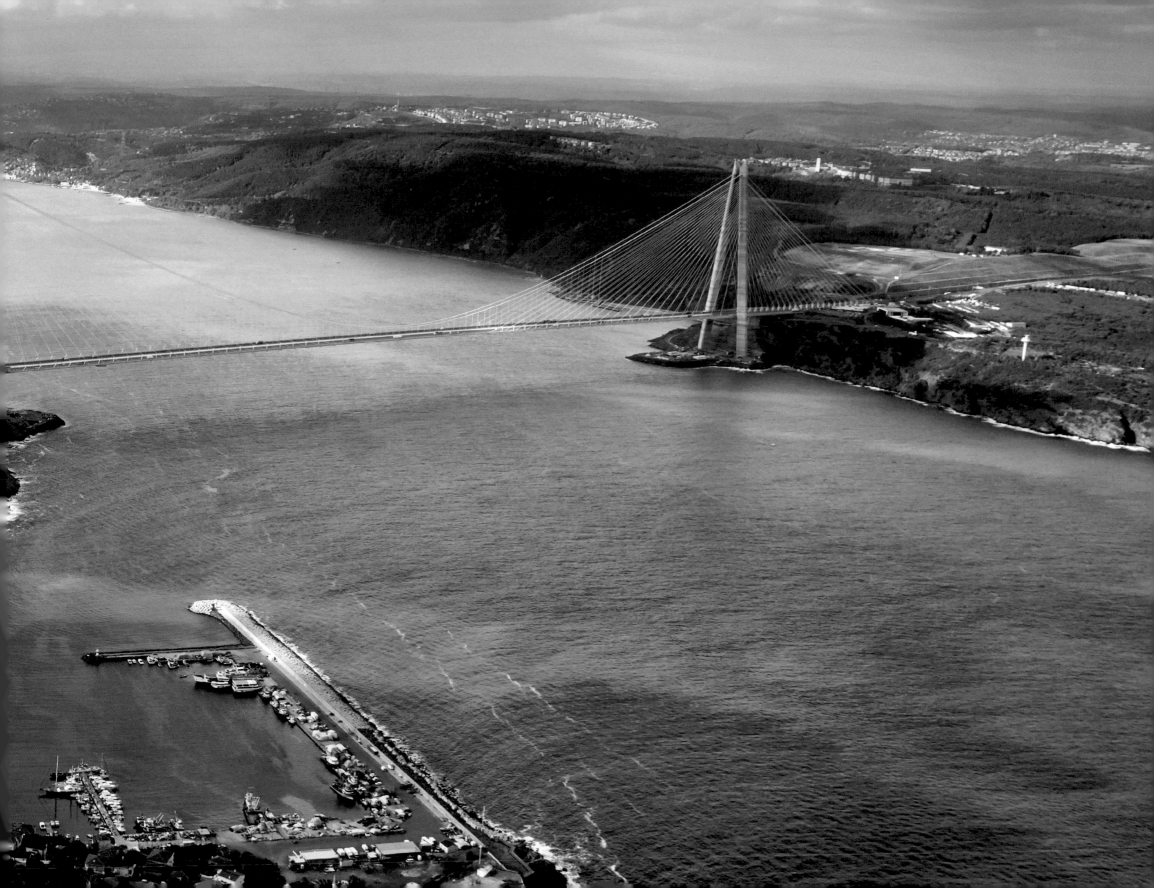

aducts and the bridges crossing the Bosphorus itself are part of the essence of the city, as is an undeniable appreciation for the most complex expressions of structural challenge. Great Turkish builders took on sublime engineering projects right from the beginning of the Sultanate, when it superseded the Roman Empire, and they were summoned to re-adapt and modify existing buildings—for example Hagia Sophia—within a very short time. This is what also happened with the aqueducts and the underground "basilicas" that provided water supplies for the city. A history, therefore, that takes us back to long ago, to the time when the entry of merchant ships to the Golden Horn from the Bosphorus was blocked by raising a large chain from Constantinople toward the Galata Tower, so that no enemy ship could go beyond it—an early version of the "catenary," the forerunner of the one chosen for the Yavuz Sultan Selim Bridge to cover the wide span of the crossing. It was a defence that naturally was overrun several times in the course of history, until the siege of Galata that led to the fall of Constantinople in 1453. Fifty years later, around 1502, one of the initiatives of the Ottoman era for modernising the capital of the Empire was the commission by Sultan Bayezid II to Leonardo da Vinci for a bridge over the Golden Horn, between Seraglio Point and Pera. This is a little known episode, but one that is very significant in that it highlights the great cultural receptiveness expressed at the time by the Sultanate. The bridge was to have used well-known geometrical and architectural principles: the pressed-bow, parabolic curve and keystone arch. The result was to be a single bay pedestrian bridge 220 metres long and 24 metres wide. Unfortunately the bridge was never built and all that remains of Leonardo's design are some fascinating preparatory sketches held in the Topkapı archives. It was nevertheless an opportunity for Leonardo to come in contact with Middle Eastern culture and to develop a very important idea for his work, the central-plan design for places of worship, which he derived partly from Ottoman mosques and hammams. Later, Michelangelo would also be invited by the sultan, following a proposal he made for a bridge over the Bosphorus. This bridge too, however, was never built. The traffic between the two shores of the

View of the Galata area, with the most recent of the bridges connecting the two sides of the Golden Horn.

Golden Horn thus continued to be conducted by boat up to the early 1800s, that is, up until 1836, when a pontoon bridge called Hayratiye (meaning "Benefaction"), between 500 and 540 metres long and connecting Azadkapı and Unkapanı, was inaugurated on the wishes of Sultan Mahmud II. Lastly, the story of the so-called "11 bridges" of Galata (the Genoese colony in Istanbul) is worth mentioning. These bridges did not cross the Bosphorus, but they do further underline the physical and architectural presence that is an element of the landscape and the building tradition of this magnificent Turkish city.

In short, the cityscape of Istanbul is dotted with bridges, and the challenge of structural design has become a distinguishing mark of the city, of its sights and of its territory. The Yavuz Sultan Selim Bridge rightfully emerges as the latest evidence of this leitmotif that has continued down through the centuries.

The third bridge over the Bosphorus is in fact the heir to a specific structural and design tradition, that of sculptural engineering of which the two designers, Jean-François Klein and Michel Virlogeux, are certainly two of the most important exponents in this era. It is a design approach in which the bold expressiveness of the structure ultimately restores the prestige of infrastructural works, placing them among the elite of architecture. It is a path paved by forerunners like the great 20th-century concrete structural engineers, from the Spanish, Mexican by naturalisation, Félix Candela to the Italian Pier Luigi Nervi, but also by figures such as Eugène Freyssinet from France. The result is a series of structures which, like the Yavuz Sultan Selim Bridge, tell a story. This bridge is in fact the tale of a structural challenge in the relationship between forces, loads and suspensions, but also of research into the potential of materials—from the steel cables to the concrete—as well as of careful and thoughtful attention to the design of the parts, of the elements that characterise it and make it unique. For instance, in the initial designs the very slender deck was made of box girders on several levels with various distribution solutions for the high-speed railway, placed on a lower deck, and the motorway lanes, central or lateral, on one or more levels. It was later developed, with more

than a few problems and with great skill, by designing two motorway carriageways, each with four 3.65 metre-wide lanes separated by a central railway corridor composed of two sets of tracks each 5.25-metre-wide for high-speed and goods trains. The result is the widest deck in the world, with a width of 58.50 metres and a maximum height of 5.50 metres which has no equal in the world. It is a system that naturally underwent, and withstood, testing in a wind tunnel with application of a wind at 300 kilometres per hour, followed by the addition of the load determined by the cars and, above all, by the train under the rails of which reinforcing elements were placed. With this geometric dimensioning, the maximum design speed has been set at 120 kilometres per hour for the two motorway carriageways, while for trains in transit it will be 80 kilometres per hour for goods traffic and 160 kilometres per hour for high-speed trains. Even the "A" shape of the pylons is dictated by the load of the train; indeed, they were conceived in this way by the designers so that the main cable could be inserted in line with the tracks, also placing the secondary cables at the centre, and thus stiffening the deck in the railway zone. Additionally, the profile of the pylons, which have a triangular section, is the result of an analysis of the incidence of strong winds present in that part of the Bosphorus on their surface, but also an actual design choice since the triangular profile integrates better with the inclination. This also applies to the very long stay cables, connected to the external part of the deck in order to make it more rigid, which precisely because of their "abundance," are flanked by the catenary suspension system that counters the perpendicular forces. Here, to avoid risks due to high wind rather than seismic activity, dampers have been designed and inserted to eliminate the vibration of the stay cables when trains pass or when there are strong wind currents. The dampers are hydraulic insulators that contain vibration (the longest cable on the bridge measures 597 metres, with a steel strength of 1,960 MPa, and is also the longest cable in the world). With these a series of important stratagems were adopted, starting from the first step: identifying the site for the on-land foundations on two small promontories jutting out into the strait. This made it possible to avoid contact

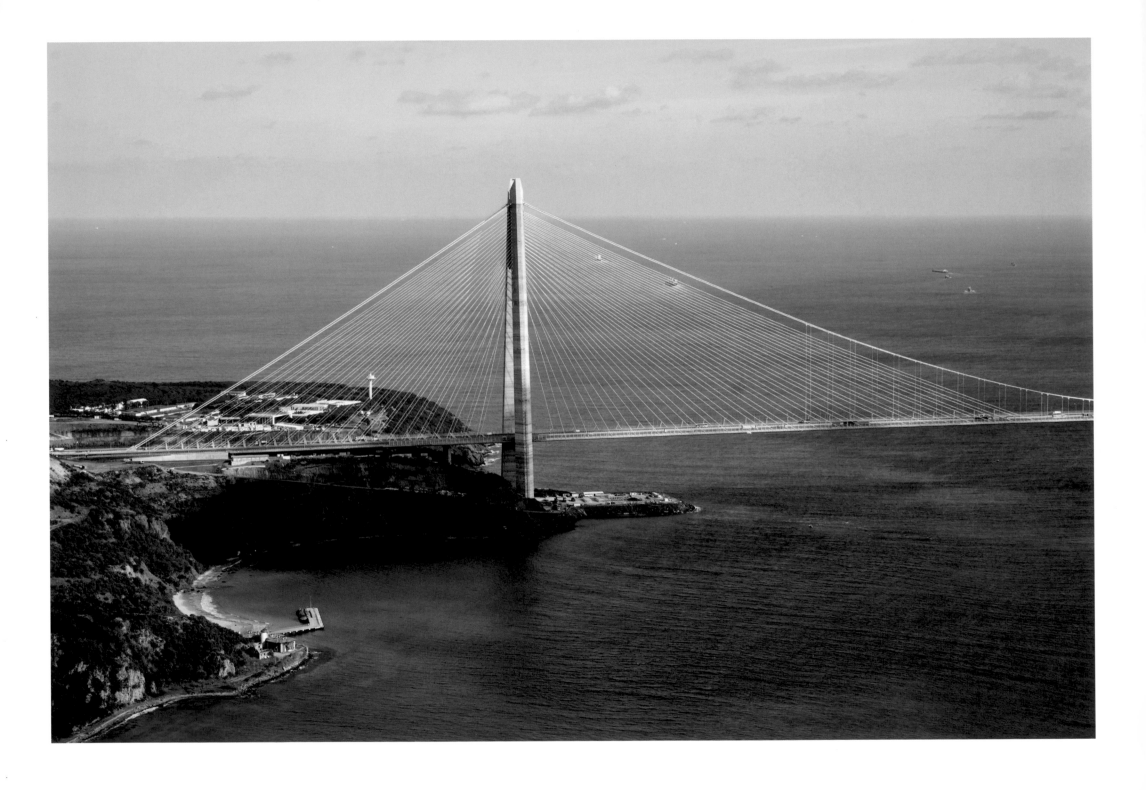

of the pylons with the water in a stretch crossed by numerous opposing currents and by busy maritime traffic. This was a positive decision that moreover involved relatively shallow excavation of the foundations (with a depth of 20 metres and a diameter of 20 metres) in rock without fractures and therefore particularly suited to receiving concrete pylons made with slipform and automatic climbing formwork systems.

A hybrid cable-stayed suspension bridge, as already stated and as its two designers have rightly defined it, Klein and Virlogeux decided to combine the cable-stayed bridge system—frequently used for many European bridges including some built very recently, and able to provide considerable stability to the structure even against stresses determined by the high winds that characterise the Bosphorus and, in particular, that area of the estuary—with a structure with a "catenary" suspension cable that takes us back to the futuristic visions of the early cast iron bridges built by Gustav Eiffel (the Garabit Viaduct 1880–84) and of the metal ones In the United States, able to cross very wide distances and cover unimaginable spans. Therefore, the Yavuz Sultan Selim Bridge has a double identity. It is cable-stayed, according to the best tradition, which is that of a structural "genre" that began long ago at the end of the 18th century with the bridge at Freyberg (1784), the work of a German carpenter, Immanuel Löscher, and continues up to today passing through the post-war years with the bridges designed by Franz Dischinger—in particular the iconic 183-m-long Strömsund Bridge (Sweden) in 1955—as well as the futuristic experiments of the Italian Riccardo Morandi on the Maracaibo Lagoon in Venezuela (1957–1962) or over the Polcevera in Genoa (1960–1964). Yet it is also a "catenary"-type suspension bridge, designed according to the load system studied at the end of the 1800s by the great Catalan architect Antoni Gaudí on which the soaring structures of the famous Sagrada Familia cathedral in Barcelona are based. In any case, the hybrid structure proposed with full awareness of the problems, and audaciously, by the designers of the Yavuz Sultan Selim Bridge, has a "noble" precursor in the 19th-century iron bridges in San Francisco and

The Tower of the Third Bridge situated on the European side.

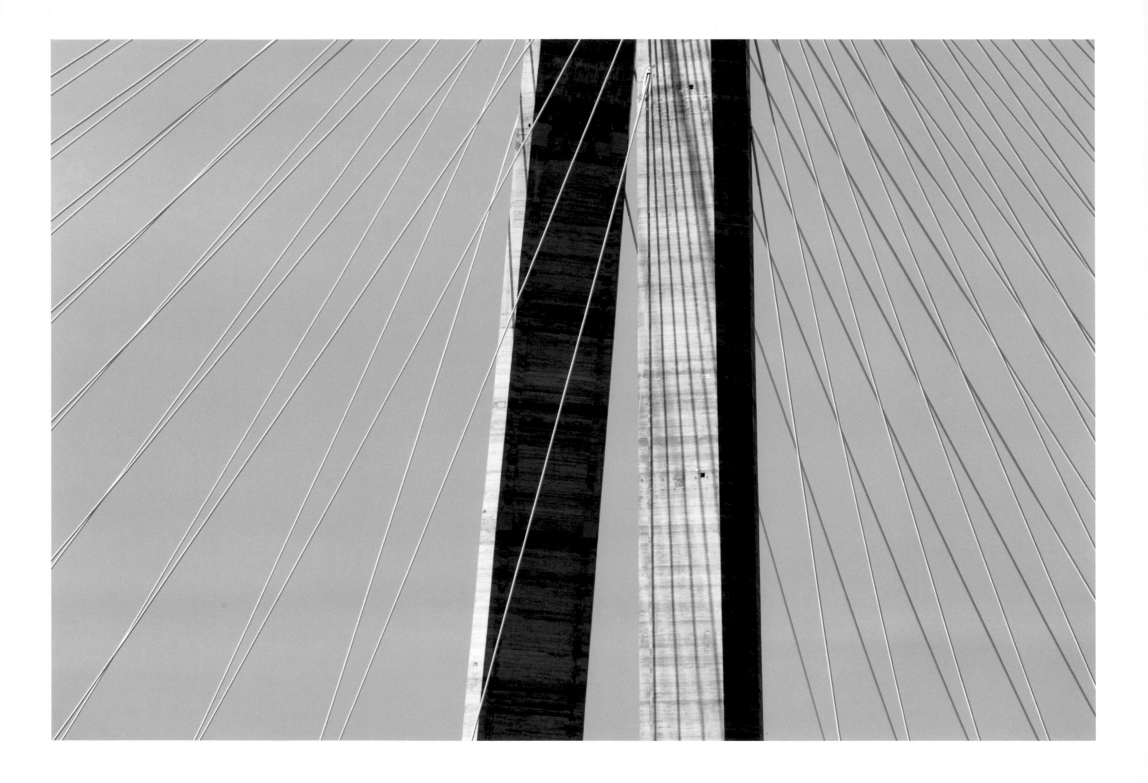

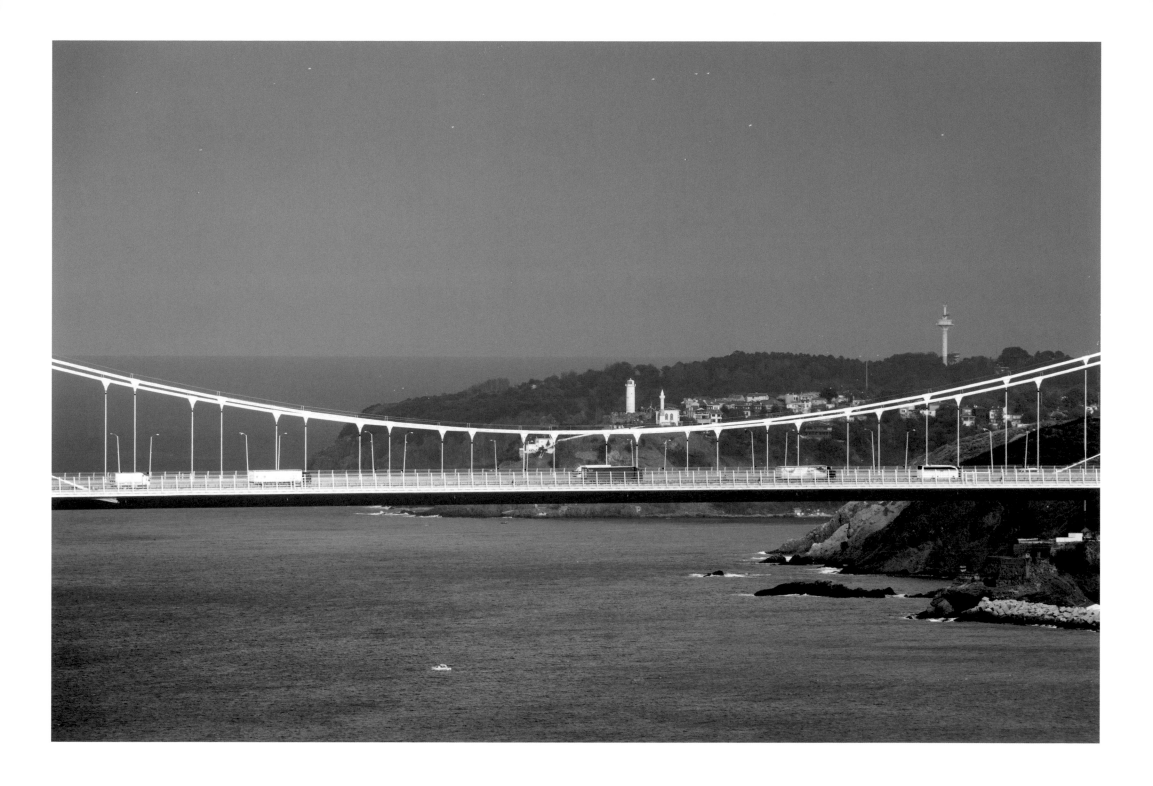

Brooklyn, but also, for its sophisticated structural concept, in the highly evolved experiments of the masters of reinforced concrete, who certainly include the Italian Sergio Musmeci, with his project dating 1953 for the Messina Bridge, an example that can be assimilated to that of the third Bosphorus bridge in terms of complexity both with regard to stresses due to wind conditions, and for the need to cover a wide span. To solve these problems, Musmeci envisaged triangular "sails," a highly original spatial system of suspension to stiffen the structure and limit the perpendicular stresses on the bridge itself, an innovative idea revived more recently for Norman Foster's London Millennium Footbridge. An emblematic example of this latter solution, in line with the research expressed in the design of the Yavuz Sultan Selim Bridge, is also the Millau Viaduct in France, completed in 2004. Each case, however, remains separate because each design is produced for a specific context, time, and environment, and conditions that are always different from one another. The designers of the Yavuz Sultan Selim Bridge also stated that the Kojima-Sakaide route of the Honshu Shikoku project was a source of inspiration in terms of its impact on the landscape. Here we are on the Bosphorus, a special territory, with a history of beauty dating back to before Istanbul itself. Today it is still an important place from a naturalistic point of view due to the reproduction of birds that pass through it and then migrate, to the unspoilt and dense forests, as well as to the strikingly beautiful rocky coasts. It is also a place of high winds and powerful currents, a landscape and territory in which every action cannot but take into account the forces of nature and the unpredictability of events, complying with them, respecting them, monitoring them and, sometimes, challenging them. Consequently, this third bridge is and will be something more than a means for connection and crossing, a link with the future.

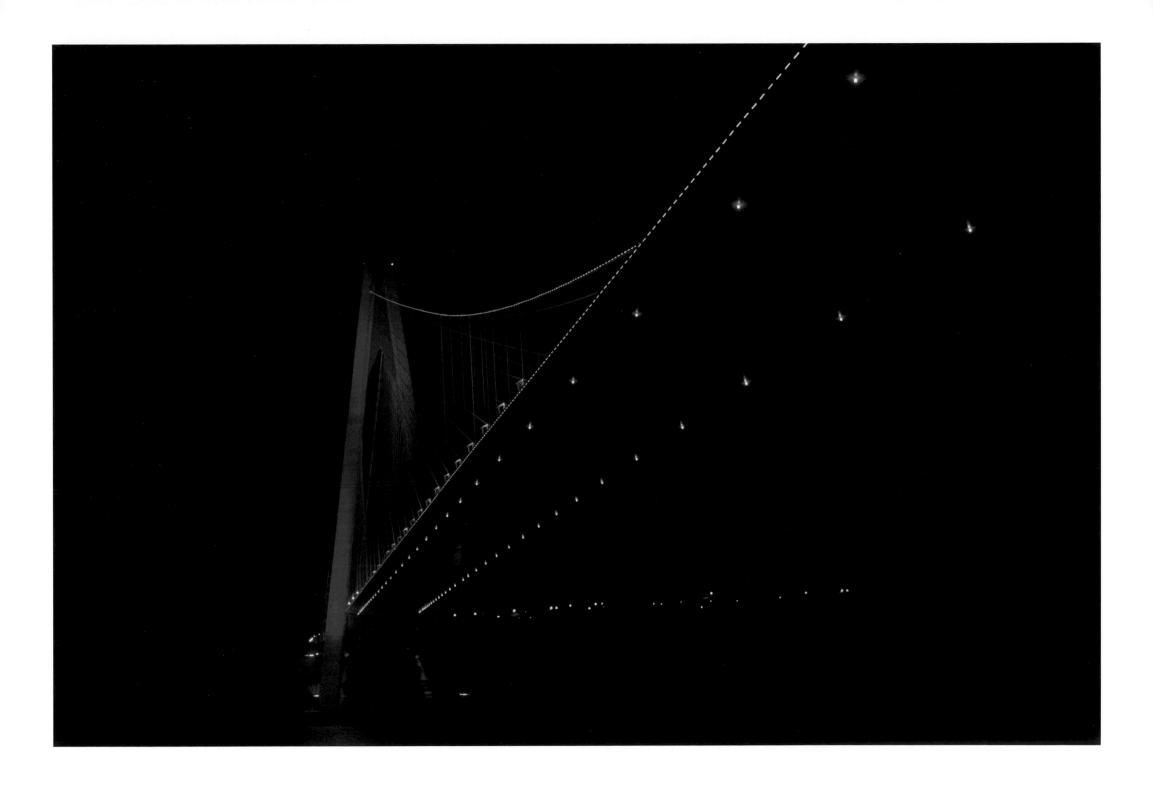

A VISION TURNING INTO REALITY

İbrahim Çeçen
IC Holding Chairman

We are proud to have duly completed one of Turkey's most important projects, the Yavuz Sultan Selim Bridge, connecting the two shores of our exceptional city of Istanbul for the third time, as well as the Northern Ring Motorway, taking into account security, economy, and aesthetic aspects.

For this project, we brought together the world's leading designers, construction and engineering companies, and numerous specialised consulting firms and formed a global consortium. Once again, we worked efficiently and harmoniously with our esteemed business partner Astaldi, with whom we completed various successful projects in the past.

We concluded this project in record time thanks to the support and guidance first and foremost of our President R. Tayyip Erdoğan, our Prime Minister Binali Yıldırım and other government officials from the Ministry of Transportation and General Directorate of Highways. Also, throughout the whole project, our financiers Garanti Bank, HalkBank, İşbank, Vakıf Bank, Yapi Kredi Bank, Ziraat Bank along with our consultant Yüksel Proje Chodai and DenizBank gave us their endless support.

I believe that, with this operation, we have broken a record not only in terms of completing of the construction process much earlier than expected, but also in terms of the quality of the monument itself. This has been a project which raised the bar in terms of global architecture and engineering standards, while incorporating numerous "firsts" and "mosts" at the same time.

The construction of the Yavuz Sultan Selim Bridge and the Northern Ring Motorway also served as a training ground for many people. In three years, we have raised 200 young engineers. I have complete faith in our young engineers, and I am sure that they will participate in and add value to other exciting endeavours. Furthermore, numerous universities and engineering committees from Turkey and around the world visited our work site during the construction period to witness the unique construction process and learn firsthand.

Throughout the whole process, we gave the utmost importance to the preservation of the environment and the ecological balance. For three years now, we have been running the biggest private sector afforestation project in the history of Turkey. In the last three years, we have planted 3.1 million trees and plants. Our goal is to increase this number to 5.1 million by the time the afforestation project is finished.

Every centimetre of this bridge involved tremendous effort, dreams, and the hard work of approximately 10,000 people, along with the hopes and sacrifices of their families. While we were breaking this record, we were able to count on their full support and strength.

Throughout my career, I have accomplished things that I am proud of and I am very happy for that. We have completed many projects up until today. But with this latest one, we have raised the bar very high. Building such a monument is a great chance; it is a great opportunity and at the same time it is a source of great pride. Undoubtedly, this pride belongs not only to us, but to the whole country.

CONVERSATIONS

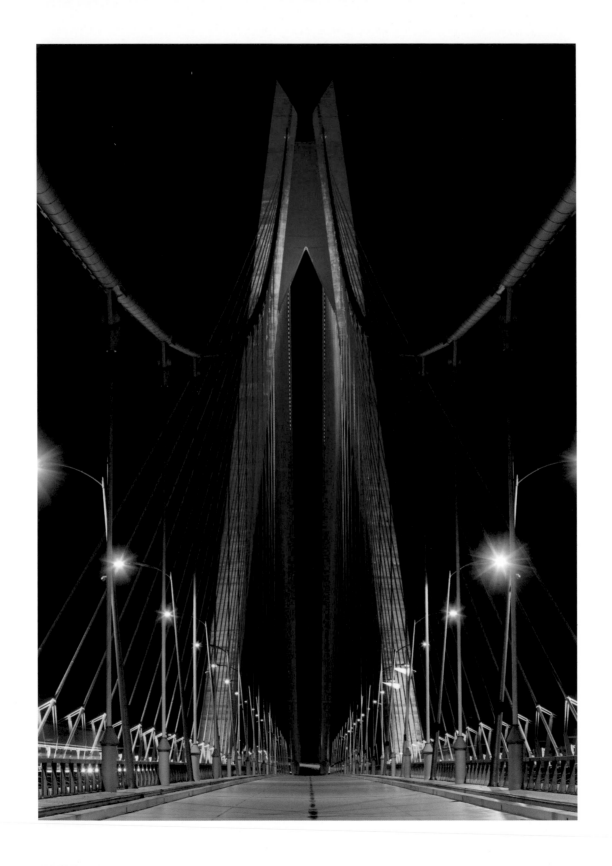

A CHALLENGE SUSPENDED IN TIME AND SPACE

Fırat Çeçen
Chairman, ICA and IC İçtaş Construction

IC İçtaş Construction is a global company with over 45 years of experience in the construction sector, both in Turkey and abroad. IC İçtaş Construction has signed many successful projects including airports, ports and marinas, high-speed train lines, roads and bridges, high-capacity power plants, smart buildings, business centers, tourism facilities, health facilities, universities and schools. Besides construction projects, the company also manages sea port and marina operations and is an active player in the energy sector.

After the great effort that a project such as the Yavuz Sultan Selim Bridge entailed, what do you see, today, when you look at the 322-metre high Third Bridge? Is it a futuristic bridge? How does it compare with the previous two bridges?

As you may know, the Yavuz Sultan Selim Bridge is one of the world's most impressive bridges thanks to its aesthetic and technical qualities. It has been an inspirational engineering, innovation, and research and development journey, breaking ground and introducing first-time-ever applications.

Compared to the July 15th Martyr Bridge (First Bridge) and Fatih Sultan Mehmet Bridge (Second Bridge), the Yavuz Sultan Selim Bridge (Third Bridge) is a hybrid structure with many eye-catching technological and design features.

The bridge was designed in partnership with great names from around the world to create a remarkable engineering work, both in Turkey and beyond. As a result, the project has constantly been in the spotlight, even while under construction.

The Third Bosphorus Bridge features the highest bridge tower, the longest main span and the widest deck with a railway passage; it provides all of these systems in a single-storey elegant deck only 5.50-metre deep: as a result, the bridge is also a work of art. It is also a great engineering masterpiece featuring both suspension and cable-stayed bridge technologies. In addition to the bridge section, ICA completed the construction of a 230-kilometre motorway and its connection roads. ICA will also provide operation and maintenance services for ten years. In this respect, the bridge needs to be considered as a significant investment project in the region in order to best describe its specifications, unlike those of other bridges.

Could you go over the most significant phases of the wide-ranging project

including the Northern Ring Motorway, of which the Third Bosphorus Bridge certainly represents the most symbolic element?

Late in February 2012, the KGM (the General Directorate of Highways) issued a call for tenders for the construction, operation, and transfer of the Northern Marmara Motorway / Odayeri – Paşaköy Section, including the design and construction of the Third Bosphorus Bridge. Connecting Europe with Asia, the main bridge will certainly become an iconic and outstanding structure and will be a new landmark in the Istanbul region. Consequently, the authorities expressed major concerns on subjective and aesthetic considerations in parallel with the definition of the functional requirements for the structure. Combining all requirements in a very elegant and efficient structure was an incredible challenge during which we had to summon all our creative and innovative ideas to come up with the best, most attractive, and most sophisticated design at the level required by this new symbol. The starting points were of course to consider and study the architecture of the two existing bridges, as well as

to measure the impact that the heavy trainloads could have on such a long span structure. The conceptual design of the Third Bosphorus Bridge offers an elegant and top-class crossing over the strait, responding perfectly to the task of underlining its symbolic role as the link between two continents to become one of the landmarks of the extraordinary city of Istanbul.

We have faced many challenges during the construction of a project and motorway of this size. We experienced twists and turns while achieving improvements in various applications. The construction period, especially, presented us with a great number of challenges to overcome. Yet in the end, we had more pros than cons. Our solution partners, subcontractors, engineers, and our company were committed to the project. This is a project like no other built before.

Your infrastructural operation can be considered one of the most significant recently undertaken between Europe and Asia. You managed to complete the Third Bosphorus Bridge in only three years, truly a record in terms of time and engineering. What was the

organisational plan and what was its most significant feature?

This project is the result of a commitment that began on the night that we prepared for the tender. Naturally, we put great effort into the preparation period, but our journey began on the tender night. After having won the tender, we immediately started work on the design and planning phases. We built a dynamic organisational structure. We started off with three people. We then increased the team to 3,000, and finally about 10,000 people were working on the project.

What are the features of this area, which from now on connects directly to Istanbul along the motorway? And how will the bridge solve the severe traffic issues of the city?

This project's location ensures urban connections in Istanbul, while easing the busy traffic on the Trans European Motorway TEM. Transit is now easier thanks to the bridge and motorway. This is especially important, considering the time restrictions that were in place for heavy vehicles using the Fatih Sultan Mehmet Bridge before the Third

Bosphorus Bridge was opened. Heavy vehicles may use the new bridge and motorway 24/7.

Having the heavy vehicles use the Yavuz Sultan Selim Bridge and the Northern Ring Motorway has eased the busy traffic on Fatih Sultan Mehmet Bridge. The rush hour traffic in the evening has been increasingly reduced.

This project was developed thanks to a partnership between IC İçtaş Construction Industry and Astaldi with an investment and operation period of ten years, two months, and 20 days. The scope of the project Includes an approximately 115-kilometre-long main motorway and following connection roads, viaducts, motorway bridges, and tunnels, as well as the Third Bosphorus Bridge. How did you handle the partnership with the Italian group?

The Yavuz Sultan Selim Bridge and Northern Ring Motorway is not the first project for which we partnered up with Astaldi. We were working together on the Saint Petersburg Western High Speed Diameter (Peripheral Motorway) and Pulkovo Airport. We believe that we are a perfect match with Astaldi. We share

the same vision and we nurture each other with our experiences. We worked in great harmony and very effectively on this project as well.

Besides the Turkish and Italian technicians, important engineering specialists (French and Swiss) have been consulted for the project. What were their roles and contribution? Did you also consult specialists in the urban and sociological fields?

Within the scope of the project, we worked with companies and professionals with great experience in the field. The concept design of the bridge was devised jointly by Michel Virlogeux, the "French bridge master," and the Swiss company T-Ingénierie. Other project design teams, Emay and Protek Proje, are among the top companies in Turkey. We also worked with Yüksel Proje Chodai, supervising our work on behalf of the General Directorate of Highways during the construction period, and Hyundai – SK J.V., our subcontractor. They were all valuable assets for this project.

The project also had an environmental and social impact. We partnered with the world-renowned AECOM to prepare the Environmental and Social Impact Evaluation report for the project. We were also audited by AECOM once in every quarter on all operations. In addition to that, the project was audited by Mott MacDonald, technical advisor of the banks, with regard to its technical aspects and its environmental and social impact during the construction period, and by Marsh, insurance advisor of the banks. With these international audits, the project achieved world-class standards.

How was this large project financed? How did the process work?

The Yavuz Sultan Selim Bridge and Northern Ring Motorway's main financing agreement was signed with a consortium of leading Turkish Banks, namely Garanti Bank, İşbank, Yapı Kredi Bank, Ziraat Bank, Vakıf Bank, HalkBank, in 2014.

The financing agreement that was signed at the beginning of the investment period loaned 2.3 billion USD for a total 9-year term. This financial loan is regarded as the highest loan provided at one session to a "greenfield" project in the history of Turkey. Together with the additional investments

requested by the General Directorate of Highways (KGM) and corresponding additional financing, the total financial loan for the Project amounted to 2.9 billion USD. According to the contract, the plan is for ICA to run the operations until 2026. For the banks that supported the project by providing such a high loan, KGM's revenue guarantee and the Undersecretariat of Treasury's debt coverage guarantee were significant as both departments were involved in organising the bidding procedure.

In addition to these factors which contributed to the financing of the project, the confidence that investment banks have in both the country's economy and in the ICA consortium played a major role in realizing this project. As the IC Group, we have worked with these banks, namely the largest banking corporations in our country, during several of our projects. These banks have been contributing to our advancement with their ongoing support, faith, and confidence in our group's success.

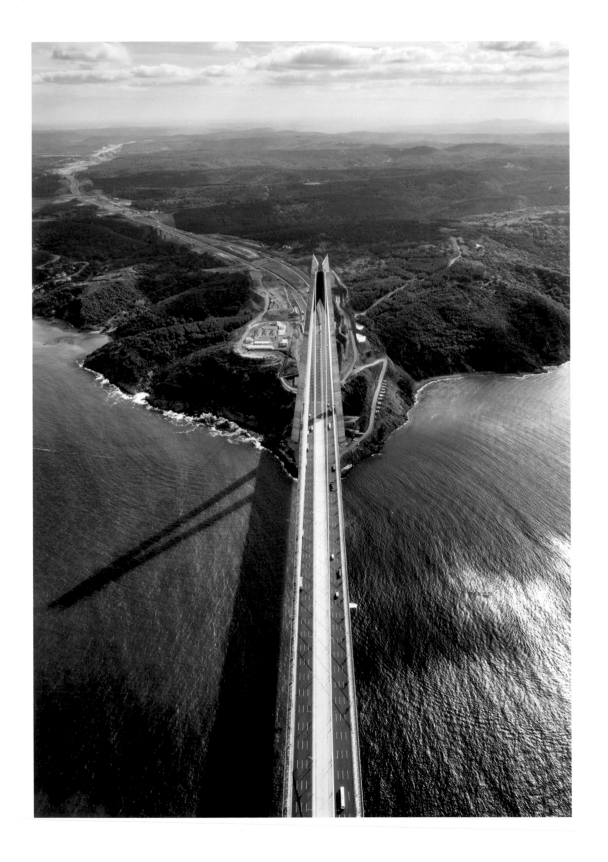

A MARK ON THE LANDSCAPE

Paolo Astaldi
Chairman, Astaldi

The **Astaldi Group**, founded more than 90 years ago, ranks among the world's top 100 contractors and among the top 25 in Europe, with established leadership in Italy and abroad. The Group's segments of activity range from transport infrastructure to hydroelectric and power plants, from civil and industrial construction to systems and facility management, as well as management of complex systems. The Group is the third in the world in the area of bridge construction.

Yours is one of the most internationally renowned Italian groups in the complex field of infrastructural development. Can you tell us how you came to reach this undisputed position of leadership, preserving the family's control over the group?

We can trace our heritage back more than 90 years, to when Mr. Sante Astaldi founded the company in 1922. Since then, a member of the Astaldi family has always served on the board and I am as committed as my predecessors to fostering the company's culture of innovation and fuelling its ambition to take on the most advanced engineering projects in the world. Astaldi is rooted in Italy and has construction at its core. At inception, the company was focused on major civil works projects in Italy, but it soon expanded its activities at home and internationally, and by the late 1990s our global footprint stretched across Africa, Europe, the Middle East, the Americas, and Asia. One of the defining moments for Astaldi came in 2002, when the company was listed on the Italian stock exchange. We are now well positioned as a leading global construction group, specializing in transport infrastructure projects, and having accomplished a number of engineering firsts with our projects. As Astaldi has grown, it has never lost sight of its identity; something I believe is due to the powerful role that values play in a family-owned firm's success. Now in its third generation of managing the business, the Astaldi family has ensured that the company lives up to its founder's ethos. As a result, our customers trust the Astaldi name—a name which has become synonymous with the highest quality in design and construction in infrastructure projects around the world; I like to call it the Made in Italy of Infrastructures. Looking back over the Group's history, I am extremely proud of all we have achieved. In almost a century of history, Astaldi has built more

than 15,000 kilometres of motorway and upwards of 160 kilometres of bridges and viaducts. We have been central to some of the largest and most complex infrastructure projects in the world—the Third Bosphorus Bridge being a prime example.

Astaldi operates in 26 countries across the world. What does Turkey mean to you?

The fact that our field of action is global comes from our company's history, it's in our DNA. Astaldi has been operating in Turkey for over 30 years. We started in 1985 when my father had the excellent foresight to come to this country and felt welcome, a feeling that I shared with him. The first project was the Anatolian Motorway and after that, as the company increased its activity, we reorganised our Turkish business to support our efforts. For example, our decision to become a direct investor in Turkey's major "BOT" (Build, Operate and Transfer) projects was followed by the founding of Astur, Astaldi's Turkish company, to enhance our integration with the local construction market.

Turkey is without doubt one of our most important markets, where we are one of the leading infrastructure companies and where we operate as a local player with a global approach. We have completed many key transport infrastructure works that have helped transform the nation's transport system. For example, we brought our extensive expertise working on underground lines across Europe to Istanbul with our construction of the city's new underground—a 20-kilometre double-track line with 16 stations that was completed in 2011.

Much of Astaldi's construction expertise has been built up through our work in Turkey. It is a market that is very special to us—some of the partnerships that we first established in Turkey have become the basis for company-wide initiatives around the world. Turkey has given us the opportunity to show our know-how through some of the best examples of infrastructures built today, such as the Izmit Bay suspension bridge, the world's fourth longest suspended bridge worldwide; the Haliç Bridge across the Golden Horn; and of course the Third Bosphorus Bridge, the widest hybrid bridge in the world with towers taller than the Eiffel Tower.

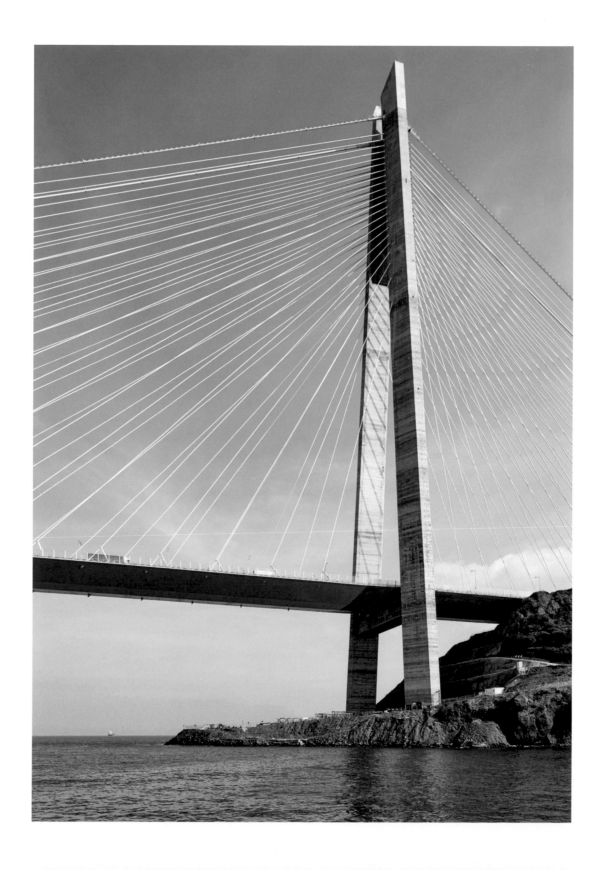

The Third Bosphorus Bridge was a wide-ranging operation, and certainly a big challenge for you. Incidentally, the choice of one of the designers, Michel Virlogeux, was the result of a suggestion by Astaldi. What do you see now when you look at the Yavuz Sultan Selim Bridge?

The Third Bosphorus Bridge is a bridge of firsts: the longest and widest hybrid bridge worldwide. Astaldi is proud to have been involved in a landmark project that is sure to have an important place both in the history of Turkey and in the history of global infrastructure. To construct a bridge of this scale and of such engineering complexity was extremely challenging, and demanded that Astaldi draw on the very best of its technical know-how. Finally, the combination of functionality and beauty makes us proud, and seeing the bridge open and knowing that Astaldi contributed to the development of a country with which it has a long-standing and successful relationship has been very special indeed.

It looks as though you like challenges, is that what drives you?

Few projects are as challenging as the construction of the Third Bosphorus Bridge, but we like challenges. This is the reason why we have submitted and won the tender for a challenge that stands out as being truly visionary: the "European Extremely Large Telescope"—the largest ground-based telescope in the world—which is being built in Chile. We were proud to have been awarded the contract for the design and development of the dome and main structure of the E-ELT in 2016. We have been operating in Chile for ten years, working across a wide range of construction projects, from the modernisation of the country's largest airport, to the underground expansion of the world's largest open-pit mine for CODELCO. We are excited to take on this groundbreaking project that will demand the very best in engineering skill and advanced technology.

Looking back to the projects we have delivered, our first Turkish project stands out as particularly challenging because we had to design and apply avant-garde anti-seismic measures never used before, but which proved to be extremely effective. I am referring to the stretch of the Anatolian

Motorway, approximately 120 kilometres of motorway with viaducts and tunnels lying across an active seismic fault.

How did you begin cooperating with İçtaş? Can we draw similarities in the management structures of the two groups, which still include representatives from their founding families?

Astaldi has built a strong and successful partnership with İçtaş over five years of working on several projects across Europe. Since our first collaboration in 2011 in Russia on the extension of Pulkovo International Airport, we have worked together on evermore complex and ambitious projects, culminating in the Third Bosphorus Bridge.

The Pulkovo airport is one of three large-scale transport infrastructure projects that Astaldi and İçtaş have undertaken in Russia as a joint venture partnership. One of particular strategic importance to the country's transport system was the Western High Speed Diameter motorway in Saint Petersburg. This €2.2-billion project was extremely demanding from an engineering point of view, as it involved constructing an eight-lane motorway, largely on the Baltic Sea, two cable-stayed bridges, and a tunnel running beneath the Smolenka River. Finally, we are working together on the M11 motorway in Saint Petersburg, 140 kilometres of motorway, linking Saint Petersburg to Moscow.

The smooth and successful running of Astaldi-İçtaş joint venture projects is testament to the complementary nature of our companies' skills and the effectiveness of our working relationship. Like Astaldi, İçtaş is renowned for its expertise in engineering and infrastructure projects, as well as for its track record of operating as a leading European and, increasingly, international player. The similarity extends to our managerial structures; at the heart of both businesses are the families who founded them, and both have found success through the passion and professionalism that their founding families uphold. The culmination of our working relationship has been the Third Bosphorus Bridge and the Northern Ring Motorway—by far our most ambitious collaboration to date.

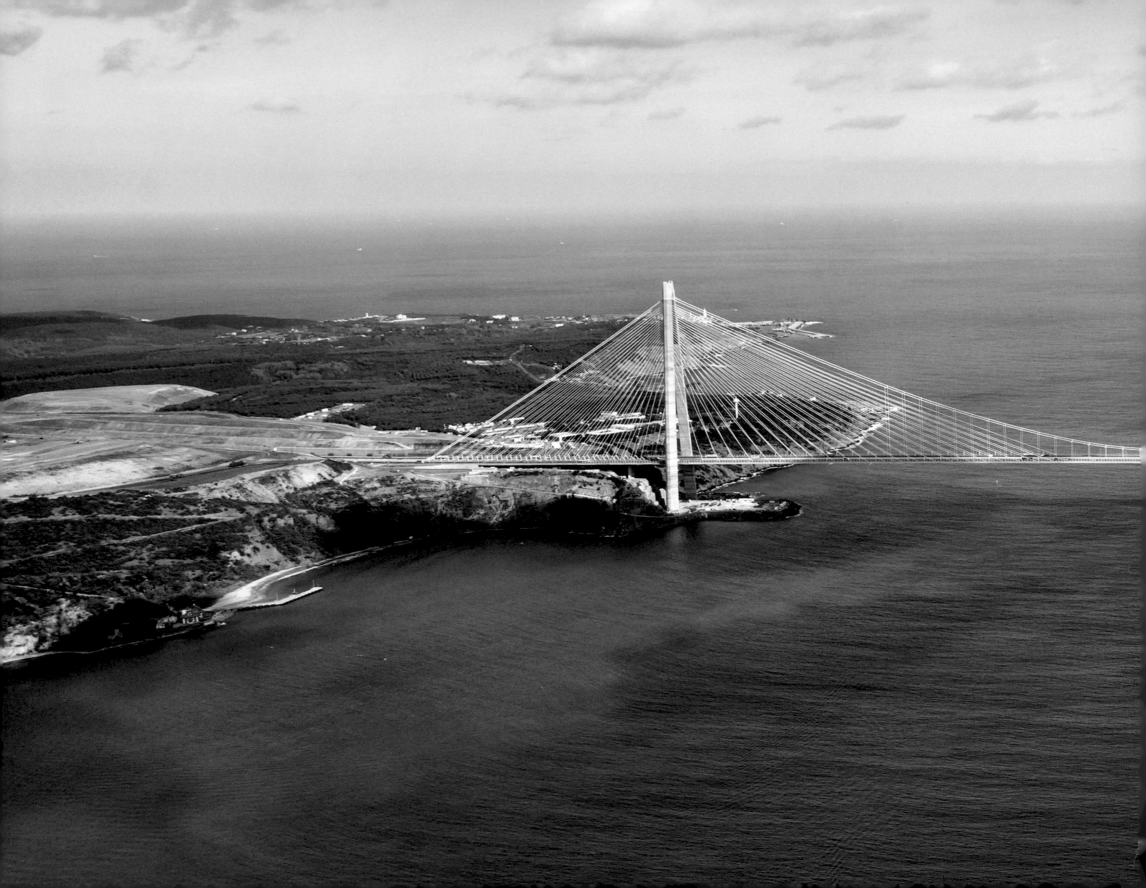

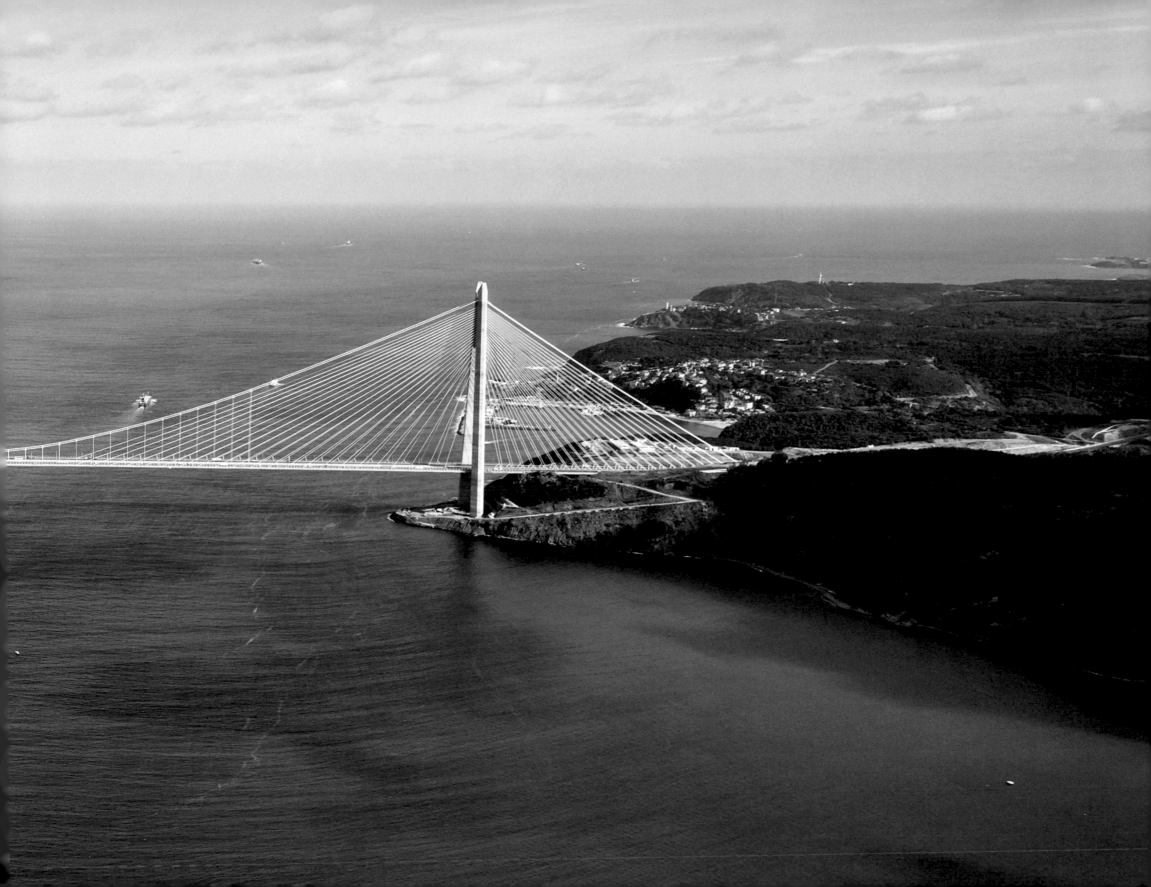

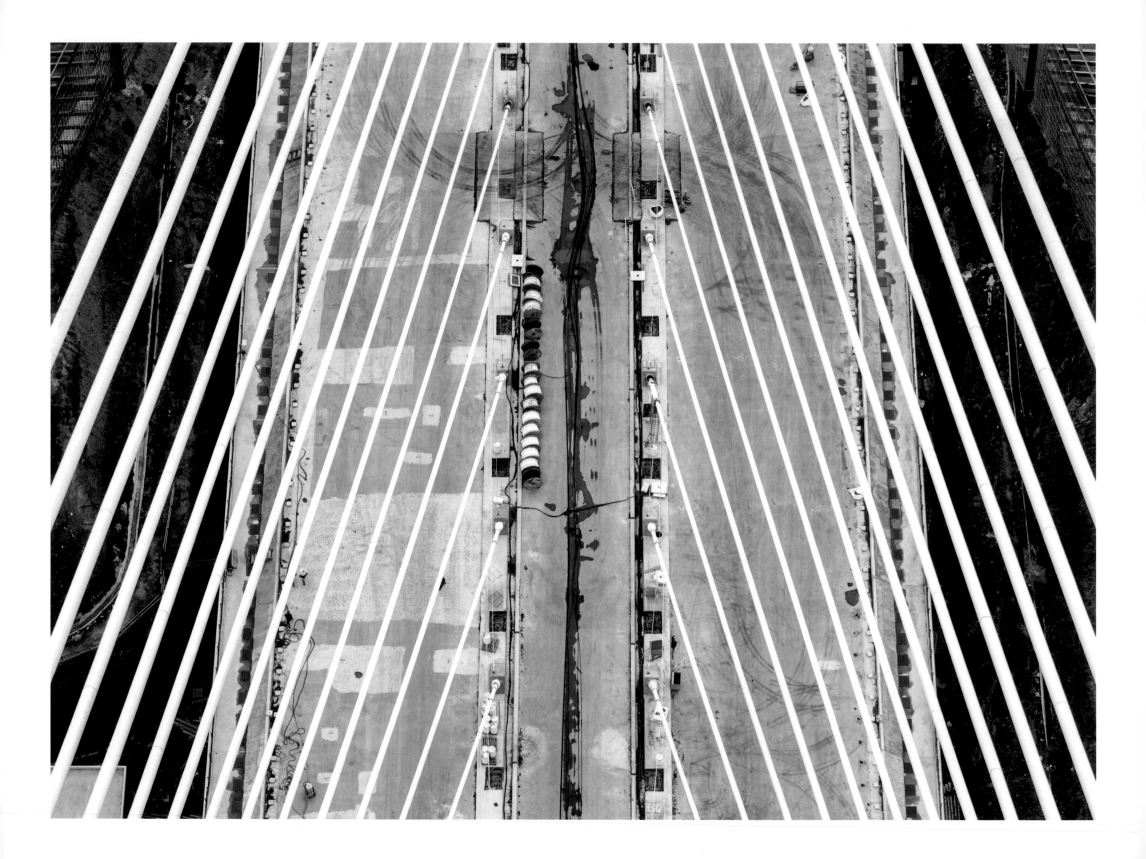

REVOLUTIONARY INNOVATION

İsmail Kartal
General Manager of Highways

The Yavuz Sultan Selim Bridge has become known as a state-of-the-art bridge. What are the features that led to this title?
The Yavuz Sultan Selim Bridge is not an ordinary engineering structure but a milestone for many of the superior technological and structural aspects it features, especially for the history of world engineering. The bridge, designed as a combination of a suspension bridge and a cable-stayed bridge, is a unique example in its category, a hybrid cable-stayed suspension bridge. The structure comprises several revolutionary innovations, such as the world's highest bridge towers, the widest deck, and the longest rail system suspension bridge. With a main clearance deck area of 83,072 square metres, it is the equivalent of ten standard football fields, and weighs the equivalent of four passenger aircraft, while each single decking segment weighs 900 tonnes. The steel wire used for its construction measures 124,832 kilometres and is long enough to circle the world three times.

How was it possible to complete construction of the Yavuz Sultan Selim Bridge in the record time of three years? How was this success achieved?
All efforts for the construction of the Yavuz Sultan Selim Bridge were conducted with painstaking sensitivity. I also personally and closely witnessed this particular perseverance and meticulousness. On some occasions, just for one millimetre, project participants met time and time again to discuss and reach the right conclusion. No moral or material sacrifice was spared to produce the best. A venture of this kind would normally have taken at least five to six years to be accomplished; it is therefore a matter of pride in itself that the construction of the Yavuz Sultan Selim Bridge was completed within such a short period of time and put at the service of our citizens.

As a witness to the construction, what did you feel on completion of the project?

We are extremely lucky to have been able to participate in and witness all the construction stages of the Yavuz Sultan Selim Bridge, from planning to completion. Knowing that we are passing on a worthwhile achievement to our country and to future generations helps us overcome all our exhaustion, and allows us to remember the distress we lived through from time to time with a smile, simply as fond memories. It is not easy to find the words to express the pride we feel at having produced this landmark, which will serve mankind for many years to come. Moreover, considering the thousands of vehicles and hundreds of thousands of people using this work of art—one that we built—every day, we cannot feel proud enough of this achievement, which we now present to our nation.

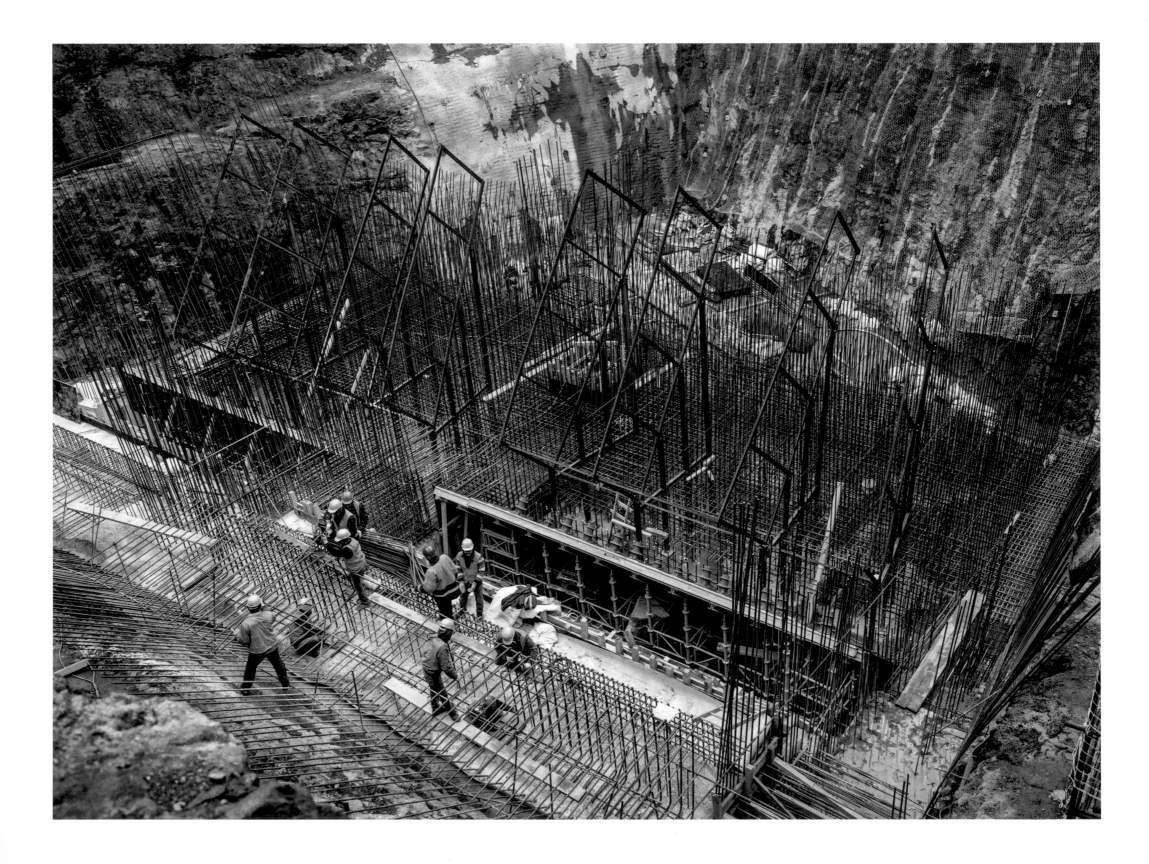

A RACE AGAINST TIME

Beyhan Yaraman
Chief Engineer
General Directorate of Highways, Region 1

Your role within the government for the General Directorate of Highways is also a technical appointment and a great responsibility. What did this project mean to you?
The Yavuz Sultan Selim Bridge, demonstrating Turkey's strength and skill in engineering to the whole world, is a bridge of "firsts" in terms of its technical and aesthetic qualities, as everyone will agree. Therefore, it is special for both our country and the world.
We have participated in the construction projects of numerous bridges and motorways before, however this time we were tasked with one of the most important engineering projects in the world: the Yavuz Sultan Selim Bridge and a colossal motorway construction.

What was the initial impact with this project when you first became involved in it?
To be frank, in the beginning we had our doubts as to whether we would be able to complete the project on time.

However, once construction started, we saw enormous efforts. Multiple engineering companies from different disciplines worked synchronously with the world's leading technical experts. We have all learned new things from each other and witnessed the importance of knowledge and experience, firsthand. Over 10,000 people, including engineers and construction workers, worked with great effort and commitment to build the Yavuz Sultan Selim Bridge, the world's widest and longest suspension bridge, with a railway and the world's highest towers. We would like to thank everyone for their hard work in making this project perfect and completing it on time. Also, we would like to extend our gratitude to our Director İsmail Kartal, who was personally involved in every step of the project.

In your opinion, which of the numerous challenges and difficulties that such a large project must have entailed was the most significant?

One of the most challenging issues was time. We were indeed racing against time. Seeing the bridge rise every day, every moment was extremely exciting. Every moment from the day we broke ground until the day the last section of deck was fitted and the bridge was opened officially, we felt we were witnessing history.

What reactions did a project of such scale spark?

Many people shared this excitement. The project drew huge attention. We hosted hundreds of guest groups from all around the world during the construction phase. We promoted the project with pride. We, as a team, were aware of how lucky we were to be a part of such a project from the beginning until the end.

What is your final thought on this experience?

Construction of the Yavuz Sultan Selim Bridge was completed in only three years. Dynamic collaboration between thousands of people working on the project and hundreds of partners connected the two shores of Istanbul for the third time, and marked the place of this bridge in the history of world engineering.

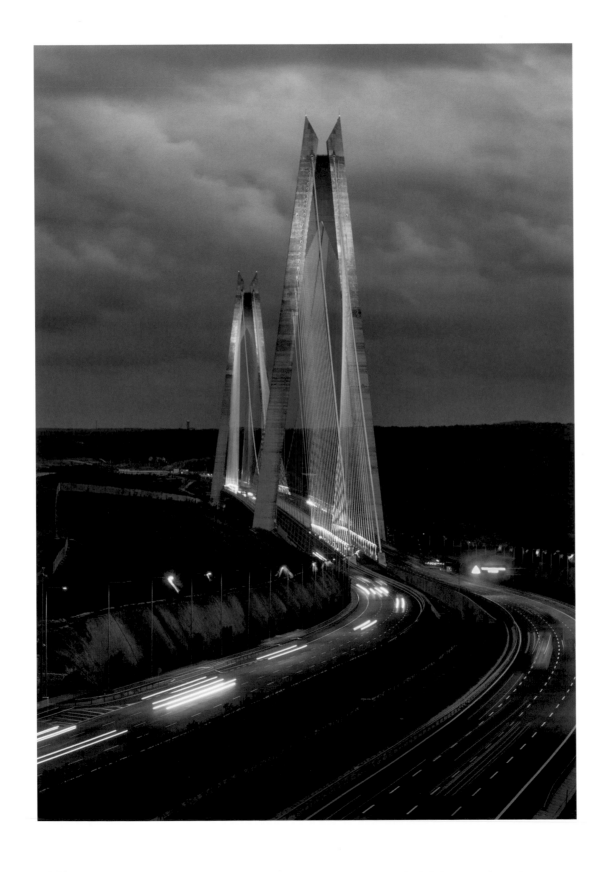

A PLURALITY OF VOICES: THE MANAGEMENT TEAM

ICA, a joint venture founded by İçtaş Construction and Astaldi, pushes the boundaries of contemporary engineering techniques, combining them with international expertise to accomplish seemingly impossible projects. Having carried out various projects which exceed global standards in terms of architecture and engineering, ICA, with its dynamic organisational structure, its synergy and specialised staff, is striving to continue its success in the long run. ICA's recent projects include the expansion of Saint Petersburg Pulkovo Airport, the Yavuz Sultan Selim Bridge and Northern Ring Motorway Project, Saint Petersburg's WHSD (Western High Speed Diameter) and the M11 Motorway Project connecting Moscow and Saint Petersburg.

Telling the story of the Yavuz Sultan Selim Bridge and the Northern Ring Motorway has meant talking to the multitude of people involved in the management of this enterprise at the most diverse levels in various specific roles. Countless professionals who, from their "control rooms," contributed to putting together a single jigsaw that was as complex and wide-ranging as the construction of the bridge and the motorway. Thus, in addition to our conversations with the two key players in this project, namely Firat Çeçen, Chairman of İçtaş, and Paolo Astaldi, President of Astaldi, both of whom explained the choices made, the reasoning and the peculiarities of the project as well as the related wider context in which their two companies have been working for some time now, we also interviewed those who, as İçtaş personnel, played leading roles within the subsidiary company ICA, and the Astaldi managers who supervised the ICA venture for construction of the bridge.

It was Murat Soğancıoğlu, Executive Board Member and Infrastructure Investment General Manager for İçtaş, who introduced us to the initial stages of this important partnership between two giants in the world of infrastructures. "In 2009, we were developing some ambitious projects with Astaldi, including the construction of an airport and two bridges in Russia. When the opportunity to take part in the Third Bosphorus Bridge project arose, we contacted the Italian company, who were quite eager to get involved. We discussed how to approach this complex enterprise with them, starting with the fundamental choice of which designers to employ. We subsequently began working together between Turkey and Russia, as the teams were based in both countries. We have considerable experience in the field of infrastructural development, but being able to rely on the support and expertise of Astaldi, who at the time were more experienced

in terms of bridge construction than we were, was key for us." As Olivio Angelini, Deputy General Manager for Astaldi, reminded us, "this was the first time that a hybrid bridge—suspended and cable-stayed—of such a dimension was to be constructed. Of course, because the bridge was the first of its kind, we faced a number of challenges, not least because of the limited time frame we had to build it. Astaldi and İçtaş relished each new challenge and our engineers found innovative solutions to every operational question they faced."

Filippo Stinellis, CEO of Astaldi, went on to say that "the chief advantage of consortia and joint ventures is that they combine the very best of members' specific competencies, technical expertise, and experiences working within particular regions. This is highly attractive to clients, particularly when a project is of the scale and complexity of the Third Bosphorus Bridge. Forming a consortium or joint venture enables members to share in large projects that can be too big for a single company to undertake alone. Members also have the flexibility to take on as much involvement as they wish. Of course, a key advantage for members of a consortium or joint venture model is that they share the project risk and cost."

Furthermore, the significance of a series of projects previously carried out by Astaldi has represented a substantial element of the partnership on this specific occasion, as Filippo Stinellis clearly stated. "Astaldi has long recognised the potential commercial benefits of forming collaborative structures to undertake significant construction works, and we have a strong track record of doing so. In fact, since Astaldi began operating in Turkey in 1985, all but one of the multiple projects that we have undertaken here have been through a joint venture model. These projects include the Kadıköy-Kartal Metro line, the Haliç Bridge, the Milas-Bodrum International Airport, and the Izmit Bay Bridge."

More specifically, the Italian group played a strategic role in some of the engineering aspects of the Yavuz Sultan Selim Bridge: "We drew on our experience working on large-scale complex engineering projects to develop successful strategies for certain aspects of this project. We devoted our most

experienced managers and engineers to this extraordinary project to take on the responsibility for off-site fabrication, project control management, design management, engineering supervision, and production supervision."

He went on to add that "what makes this project so special is that it is unique: it is the result of the best design solutions, and showcases advanced engineering skills on a world-class level. In engineering terms, it is a hybrid solution called the "High Rigid Suspension Bridge." What I mean by this is that—as a hybrid bridge that is both suspended and cable-stayed—the Third Bosphorus Bridge is rigid enough to minimize the oscillations of the deck caused by the railway running between the two motorway lanes."

The most emblematic case was certainly the challenge represented by the complex system of cable and suspension elements: "for any cable-stayed bridge, it is crucial that the saddles are cast and welded with the utmost precision; for this particular project, we had the added challenge of working within a very limited time frame. Acciaieria Fonderia Cividale was the company responsible for constructing the saddles and delivering them from Italy to Turkey. Each saddle was measured to the micrometre and weighed around 110-120 tonnes, and it was thanks to the great efforts of Acciaieria Fonderia Cividale that they were delivered on time. To bring the saddles from Italy to our work site, we first had to rent one of the largest cargo planes in the world and then ship them through the Greek Corinth Canal. Another unique aspect of this project was the shipyard facility that was constructed especially to assemble the deck segments. When fully operational, the shipyard produced two entire segments of the deck, from scratch, every month.

I must also mention the extraordinary lifting equipment that we used for this project. The four Derrick cranes that put the towers in place were the tallest in the world and able to lift steel segments of a record weight of 940 tonnes. These cranes, as well as the other lifting systems that were used, were specially designed for this project."

The concept-design of the bridge was clear almost from the inception. The idea for the hybrid system was commendable, and demonstrated the

skill of the two designers; on the other hand, it presented the team with a series of structural and organisational issues. The comments by İsmail Fadıl Yazıcı—Project Director—were enlightening with regard to the construction details and decisions on sizing and materials for the bridge, when he stressed that this project "incorporated many firsts in terms of engineering. It is a milestone in the history of engineering. Also, the experience itself, the pride and joy it brings to our hearts, is totally priceless." He also detailed the systems that had to be used to ensure full control of the project from conception up to completion, adding "Solely for this project, we built a weather station to monitor the weather of the region more accurately. We poured 3 million 200 thousand cubic metres of concrete, and with this amount of concrete you can build 32 skyscrapers. We used 500,000 tonnes of structural iron and 57,000 tonnes of structural steel. Almost 10,000 people from 15 to 20 different countries worked on this project. Approximately 50 million man-hours were assigned to it. On the other hand, the global finance sector examined the financial aspect

of the project with admiration. It is easy to give more figures and examples regarding this project. However, I do not think there are enough words or numbers to describe the enormousness of the Yavuz Sultan Selim Bridge and Northern Ring Motorway Project." Murat Soğancıoğlu went on to talk about the incredible scale of the bridge when, describing the story of the project that started between 2009 to 2010, he said that it was "a large and complex project, and one of the few of its kind to be developed with private investments. It was not a government programme: after securing the financing and investing our equity, we developed the road and bridge, which we will eventually hand over to the government. In 2009, in the early stages, we had to find the best solutions for developing the project, which was not an easy task. We began working on the feasibility of the bridge and discussing with some designers, as well as various groups; however, we soon had to put the whole venture on hold, as initially not enough bidders responded to the tender. Later on, the Government announced that they would divide the project into segments

and introduced a new tender."
Certainly, the economic decisions and the financial planning prior to this incredible venture had a significant policy impact on the whole process: "While evaluating this investment, we had to take into account the considerable funds required: we're talking about 3 billion dollars of financing. We started the project with our own equity, before we completed the lending structure. Time was crucial: for this reason, we initially invested our own resources, and then proceeded to raise the funds. Some of the investors, especially foreign, told me how brave they thought we had been: we had not even secured financing on such a unique project before we started investing equity." He then added that "the positive aspect of this specific project was that the Turkish Treasury guaranteed the financing: this was an important safety net, and because of it, it was easier for Turkish banks to step in. We worked with six local banks and thankfully they supported us very well." Not only the specific nature of the chosen site, but also the related structural challenges and the need to find suitable and unique solutions for this exemplary case of sculptural engineering, made

essential contributions to the excellent success of the project. Filippo Stinellis himself underlined, for example, that "the bridge's location made the wind a crucial factor. So not only is this a hybrid bridge, but it also had to have a structure with a specific bird-like shape in order to withstand the strong winds that cross the Bosphorus channel. We found this solution after submitting the prototype model to extensive wind tunnel tests that were performed mainly in Italy, at the Politecnico di Milano." Regarding the seismic nature of Turkey, Olivio Angelini went on from this comment by Stinellis, adding: "The consideration of earthquakes was one important deciding factor in the final design of the Third Bosphorus Bridge. With this in mind, the decision was made to construct a hybrid bridge that was unique in having an unusually high level of 'stiffness,' both during its erection and in its final form. The choice of location for the bridge—away from any active fault lines—was also the subject of careful study and subsequent deliberation. Furthermore, we designed an innovative, technical solution to minimize the impact of the earthquake on the

bridge: these are called the "pendulum bearings." By using this unique support system, we were able to control the longitudinal movements of the bridge's deck caused by the train tracks— as well as any potential movement caused by earthquakes—whilst also ensuring a high overall 'stiffness'."
Not only does the area in question have a number of important environmental characteristics, but it is also earmarked for major infrastructural changes in the future. Murat Soğancıoğlu told us that "the location for a new airport investment was finalised after the construction of the bridge started. Of course now this is crucial, because our road connects the two existing airports (one on the Asian side and one on the European side), and when the new airport is built in 2018, we will be connecting the three of them, thus making our route critical. The importance of connecting the three airports is that the third bridge will absorb some of the heavy traffic crossing the second bridge at all times. The situation is already much better: after ten in the morning, the second bridge is empty and commuting has been made considerably easier."

Respect for territorial conditions immediately became one of the most important aspects of the project, as Murat Soğancıoğlu explained: "We conducted an environmental analysis, to see how much of the area we could protect. Subsequently, we drew up a landscaping plan and we replanted more than five times the area we deforested. Furthermore, this area is an excellent spot for birdwatching, as our research on bird migration routes shows." Moreover, as İsmail Fadıl Yazıcı stated, already during its construction stages, the bridge had interesting international repercussions, so much so that it attracted "university deans and chancellors from more than 300 universities, who came from all over the world to observe the construction. Since the project was universal, the world followed it very closely."
It is therefore a sophisticated landmark, as Olivio Angelini enthusiastically claimed, "our most ambitious project to date, in many ways symbolic of the strong partnership between Astaldi and İçtaş," but also a unique opportunity for the Turkish territory and landscape.

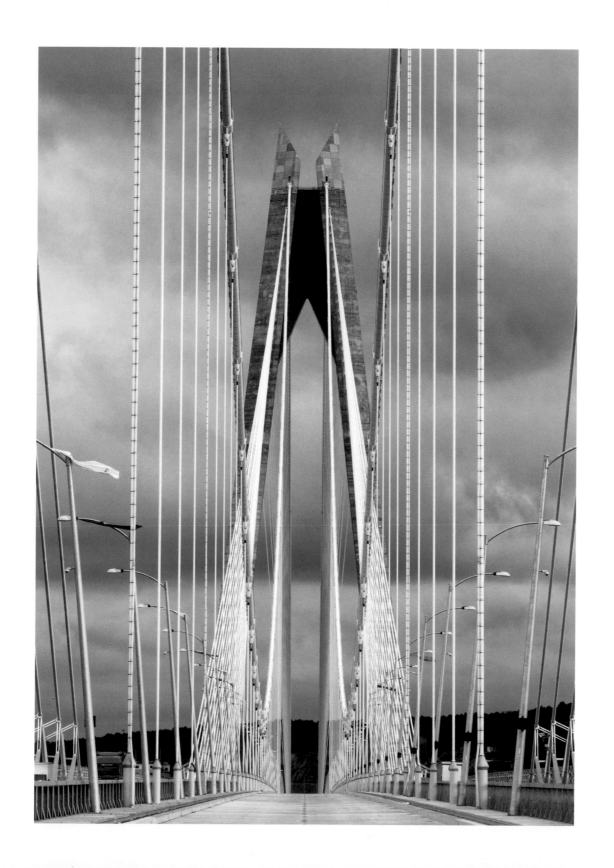

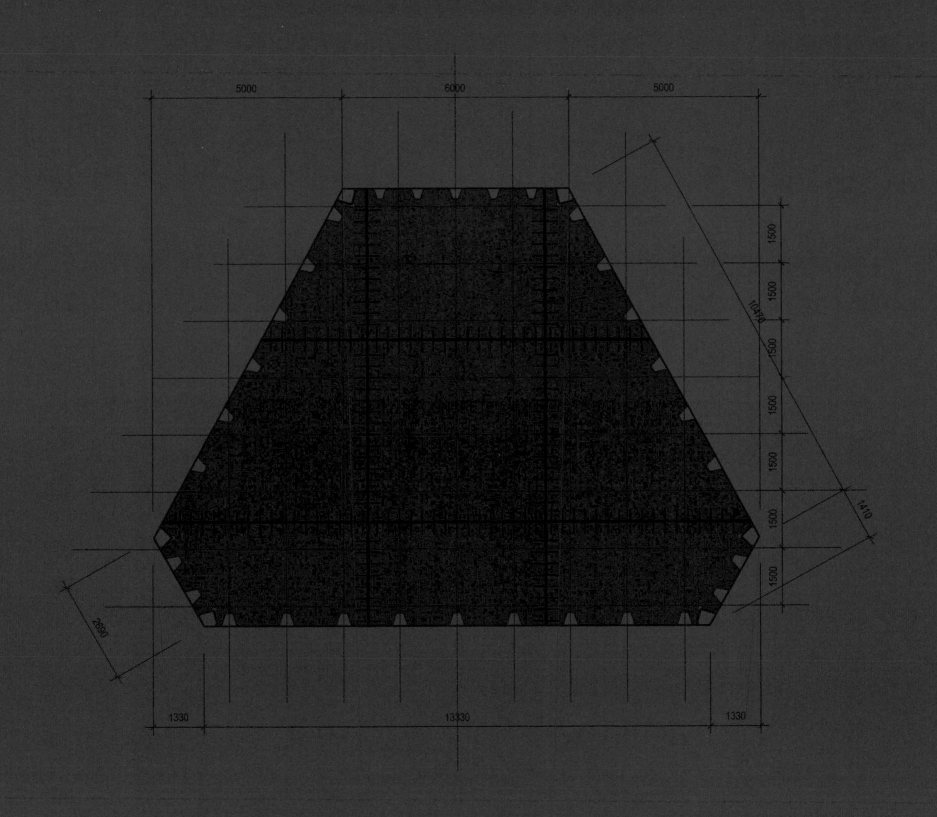

DEVELOPMENT

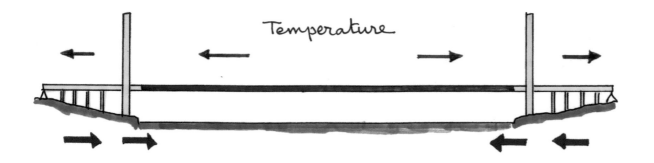

Temperature

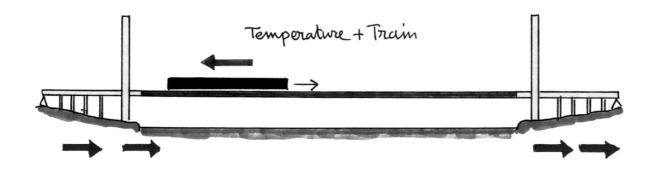

Temperature + Train

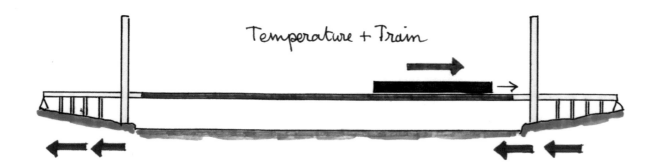

Temperature + Train

Preliminary studies of the thermal behaviour of the bridge when trains cross over it.

A STRUCTURAL CONCEPTION

Michel Virlogeux
Civil Engineer and Chief Designer

Michel Virlogeux graduated from the École Polytechnique of Paris in 1967, and from the École Nationale des Ponts et Chaussées in 1970. After spending three years in Tunisia as a road engineer, he went on to work for more than twenty years designing bridges for the French Administration. He currently works as a private consultant and is Professor of Bridge Design and Construction at the École Nationale des Ponts et Chaussées. He has designed many bridges, among which are the Ottmarsheim over the Alsace Canal, the Seyssel over the Rhone River, the Kerkinstensalmi in Finland. A number of viaducts in France (such as the ones in Auray, Bourran-Rodez, Truc de la Fare) also bear his signature, as well as the preliminary design for the Millau Viaduct with Sir Norman Foster.

You have worked on a considerable number of important bridges and viaducts all over the world, all with very distinctive features. How did you join the Third Bridge across the Bosphorus project?

I had contacts with Astaldi for the erection of the Haliç Metro Crossing in Istanbul; I designed the bridge with a Turkish architect, Hakan Kıran, but I was unable to oversee the construction. Later I worked at the design stage with Astaldi (and SETEC) for the South Approach Viaduct to the İzmit Bay Bridge, and then with İçtaş and Astaldi for the Saint-Petersburg, Russia, High Speed Diameter, also at the design stage.

For the Third Bosphorus Bridge, everything started with a 15-minute phone call with Luigi Realini, Astaldi's Deputy General Manager, on 20 or 22 February 2012. He told me that İçtaş and Astaldi—which would become ICA—had decided to compete for the 150-kilometre motorway to be built between Asia and Europe, including the Third Bosphorus Bridge. He asked me if I would agree to join them—of course I did—and which design office would be the best to develop a design. I suggested Jean-François Klein and T-Ingénierie, because I consider them to be the most imaginative to work on new ideas, also with enough wisdom to control them.

The big surprise was the time frame: the bids were to be submitted by 6 April 2012, a date which was fortunately postponed to 26 April by the KGM (the Turkish General Directorate of Highways).

But it left only two months to develop the preliminary design of one of the most difficult bridges ever built.

This bridge is a motorway and rail bridge at the same time. All over the world such bridges are two-story structures. Your design, however, is a flat one-story solution which has led to the existing hybrid construction of a

cable-stayed bridge with a suspension bridge. How did this unique solution emerge?

The competition programme prepared by the KGM and the Turkish Government insisted on the architectural quality required for the bridge, and on a familiarity with the shapes of the first two Bosphorus bridges. For me this excluded a two-story truss deck.

But a classical suspension bridge with a one-story deck (a streamlined box-girder) would have been much too flexible to carry train traffic.

This is why, with Jean-François Klein, we immediately—in the last days of February 2012—decided on a hybrid solution, with stay cables on about 35% of the span length from each tower, to reduce downward deflections by a factor of two or three. The solution adopted in the nineteenth century by John Roebling for the Brooklyn Bridge, for rather similar reasons (though without trains).

I have great admiration for İçtaş and Astaldi, and especially for Messrs. Firat Çeçen and Luigi Realini, who had the courage to select this very innovative solution, considering all the risks, including the financial ones, during the only meeting we were able to have in the very short bidding period.

I remember this meeting, in March, which took place on the site of the new Saint Petersburg airport erected by İçtaş and Astaldi, in the mud produced by melting ice and snow at the end of the Russian winter.

What kind of alternative solutions did you consider?

We had no time to effectively compare solutions—I think Jean-François made two or three sketches of other solutions, a pure cable-stayed bridge and a two-story deck—but we had no more than two or three days to make a decision due to the time frame.

For ICA this was a gamble, a winning one due to the dedication of all the teams later involved in the construction ... and to a good initial choice.

Architecture also plays a crucial role in designing infrastructures. Which architects were involved in your design process? What was it like to work with them?

We did not take an architect with us. Jean-François had some contacts with a French one, Frédéric Zirk, with whom he

had already worked—and who I know and appreciate—but the architectural success is mainly due to Jean-François, especially the elegant shape of the tower.

What was it like to collaborate with your Turkish colleagues and partner companies?
Collaboration on very large projects can be excellent (this was the case for the Millau Viaduct and for the Jacques Chaban Delmas Bridge in Bordeaux), but it can also be very difficult, sometimes ending in a lawsuit.
Collaboration with our Turkish colleagues of ICA has been really excellent and even very friendly, with the added bonus of the fantastic working capacity of the Turkish staff despite the huge pressure on the planning.
This was a bit more difficult, during the first months, with Hyundai and SK, the Korean contractors in charge of the bridge erection, due to cultural differences; however, with time and experience, collaboration became very good.

Which were the most difficult problems to solve in your design?
The most critical problem was the time frame. Each time we had to find a good solution very quickly due to the rapid erection speed.
As for all large bridges, there were many construction problems that had to be solved by ICA and HDSK.
As regards design aspects, the major problem came from the extremely high level of live loads (trains, road traffic and wind), twice as high as in road bridges, increasing the sag of stay cables and the risks of cable vibrations.
We had to limit the longitudinal displacements due to the passage of trains, by installing pendulum bearings in an unusual utilisation.
Greisch, a design office associated for this project to T-Ingénierie, had to develop a specific method for the erection of the central part of the span, since it was impossible to start from mid-span as is done in conventional suspension bridges, due to the reduced transverse distance between the suspension planes, located on both sides of the railway tracks, a consequence of the shape of the towers. And, also due to the short distance between the two suspension planes, we had to propose some solutions to avoid a progressive rotation around the vertical axis of the segments that were being lifted from the suspension cables.

Which aspects make this bridge unique in the world?

This bridge is unique for several reasons.
- It has the longest span in the world to carry railway tracks, 1,408 metres.
- The deck is extremely wide, 58.50 metres.
- It has a hybrid design, as we have seen, an association of suspension cables and hangers and of stay cables. This solution was used in the nineteenth century, but it had not been used since then.
- As the side spans are very short, due to the site, the five longer pairs of backstays are directly anchored to the ground on each bank. For the balance of loads, the deck absorbs tensile forces in the central part of the main span, about 8,000 metric tonnes under permanent loads, a unique situation.
- Pendulum bearings, usually designed as seismic devices, are used here to reduce the longitudinal displacement produced by the passage of trains.

Istanbul is located in one of the riskiest earthquake zones. What kinds of precautions were taken against earthquakes? How is the safety of the bridge ensured?

Fortunately, the site of the Third Bosphorus Bridge is not as critical as others in Turkey. The extreme seismic accelerations of the response spectrum are 2.50 times lower than for the South Approach Viaduct to the İzmit Bay suspension bridge.
In addition, long span bridges resist earthquakes very well due to their flexibility: their vibration periods are rather long, 3–4 seconds or more, when the periods of earthquake motions are generally lower than 0.5 seconds, exceptionally 1.0 seconds in soft soils.
For the Yavuz Sultan Selim Bridge, earthquakes are less of a risk than wind is. The most critical natural action on the bridge is that of the wind. But the design provides a very high safety margin; its dimensions take train and truck traffic into account.

Where do you think the future of large bridge building lies?

It is always extremely difficult to imagine the future. With regard to large bridges, as each one is unique in some way, it will all depend on opportunities, site, function ... and the owner.

Sketches of the pylon's
triangular section.

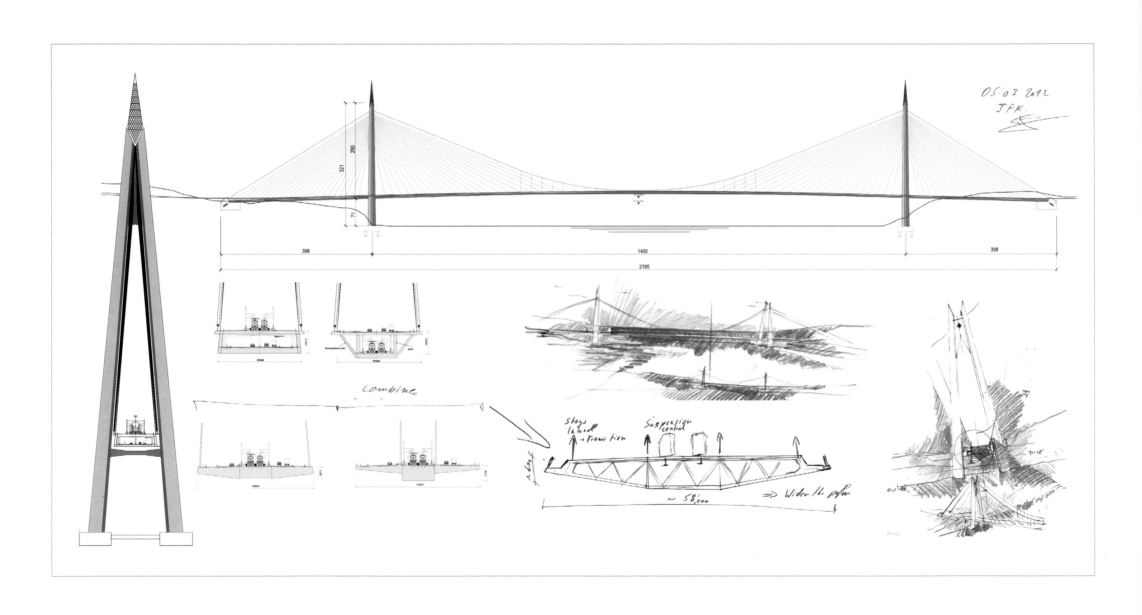

THE LANGUAGE OF SCULPTURAL ENGINEERING

Jean-François Klein
Civil Engineer and Chief Designer
T-Ingénierie — Managing Director and Chairman

Jean-François Klein is a civil engineer who graduated from the École Polytechnique Fédérale de Lausanne. He has been a partner at Tremblet S.A., which later became T-ingénierie, since 1995. Project leader for the Prince Claus Bridge pylon and the Viaduc de la Grande-Ravine, he is also the designer of the Lect Viaduct, of the Viaduc de la Ravine Fontaine, and of the Yavuz Sultan Selim Bridge with Michel Virlogeux.

Your experience, partly gained with T-Ingénierie, is undoubtedly one of the most interesting at an international level. Can you tell us about how you first began working and how you came to be part of that design "current" known as Sculptural Engineering?
Since the beginning of my career and even during my studies, bridges were at the centre of my interests. I had the chance to work with very impressive and well-known people. My mentor was Professor René Walther, a famous Swiss engineer, who developed extensive research on concrete design, on bridges and especially on cable-stayed bridges. He started his career with Fritz Leonhardt, and had close ties with the famous engineer Jörg Schlaich. While I was studying for my PhD, I was also working in Walther's design office and as a research engineer at the Swiss Federal Institute of Technology (EPFL). I therefore had the opportunity to discuss with Schlaich the results of

my PhD, and the consequences that these results could have on cable-stayed bridges. It was just an incredible experience for a young engineer like me. At a very early stage, when I was 26, René helped me to gain access to international associations like FIP (International Federation for Prestressing), where I proposed to set up a working group on bridge design. During those same years, I first met Michel Virlogeux around a discussion concerning the cable-stayed bridge of Seyssel, the first one in France. As you can see, Michel and I have been good friends for almost 30 years! Since then I continued my career working almost exclusively in the area of bridge design, promoting what I call "sculptural engineering." But to go back to the Third Bosphorus Bridge, two people were at the origin of my involvement in the project: Michel Virlogeux and Luigi Realini from Astaldi. I met Luigi more than

30 years ago at the EPFL in Lausanne; as a consequence, when Luigi asked Michel to work on the Bosphorus bridge, and Michel replied that he would be happy to do so with me, Luigi was pleased with that choice. Of course, it did not take long to convince me to join the team: everything was decided in a couple of days.

In your opinion, what were the particular problems that had to be solved in the specific case of this third bridge over the Bosphorus?
I can say that there were two major problems: one was definitively to support two train tracks over such a long span bridge, and the second one was the time dedicated to the project and to the construction. Two major constraints for the concept and the design of the bridge.

How did you achieve the series of records that characterise its design and functionalities?
We never intended to achieve any records. But we did so because of the unique location, requirements, and concept of the bridge. The bridge's span is a consequence of our decision to remain out of the Bosphorus with the pylons, to better manage the schedule and costs by avoiding offshore constructions, which would have brought a lot of technical and environmental problems. And by the way, we were sure to get very good soil conditions on the shore, something that was not guaranteed offshore. The width of the deck is the result of opting for a streamlined thin box girder, which in turn depended on the decision of placing all the combined traffic on the same level. Without the railway, a classic well-designed suspension bridge would have been the solution for the crossing. With the railway, it was just impossible to stick to a classic suspension bridge. Another possibility would have been to settle for a double deck bridge, which was out of the question for us, especially for aesthetic reasons. The height of the pylons is a consequence of the two previous parameters. It is the global concept of the bridge and of course the width of the Bosphorus at the chosen location that pushed us to achieve these results and to develop many new techniques

and designs in relation to the size of the bridge and its functionalities.

Your bridge is certainly a very original design. Did you draw inspiration from any existing bridge? And in terms of materials, did you choose concrete from the very beginning or did you consider other options as well?
References were the Tsing Ma Bridge in Hong Kong, or the Japanese bridges of the Kojima-Sakaide route carrying both rail and road traffic. About materials, I must admit that during the tender process, as we did not have access to reliable seismic and wind data, we were quite cautious about the impact of earthquakes on the bridge, and we decided to limit the weight of the towers and of the deck. Consequently, towers and even partially backspans were in steel. After the tender, as soon as we were confident about the rather low impact of earthquakes in comparison to the wind loading, we logically went back to the idea of concrete pylons, as we were convinced that it would have been cheaper and quicker to build them this way, due to the fact that we could start immediately

with competent local contractors and with a real local knowledge of the material and of the techniques.

Are you familiar with the design for the Messina Strait Bridge proposed by Sergio Musmeci at the end of the 1960s? In this case too, the design involved a "hybrid" structure, albeit with elements that are different from those proposed for the Yavuz Sultan Selim Bridge ... and the structure was to be built totally in concrete.
Sergio Musmeci was a famous engineer working on the research of a harmonic relationship between structure and architectural form. His work was quite impressive for the development of concrete thin shells and structures searching for a better use of the 2D or even 3D structural potential of concrete surfaces. However, those theories are not really applicable for a 3,300-metre span bridge. His proposal was interesting as it tried to combine suspension and stabilisation by two inverted systems. Another interesting idea was to try to slightly increase the stiffness of the suspension by creating a suspended pylon. But this concept was merely

an intuition, it would have been extremely complicated to build.

How much impact did the siting of the bridge in such an uncontaminated natural landscape have on the project concept?
For us it was clear from the beginning that in such a landscape we would have to provide the most elegant and architecturally accomplished structure. The scenery is rather dramatic, and the size of the bridge makes it visible from far away, even from the city of Istanbul. It was clear that it would have become a new landmark for the city and for all of Turkey. This was one of the key points for the decision of the single-level deck and the streamlined box girder.

Besides devising the general structure of the hybrid bridge with Michel Virlogeux, you also "invented" a series of decisive "details" to transfer forces, for the anchors to the ground but also on the deck, and others too. Could you list them and describe some of them in particular?
It is difficult to make a complete list, but the major innovations can be found below:
- World record for railway bridges span.
- Widest single box girder.
- First application of modern combined suspended cable-stayed bridges (going to the limit of modern computation and using the current cable technology). We clearly discovered a new kind of bridge behaviour, far from a cable-stayed bridge, far from a classic suspension bridge.
- First application of hybrid cable system for railways.
- First partially self-equilibrated bridge by central tension in the deck. This is a very important and innovative concept. Similar ideas were evoked by Jean Muller in the 1990s for cable-stayed bridges, but they had never been applied before.
- First long span bridge with such an intrinsic stiffness given by the conceptual design (extremely low deflection under max loading).
- First bridge of that magnitude with horizontal movements controlled by passive devices (pendulum bearings).
- First use of pendulum bearings to limit the horizontal displacement for a railway bridge (pendulum bearings are originally energy dissipating devices for seismic control).
- Many constitutive elements are by far the biggest ever built and many extrapolations had to be done, which needed special developments to fabricate them.

- Biggest steel segment ever fabricated, in such a width that it called for special lifting studies (to control the transversal relative deflections).
- A great step forward in the aesthetic and the elegance of combined Road/Railway long span bridges.
- A great step forward in the structural efficiency for combined Road/Railway long span bridges.
- By far the shortest construction time for such a long span bridge, due to the conceptual design, which allowed for simultaneous activities (thanks to the hybrid system).

Were you present at the wind tunnel tests?

The wind tunnel tests took place in Milan (Italy) for the aeroelastic and taut strip model tests, and in Nantes (France) for the rigid model tests. Of course I did follow all tests as this is an important step in the design of a bridge, and especially in this case because the tests were performed after the beginning of construction. So it was important to confirm our assumptions as well as get feedback on our design. We had to follow them very closely.

From concept to completion, what margin for adjustments was there? Are there any elements in the completed bridge that were not in your original design?

The bridge as it was planned during the competition is exactly the one that has been built. This shows the strength and the determination of ICA to follow one philosophy and one guideline to reach the goal. Without such willpower it would have been impossible to complete the bridge in the given time span. This was a major factor for the success of the construction.

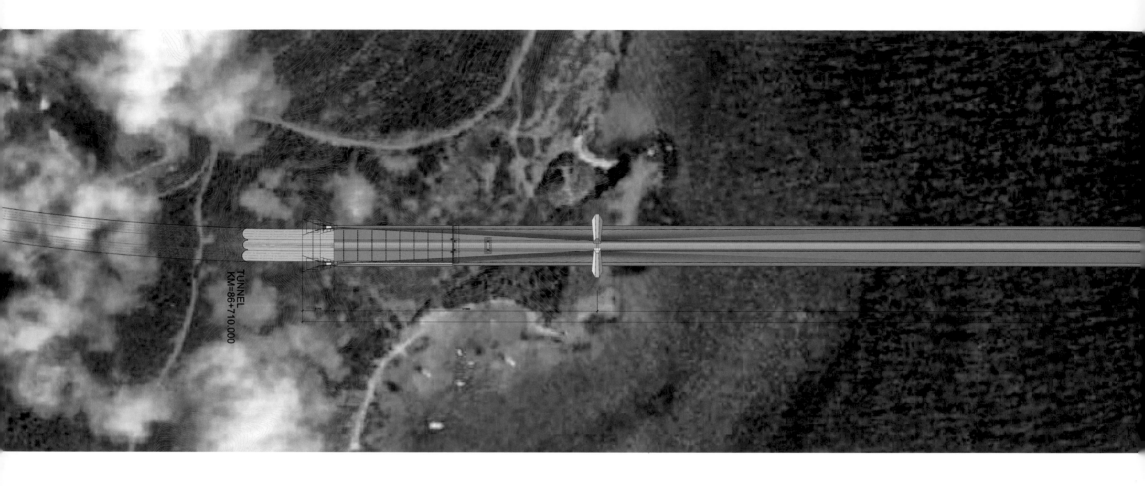

TUNNEL
KM=86+710.000

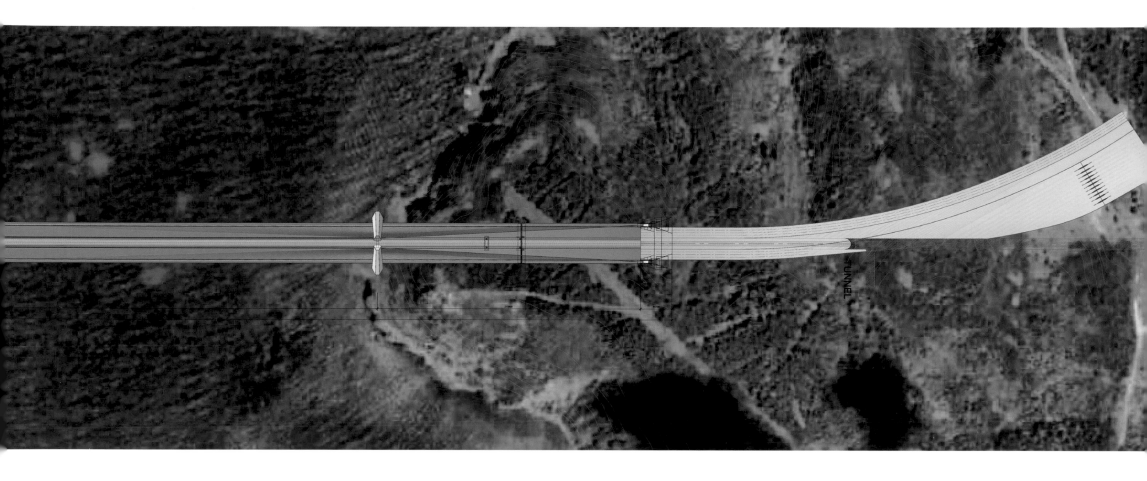

A structure able to express an aura of total modernity, an effect lent by its megastructural presence: from the surprising size of the anchor pylons on land with their characteristic "A" shape and faceted polygonal/triangular section, to the slender, limited height of the bridge deck, conceived for self-supporting segments anchored by a series of closely spaced stay wires, or rather cables, that become almost a fabric, a visual veil over the landscape. In this sense, the deformability of the bridge itself, or rather of its deck, depends not on the suspension cable but mainly on the staying system, capable of absorbing the centred forces deriving from the passing of high-speed trains and the constant and more limited flow of motorway traffic. The key characteristic of cable-stayed bridges is in fact their "almost reticular" static behaviour, even with mobile loads, so that centred forces are absorbed only by the framework of the structure. Above, one of the initial studies for the bridge and tunnels.

Geometrical location.
The main span is divided into three zones: the central part of the deck is suspended by the main cables, the areas close to the towers are supported by the stiffening cables, and in the transition zones, the deck is both suspended by the main cables and the stiffening cables. This transition is essential to provide a smooth and progressive variation of the overall stiffness of the system and avoid high bending peaks in the deck.

Europe

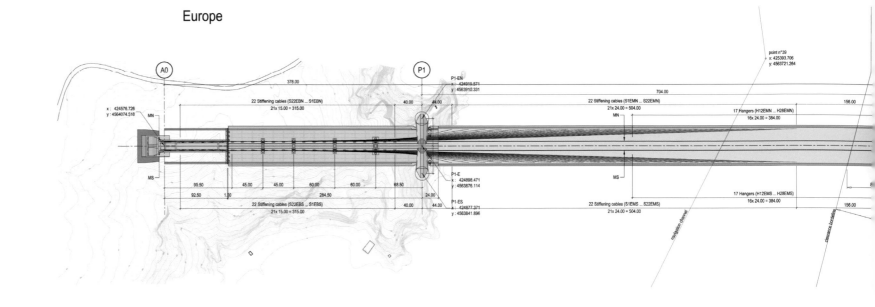

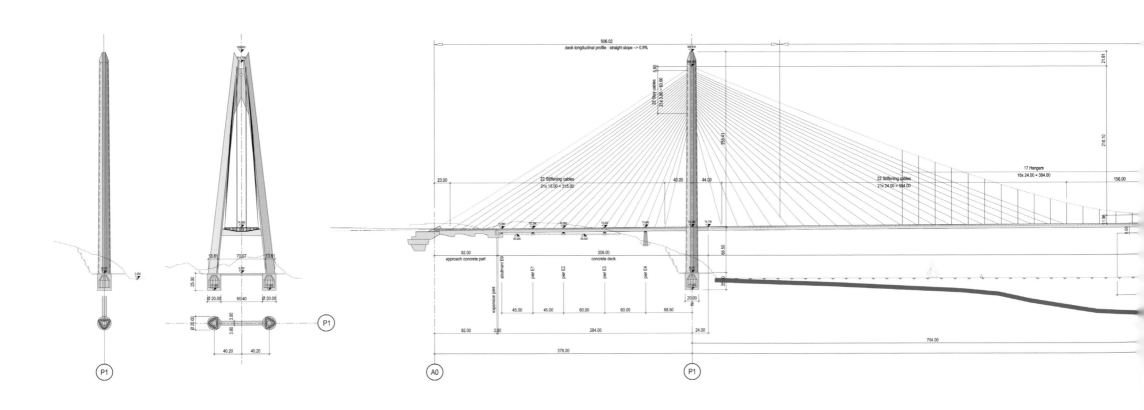

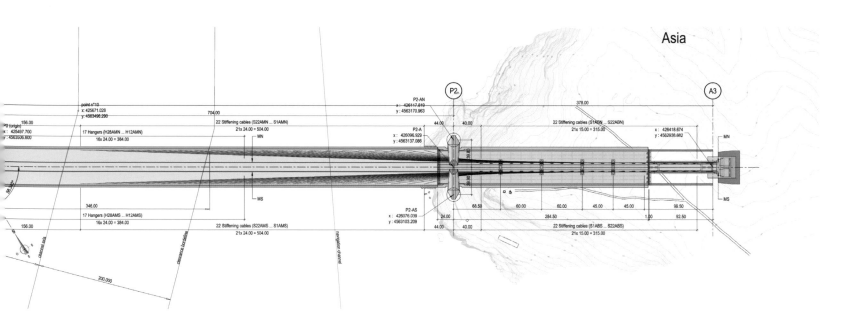

Asia

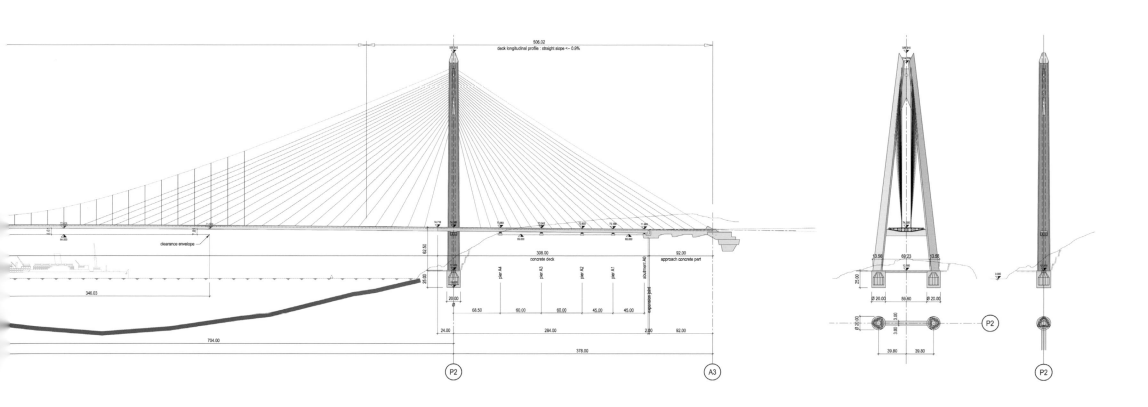

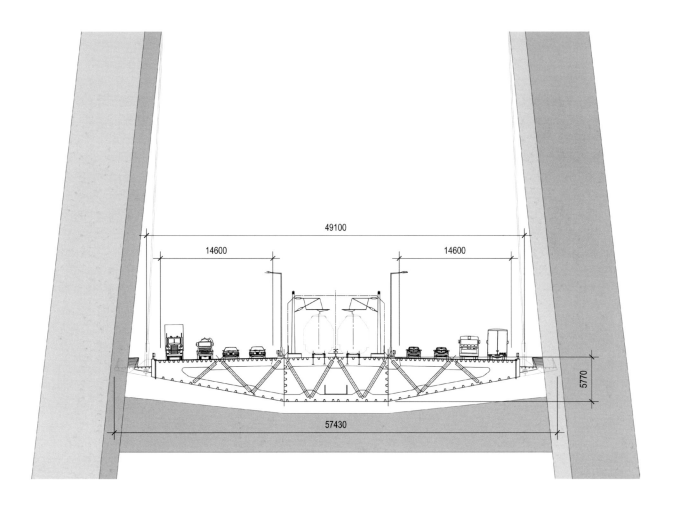

49100

14600　　　　　　　14600

57430

5770

The inclinations of the legs have been fixed to accommodate the vertical plan of the main cables in between the roadway and the railway, placing the hangers in the central zone.

On the right: a series of drawings and details relating to the cable band and hanger erection.

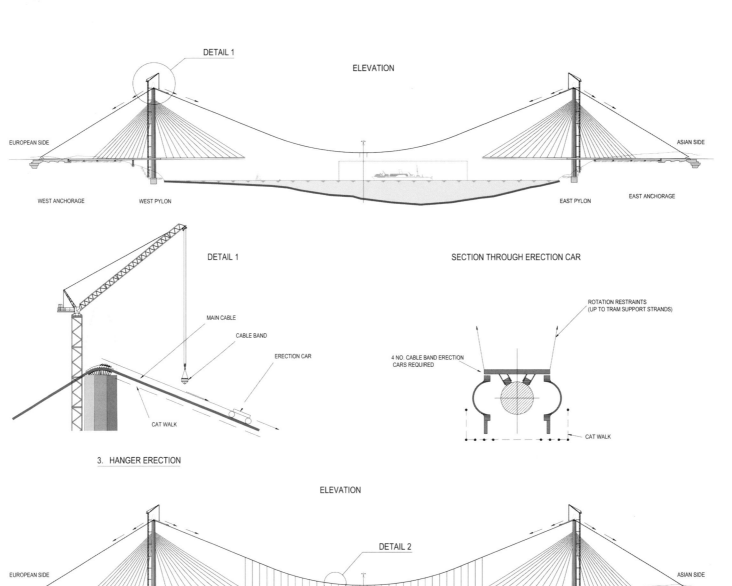

DETAIL 1

ELEVATION

EUROPEAN SIDE

ASIAN SIDE

WEST ANCHORAGE WEST PYLON EAST PYLON EAST ANCHORAGE

DETAIL 1

SECTION THROUGH ERECTION CAR

MAIN CABLE

CABLE BAND

ERECTION CAR

CAT WALK

ROTATION RESTRAINTS
(UP TO TRAM SUPPORT STRANDS)

4 NO. CABLE BAND ERECTION
CARS REQUIRED

CAT WALK

3. HANGER ERECTION

ELEVATION

DETAIL 2

EUROPEAN SIDE

ASIAN SIDE

WEST ANCHORAGE WEST PYLON EAST PYLON EAST ANCHORAGE

DETAIL 2 - HANGERS

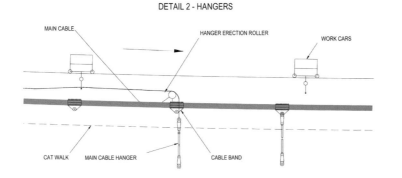

MAIN CABLE

HANGER ERECTION ROLLER

WORK CARS

CAT WALK MAIN CABLE HANGER CABLE BAND

DETAIL 2 - CROSS SECTION TROUGH HANGERS

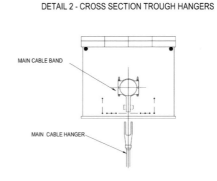

MAIN CABLE BAND

MAIN CABLE HANGER

85

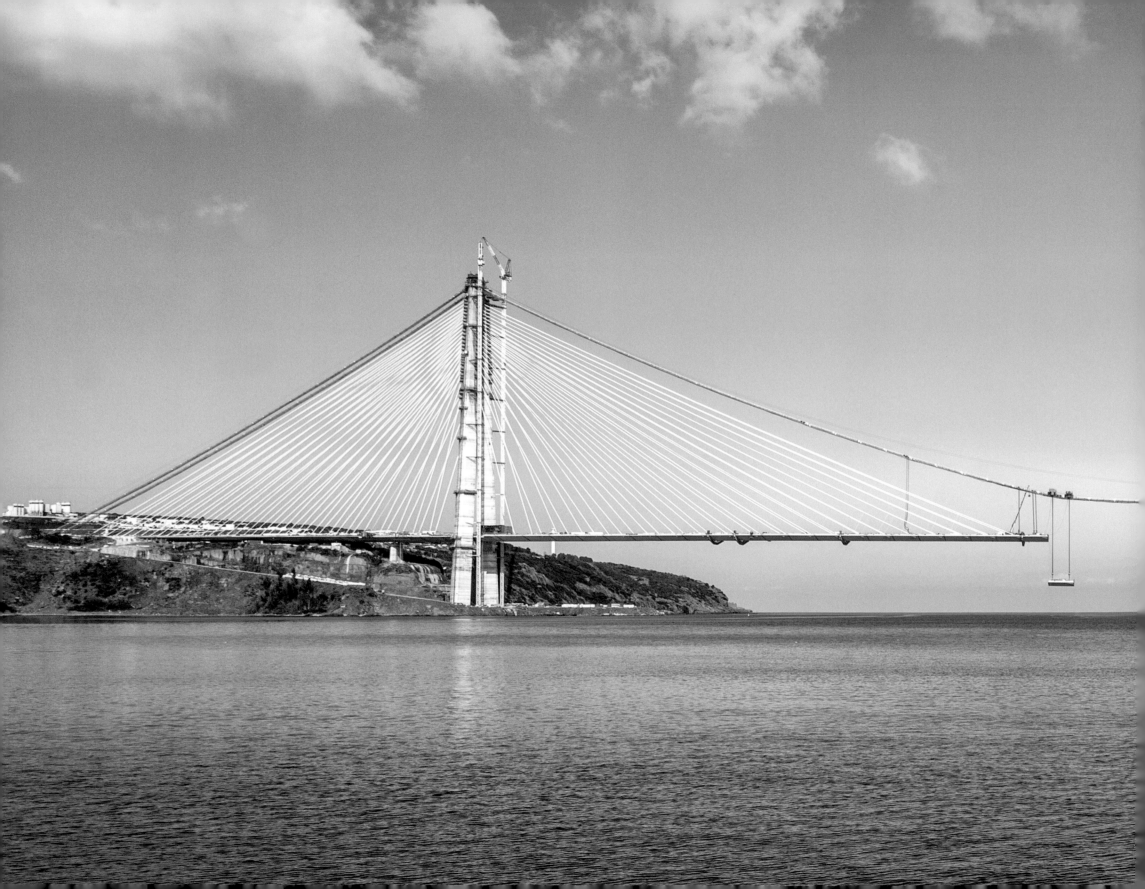

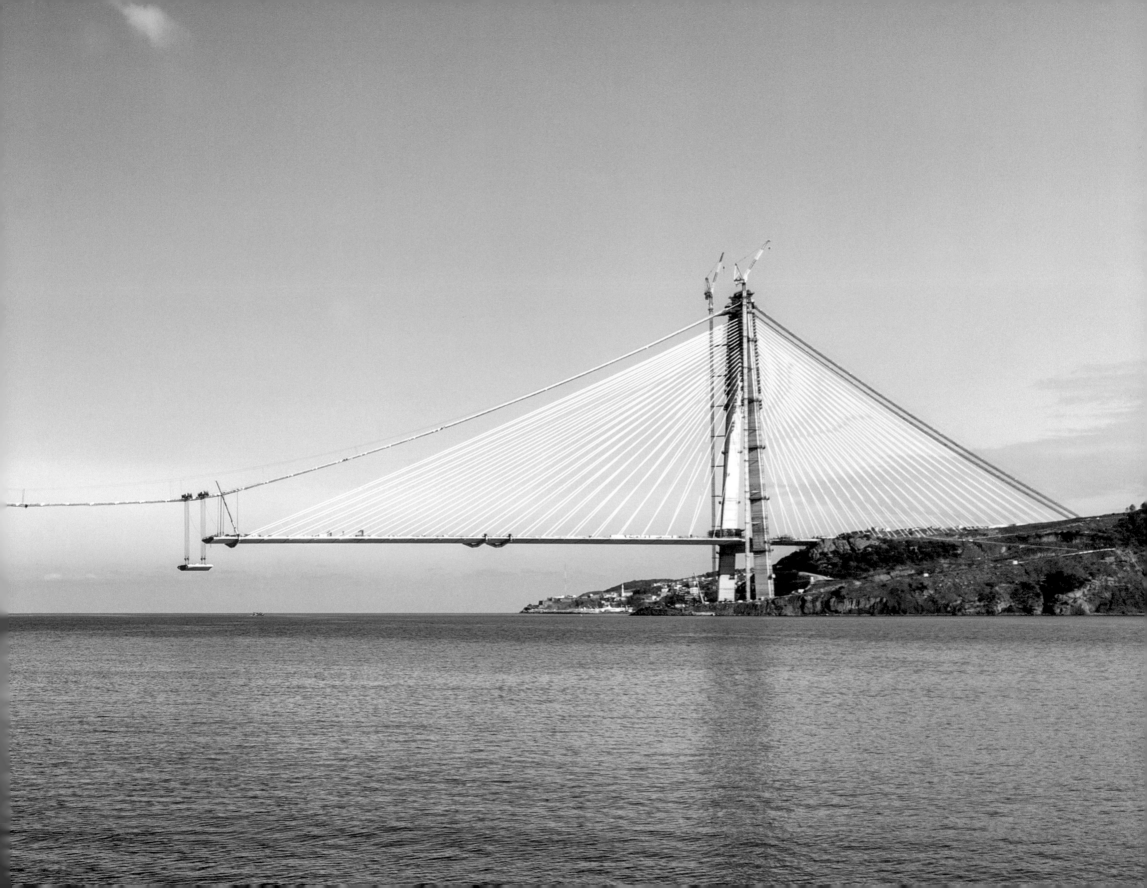

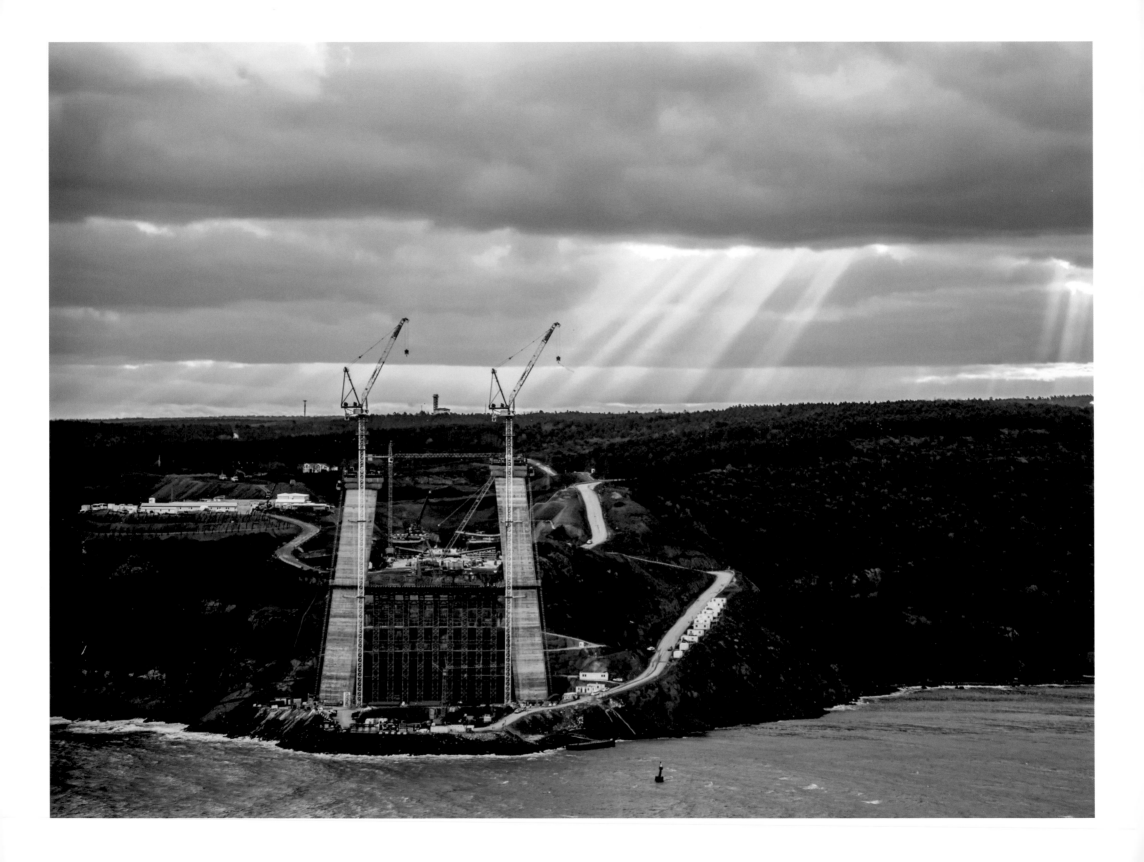

A CONCERTED EFFORT

The significance of the project and the progressive tuning and management of the complex program for its development entailed the involvement of numerous professional figures who, with the specific nature of their specialisations, contributed to varying degrees, and at different times and phases, to the construction of the Yavuz Sultan Selim Bridge. Certainly the most substantial of these contributions was the concept of the bridge masterfully devised by Jean-François Klein and Michel Virlogeux, described in two long interviews reproduced at the beginning of this chapter. Moreover, these two engineers, internationally renowned due to the leading roles they have played in the evolution of the structural concept of the most sophisticated contemporary infrastructure systems, also worked with considerable attention to the architectural composition of the bridge as well as its incredible performance capacity in relation to the loads determined by its dual function, that of carrying both road and rail traffic, and due to its response to wind and current stresses. Development of the concept for the bridge also had to travel along two parallel paths, one that

was managerial and financial, and the other focusing on technical-engineering aspects with the involvement of several contractors. The contribution by Garanti Bank, which played a role of substantial connection between the numerous financial institutions involved in this impressive venture, was part of the former of these two paths. As Ebru Edin, Garanti Bank's Executive Vice President, clearly explained, the project "was financed with a 3 billion dollar club loan provided by six Turkish Banks (Garanti Bank, Ziraat Bank, HalkBank, İşbank, Vakıf Bank and Yapı Kredi Bank) and was one of the largest financings in the Turkish Project Finance Market. This sets a good example within the market in terms of bankability, efficient risk allocation, and a collaborative relationship between public and private sectors." The first signatures for the financing of the Yavuz Sultan Selim Bridge and the Northern Ring Motorway Project were put on contract on 29 August 2013. In total, a nine-year term loan for 2.3 billion USD, the highest in the history of the Turkish Republic, was raised for a greenfield project. It is worth mentioning that for the complexity of its investment

structure this financing model received an award from the leading global finance magazine *EMEA Finance*. The project won the Best Structured Finance Deal award in the Public-Private Collaboration Model category in the EMEA region. The specificity of this financial program was not limited to purely economic aspects, but also encompassed a broader vision, touching on areas linked to sustainability and community engagement. As Ebru Edin went on to explain, "throughout the construction, environmental and social studies were conducted in line with Equator Principles, IFC Performance Standards, and local health and safety regulations. An afforestation plan involving planting four new trees for each dislocated one was implemented, resulting in the planting of 1.2 million new trees between 2013-2015. Stakeholder surveys were conducted with 2,683 stakeholders in 21 villages. Two public participation meetings and consultation meetings with NGOs were held. As a result of these surveys and meetings, certain actions were taken to better manage the social aspects." To this end, a detailed plan of action was defined by the ICA Group with the consultancy firm AECOM, with regard not only to replanting in the area where

the bridge and motorway were planned, but also to protecting the areas set aside for birdwatching, given that these are specific nesting and resting places along migratory routes for birds. As Uygar Duru, Eastern Europe Environment and Ground Engineering Regional Director for AECOM explains, "since February 2014, within the scope of the Environmental and Social Impact Assessment study, our team has been carrying out quarterly environmental and social monitoring studies covering all the construction sites, together with stakeholder engagement activities and biodiversity conservation and management studies. In addition, we ensured that all construction-related landscaping tied as seamlessly as possible into the local scenery, as well as planning and implementing an ecological bridge to enable a natural and safe passage of the fauna along it." This intervention, developed inside the Fenertepe Wildlife Park, on the European shore of the Northern Ring Motorway, is a first for Turkey. The wildlife corridor has been designed to integrate with the natural habitat; its mission is to preserve wild animals such as roe deer, pigs, and foxes, and ensure that they are not affected by

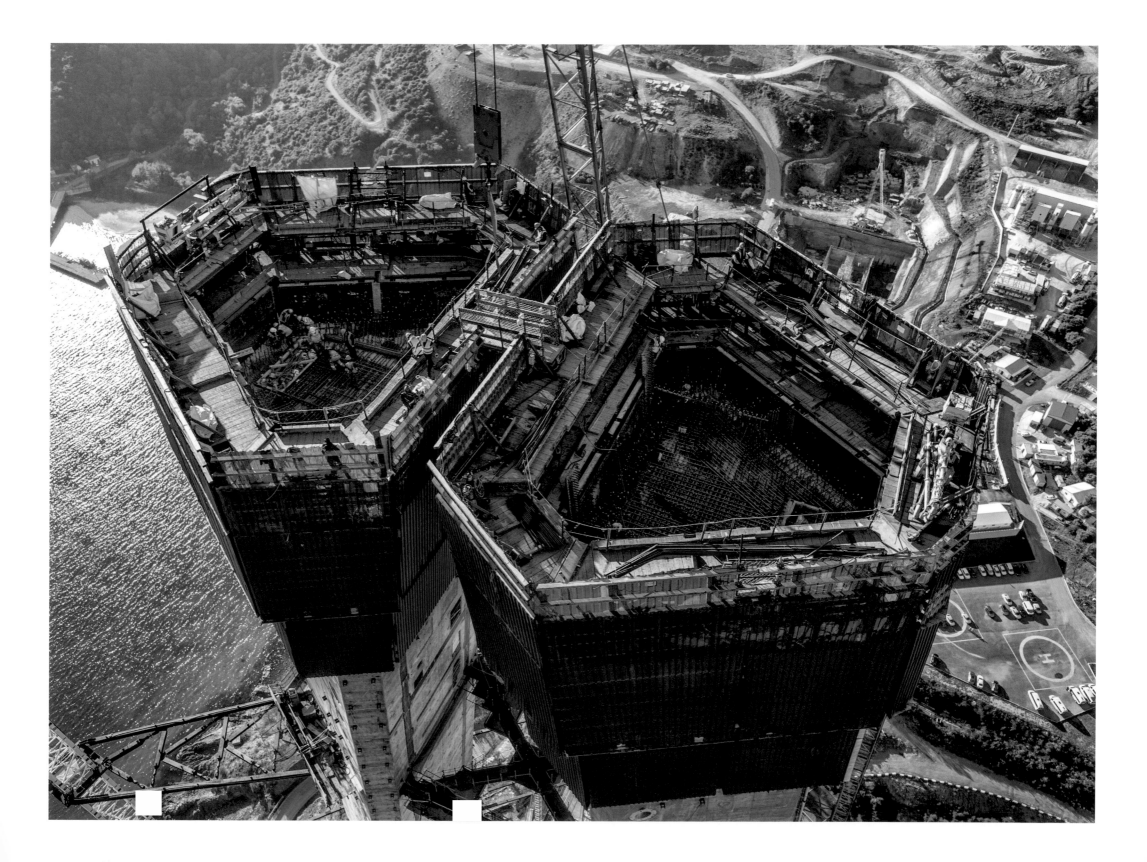

the motorway. Uygar Duru adds that "tree plantation studies are underway with a ratio of four-to-one for habitat restoration in terms of trees planted, using only locally sourced native trees and plants. We carried out seed collection for further ecological restoration, as well as bird breeding and migration studies."

In the last few years, ICA has planted 3.1 million trees and plants; its goal is to increase this number to 5.1 million, as was stipulated in July 2012, when ICA signed a protocol with the General Directorate of Highways and Istanbul Regional Directorate of Forestry as part of the Yavuz Sultan Selim Bridge and Northern Ring Motorway Project for the largest private sector afforestation project in the history of Turkey.

For these aspects and qualities, in 2016 the project received two Continental Europe Excellence Awards, in two categories: Sustainability and Advancing Our Vision. As we have said, then, the engineering and operational aspects of the project took place alongside the regulatory, financial, and environmental protection planning. It was a process conducted in parallel, thanks to the professional competence of highly qualified technical teams engaged in a concerted effort to develop the

concept according to a complex and multifaceted procedure involving feasibility studies for the engineers, geologists, technical specialists, project managers, and obviously all the contractors.

The latter, arriving from various parts of the world, contributed with their know-how to the success of an operation that was not without structural challenges and was completed in record time. Hyundai Engineering & Construction was the leader company of HDSK, a joint venture with SK Engineering & Construction, responsible for various aspects of the construction phase, specifically of the side span and suspension system.

A technical involvement that, in addition, called for a significant effort to bridge cultural differences. As Joong Ho Song, Hyundai's Construction and Engineering Project Coordinator, highlights, "the project posed considerable challenges from a technological point of view; additionally, it was the first time that the company had worked in Turkey, so this was an opportunity to establish an exciting partnership between our two countries. More than 100 engineers were involved on Hyundai's side since 2013. We were part of a multinational construction team; however, despite the occasional cultural

misunderstanding, we were able to work together toward a common goal." The bridge construction represented for the whole team not only a technical endeavour of the highest level but certainly also a race against time, as Joong Ho Song goes on to explain: "in order to meet our deadlines, we had to commence procurement and construction works, and engage subcontractors, already in 2013, while the design was being finalised. Inevitably, design changes had consequences for the whole process and affected procurement procedures, but we were able to overcome these difficulties thanks to rigorous management and integrated teamwork." The role played by Yüksel Proje Chodai, tasked with general supervision and monitoring of the Yavuz Sultan Selim Bridge and Northern Ring Motorway Project, in a sense links the two sides of the project, the administrative-financial aspects and the technical-construction ones. Celal Akın, Chairman of the Company's Board, says, "we inspected all the structures and field applications in this project, monitored technical and administrative specifications and carried out all audits on behalf of the General Directorate of Highways, as well as completing all the necessary reporting to the executive board in accordance with the

conditions of the contract. Together with our business partner Chodai, we inspected and audited Yavuz Sultan Selim Bridge's cable stayed and suspended parts." He also underlined the unique characteristics not only of the project but also of the methods used to assemble its parts, "As the project was based on a build-operate-transfer model, our extensive technical know-how and expertise were our greatest assets. The project was completed in record time when compared with other projects in Turkey, in only three years. Within this short period, we reviewed 30,000 design drafts and reports to verify their compliance with global standards. At the same time, we conducted physical surveillance on the field and reported our findings to Management." The Yavuz Sultan Selim Bridge and Northern Ring Motorway project represented a unique experience for the key players in this highly technological and complex adventure, from contractors to designers, who all agree in considering it a benchmark for their future operations. A view that further reinforces its importance, projecting the bridge well beyond Turkey's national confines and its function as crossing and link.

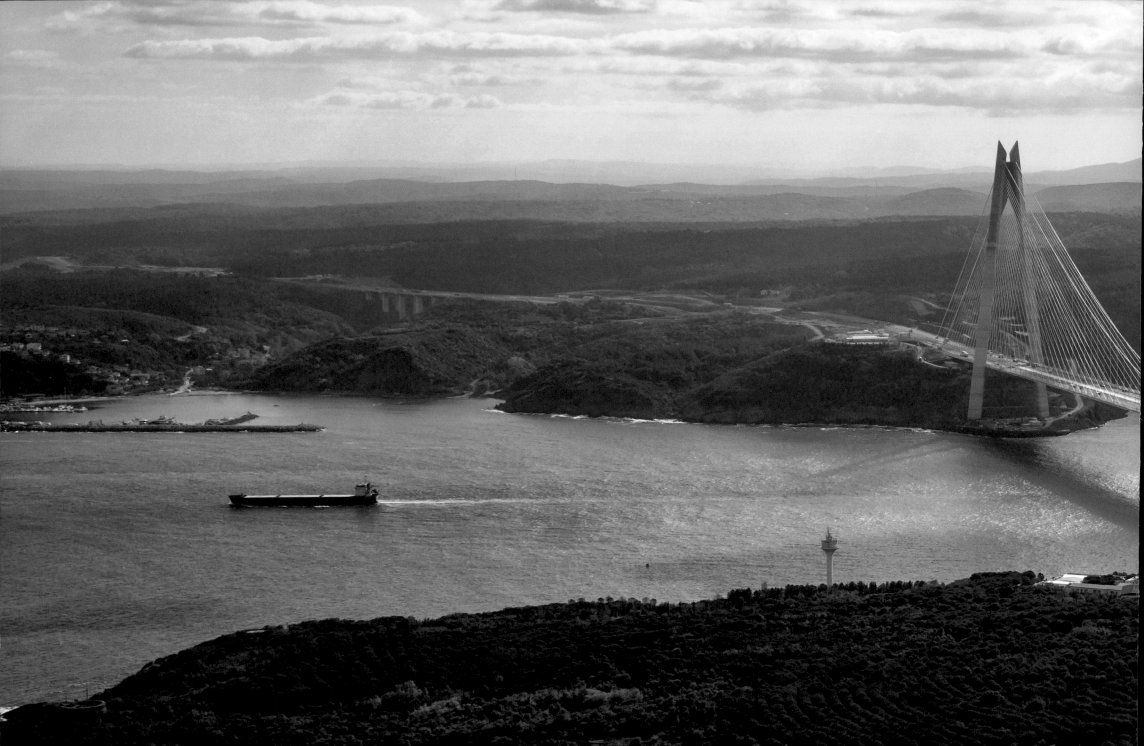

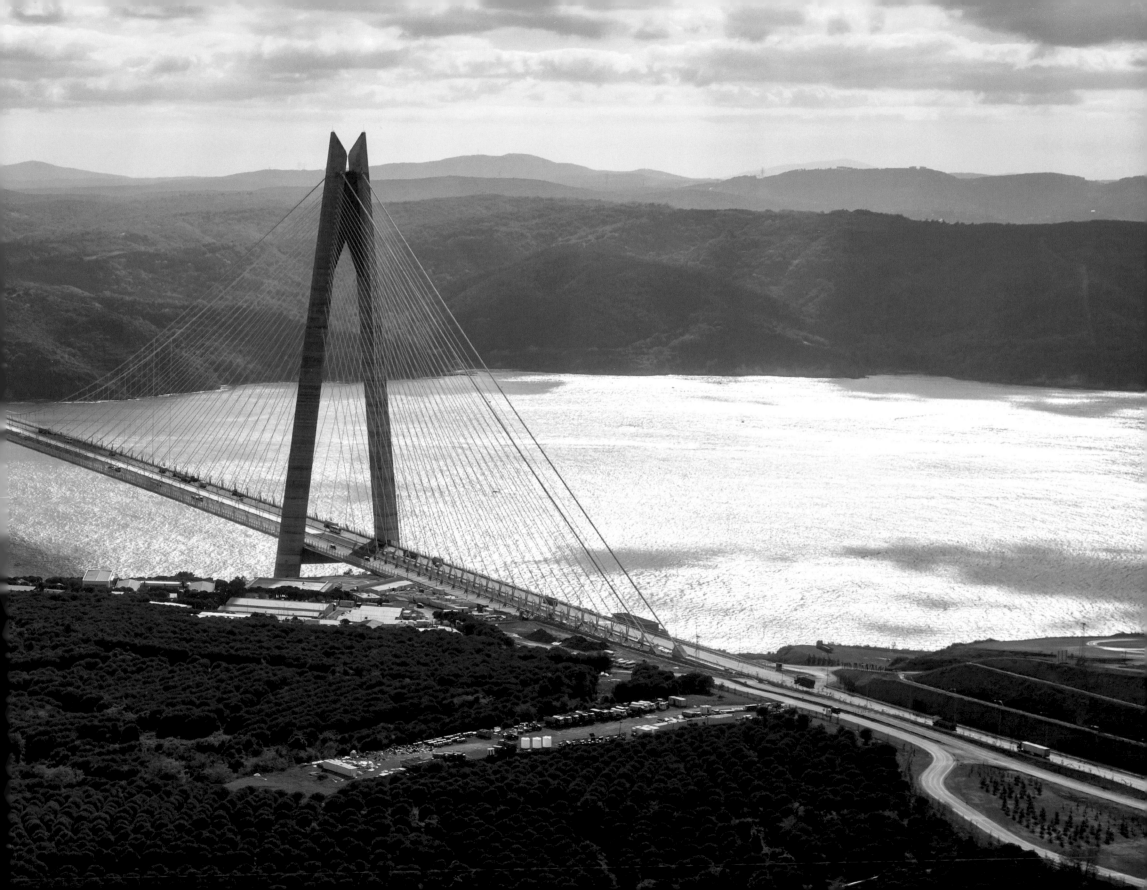

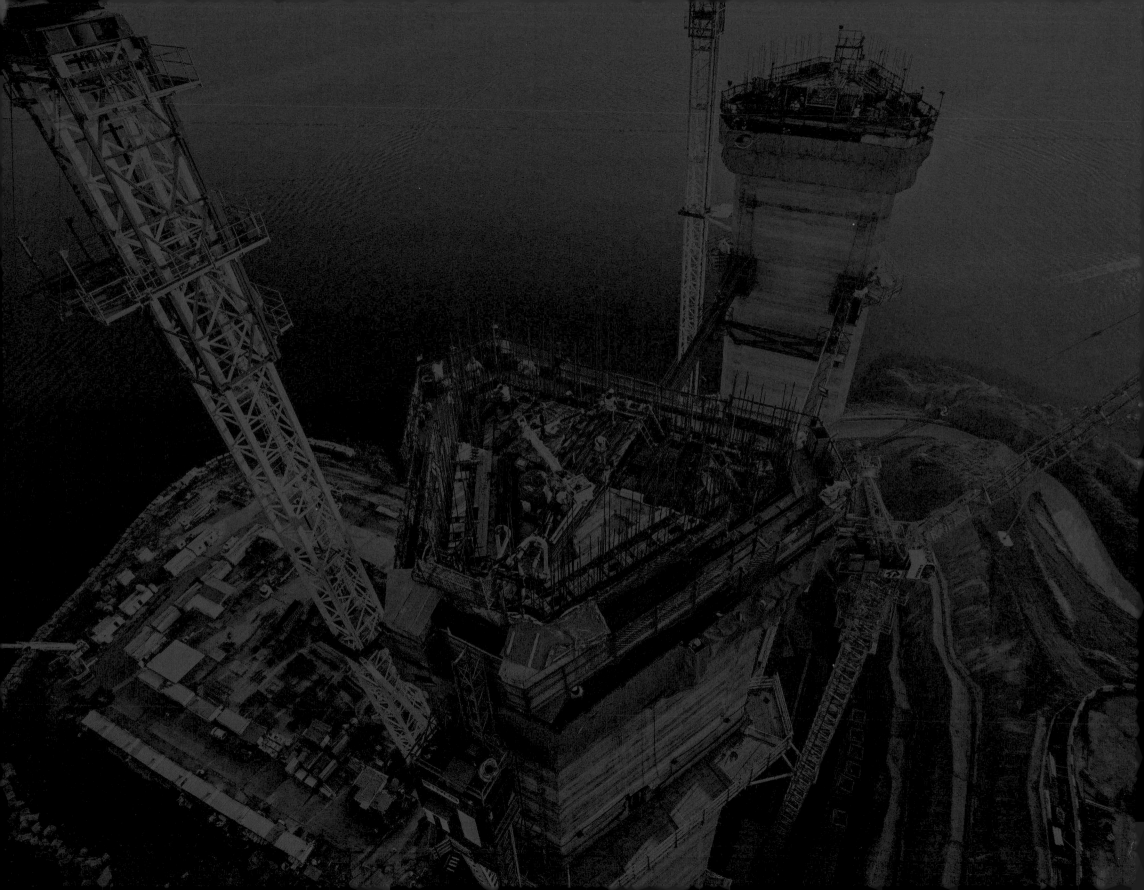

CONSTRUCTION

FOUNDATIONS WERE EXCAVATED INTO SOLID ROCK
TO A DEPTH OF 20 METRES, WITH A DIAMETRE OF 20 METRES.
AS A RESULT, NO WATER SURFACED DURING THE EXCAVATION.

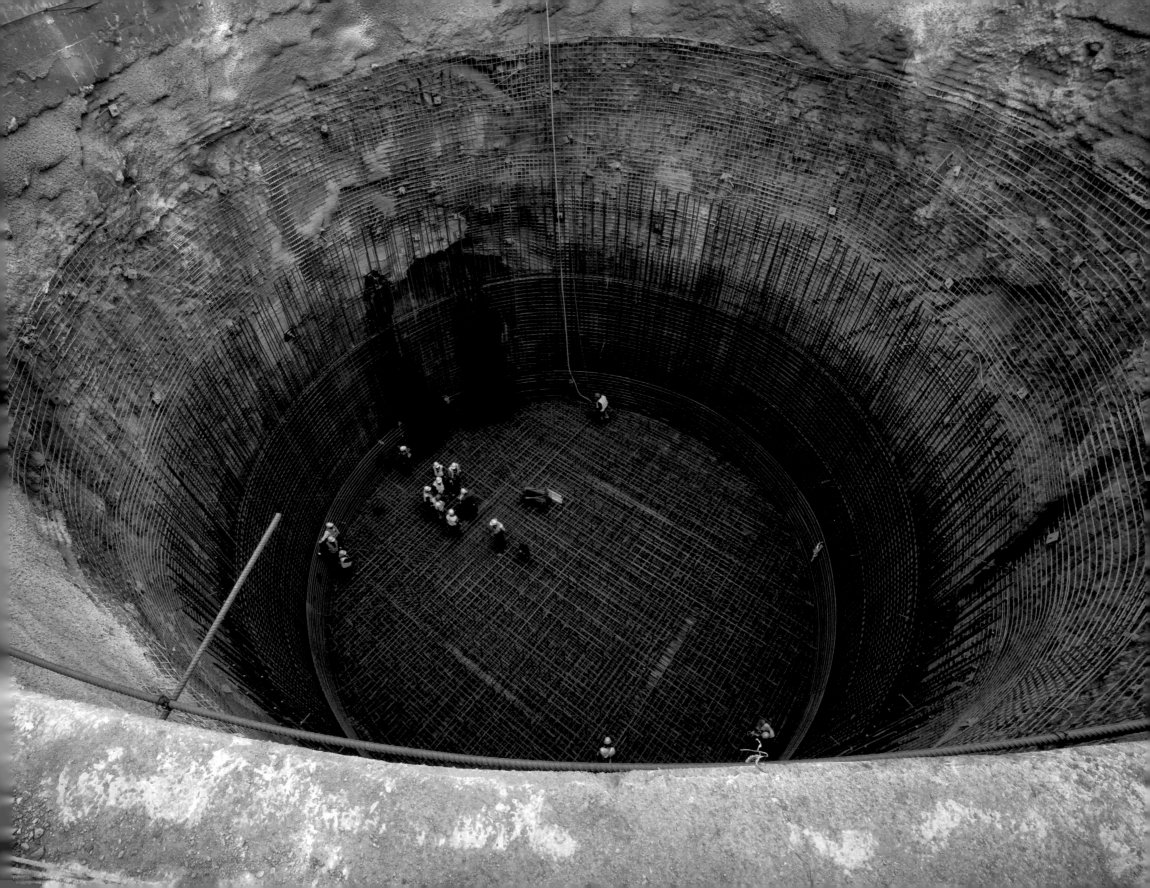

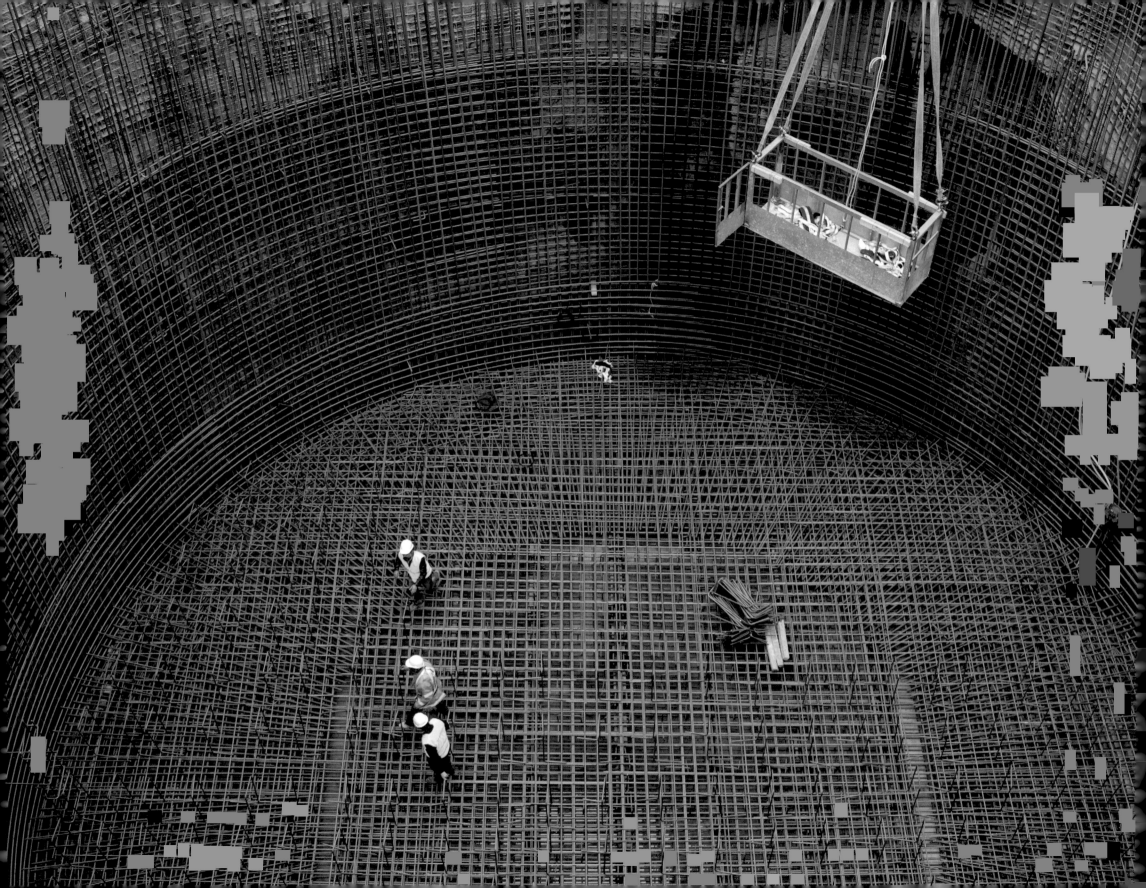

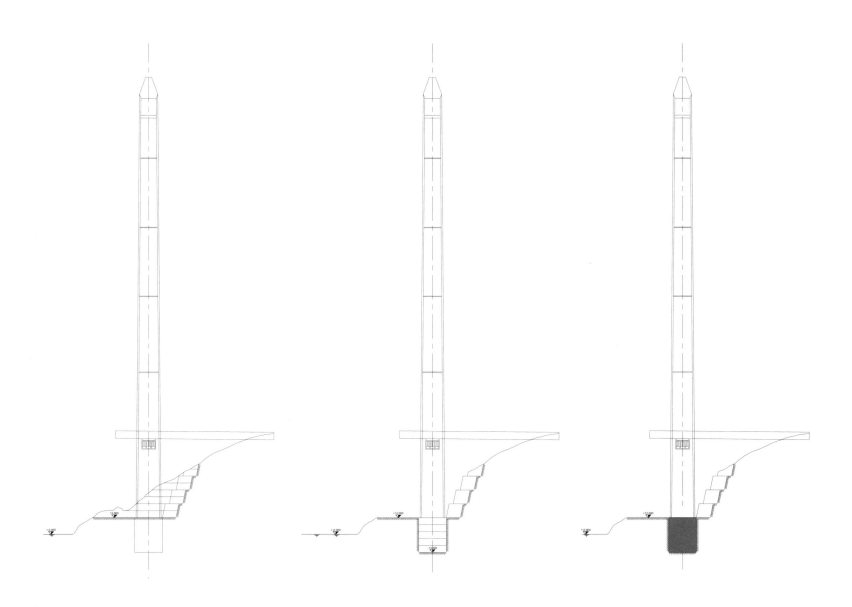

MAY-JUL 2013 Earthworks, excavation for foundation, rebar and concrete foundation.

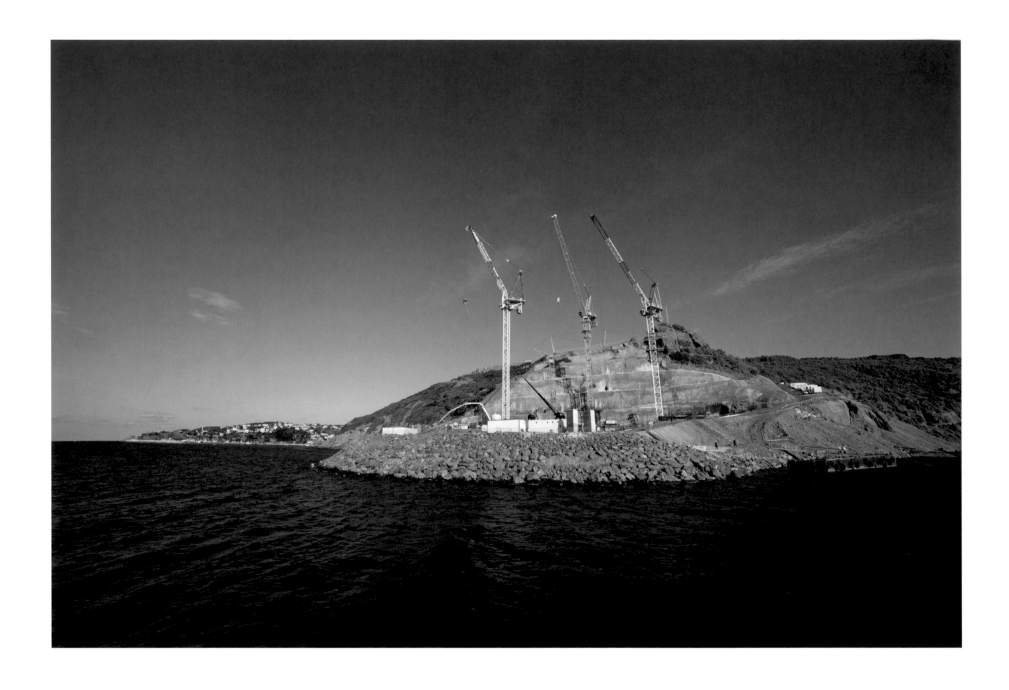

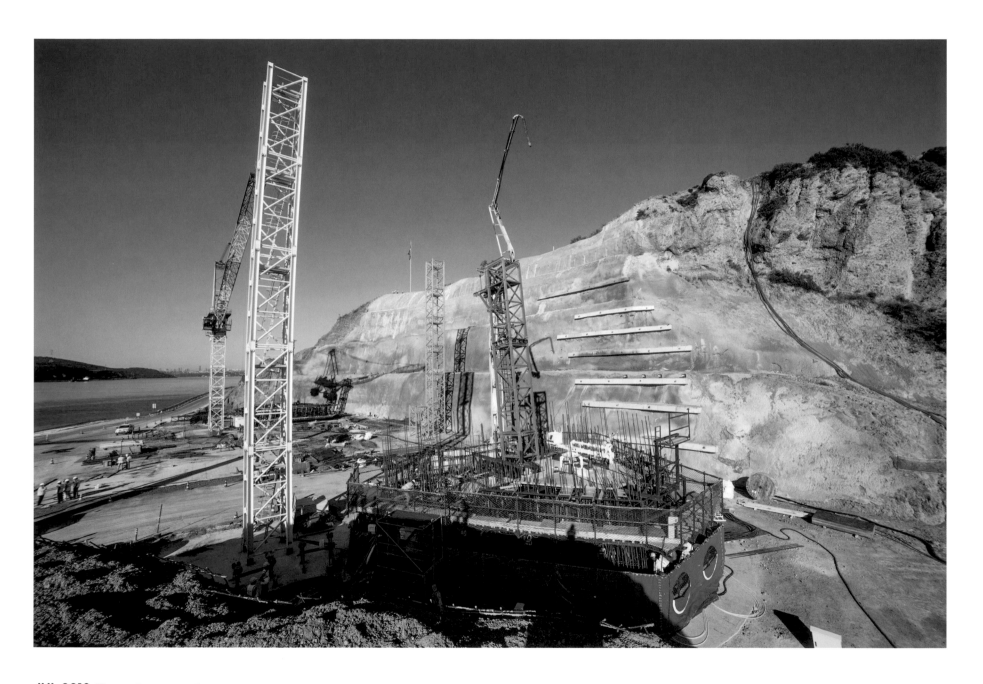

JUL 2013 The pylons growing.

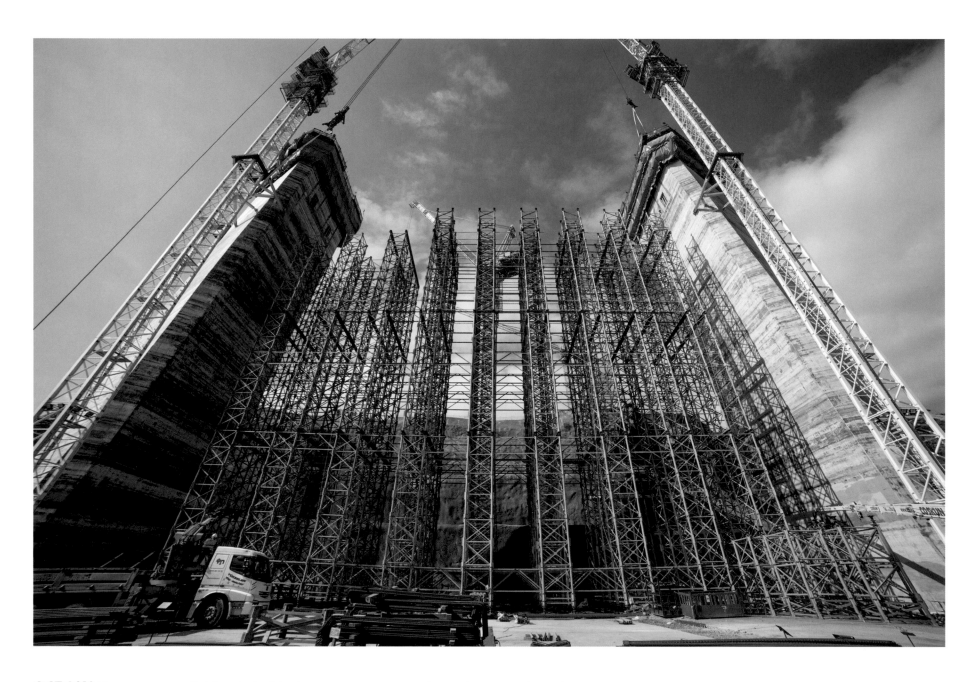

OCT 2013 Temporary scaffolding to build a lower concrete cross beam between the pylons.

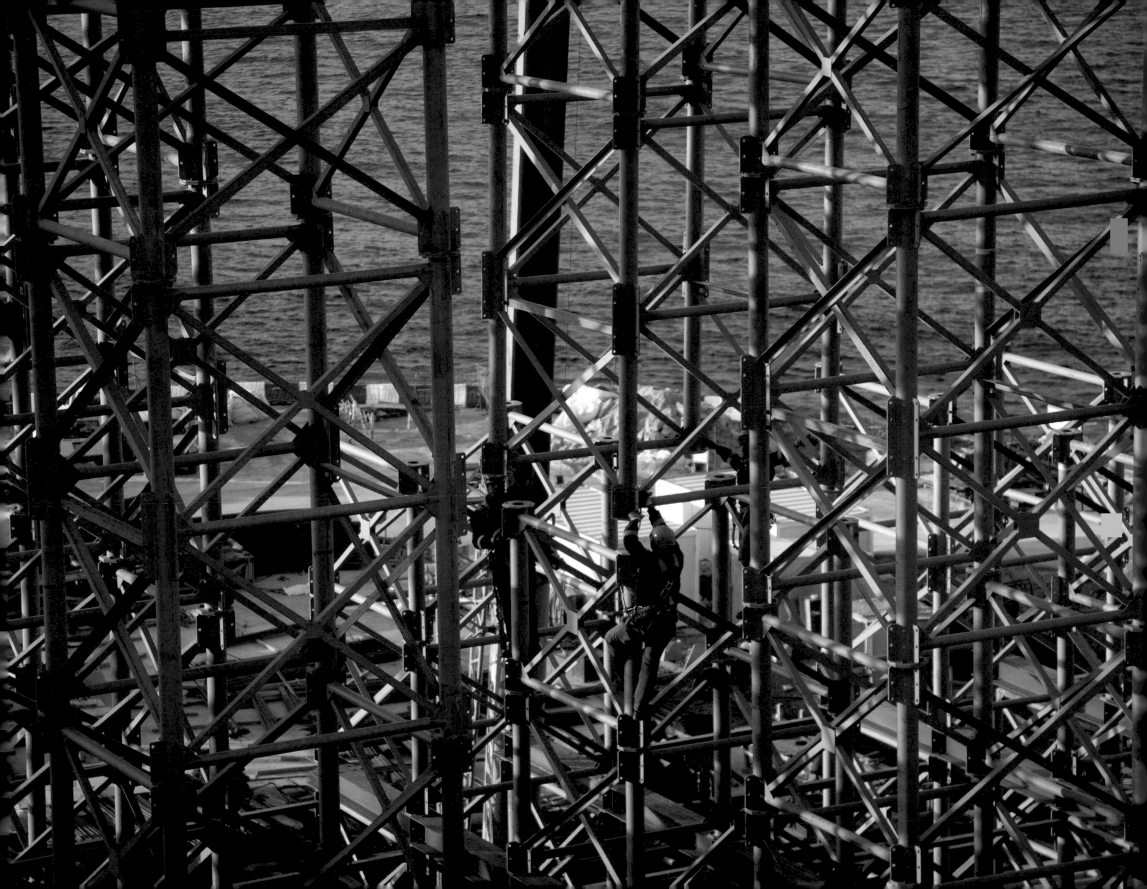

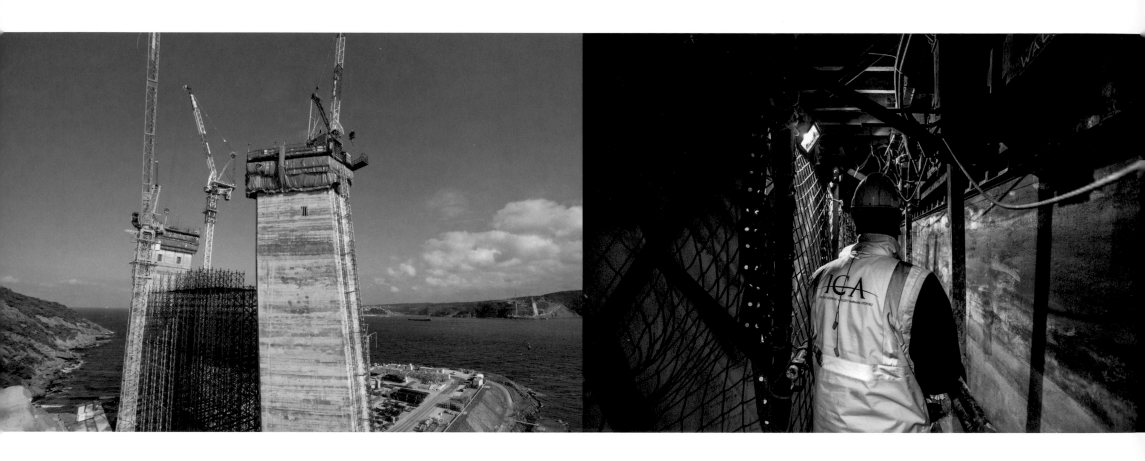

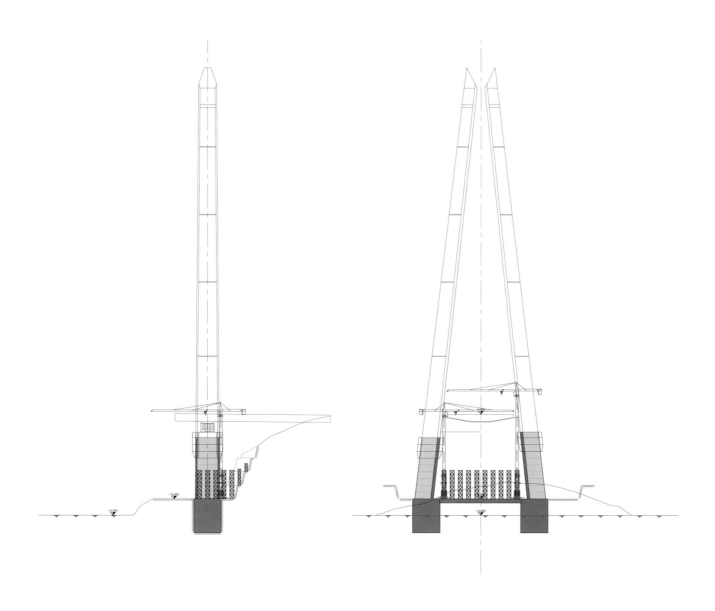

OCT 2013 Slip form reaching the bottom of the lower crossbeam.

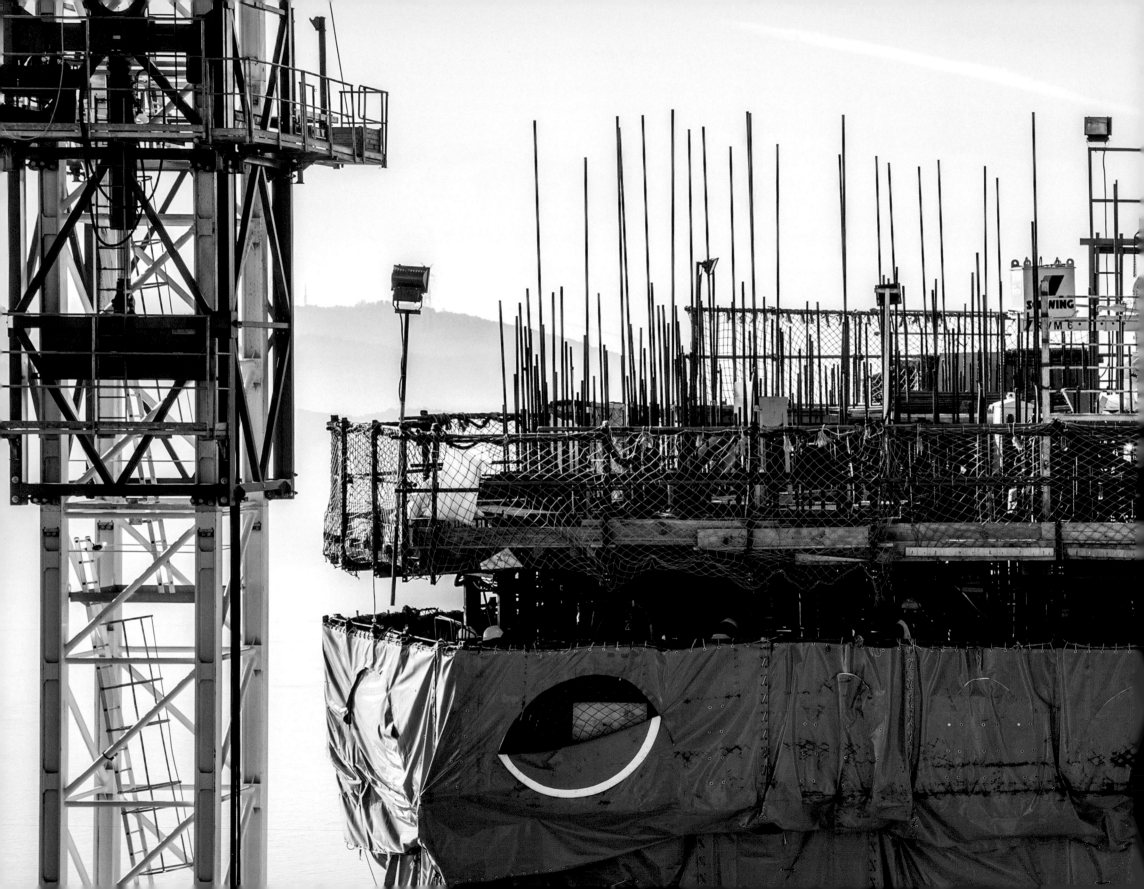

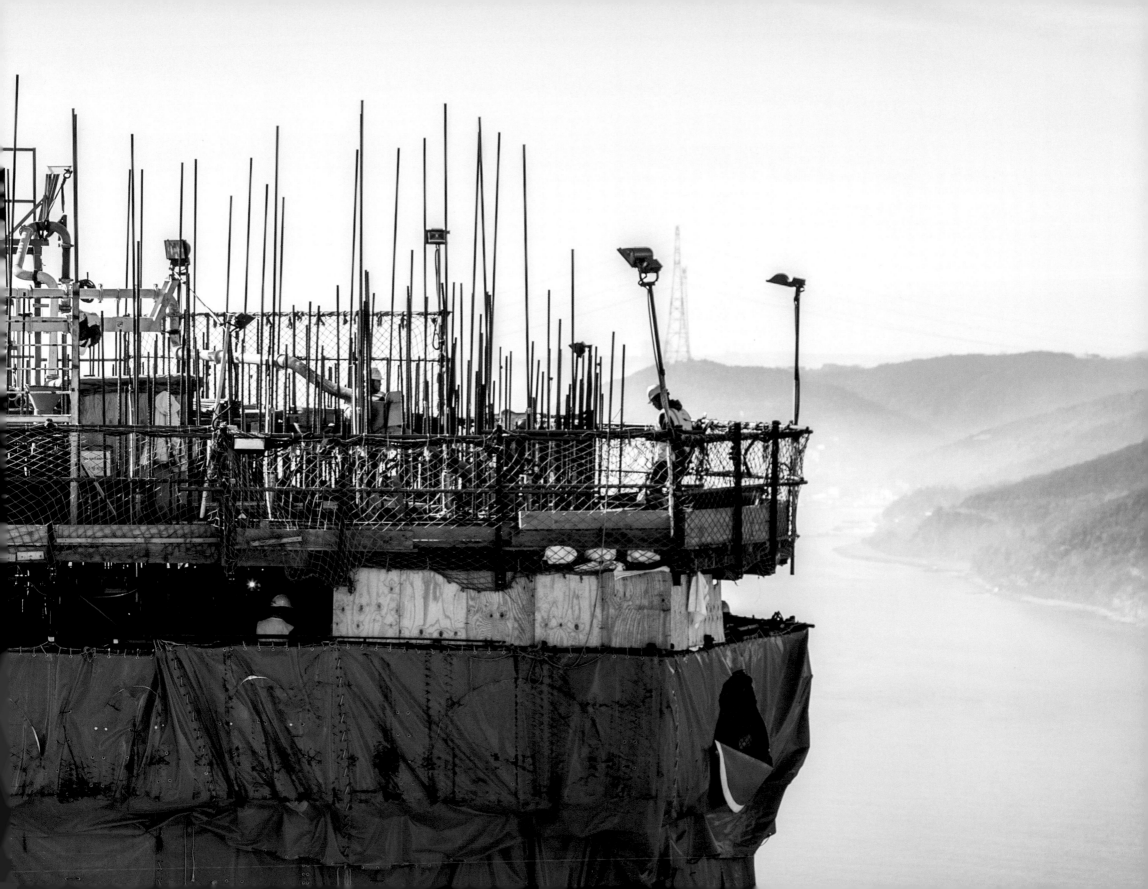

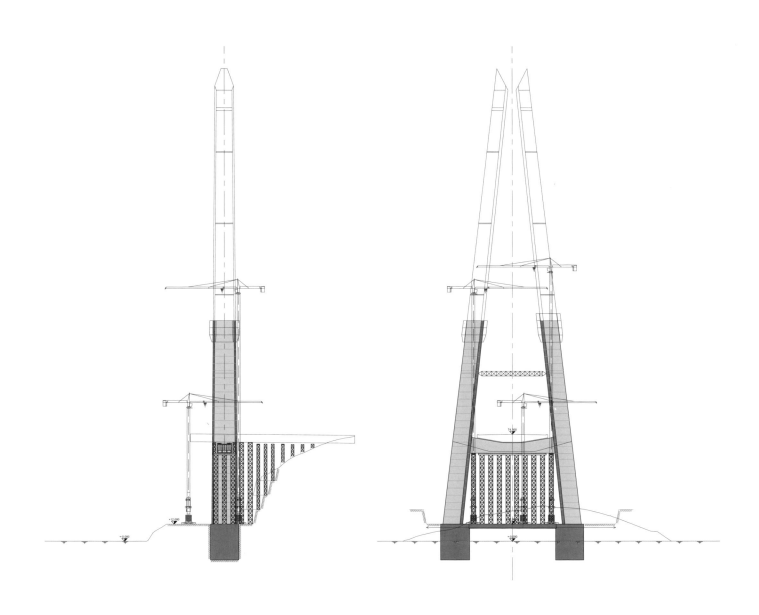

DEC 2013 Slip form, installation of temporary strut no. 1.

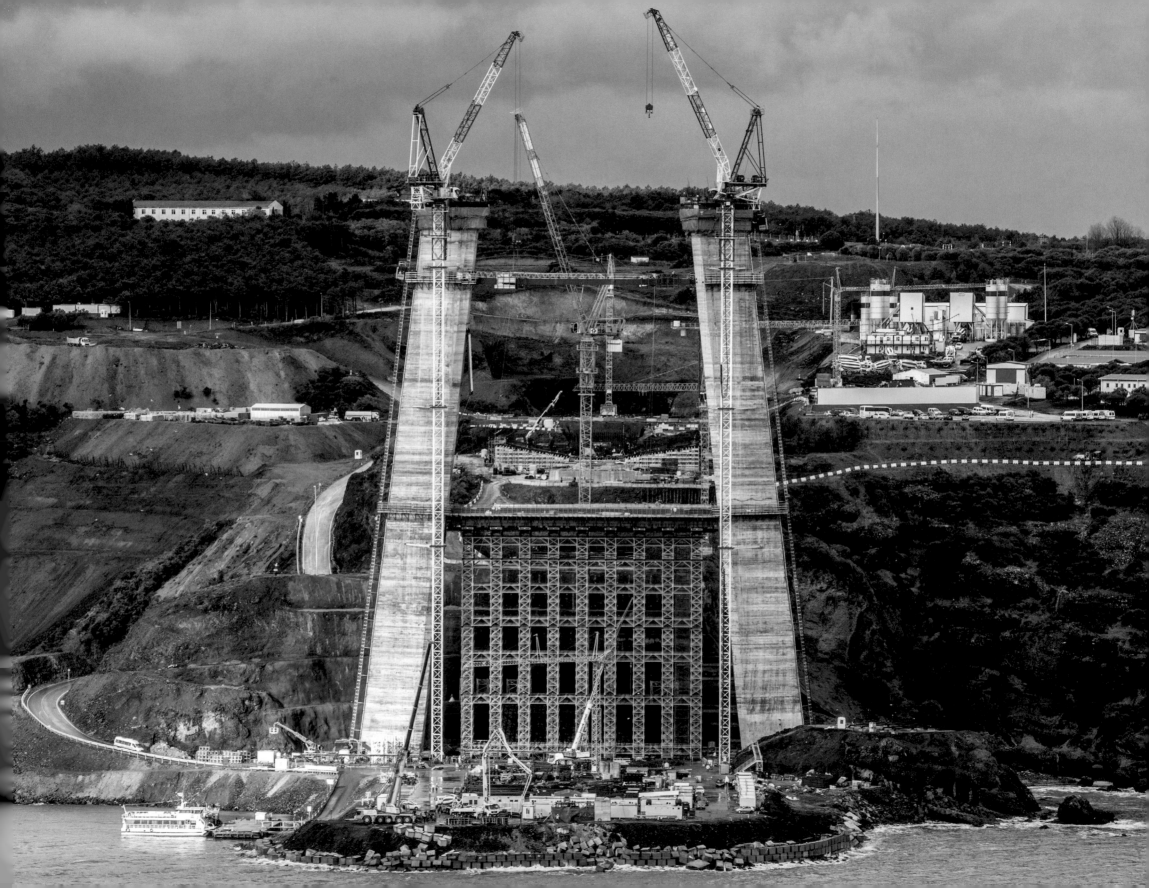

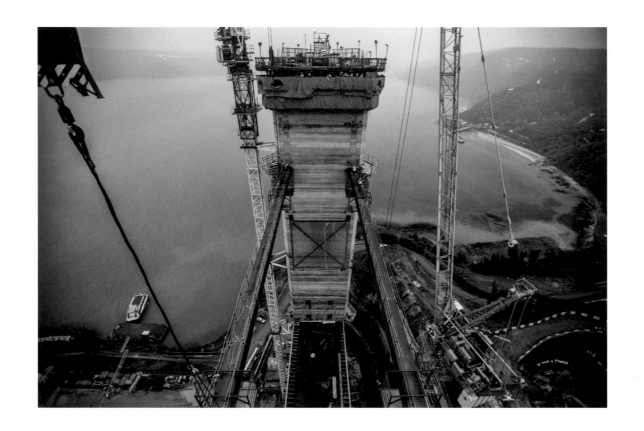

DEC 2013 The "suspended" building site and life on the slip form.

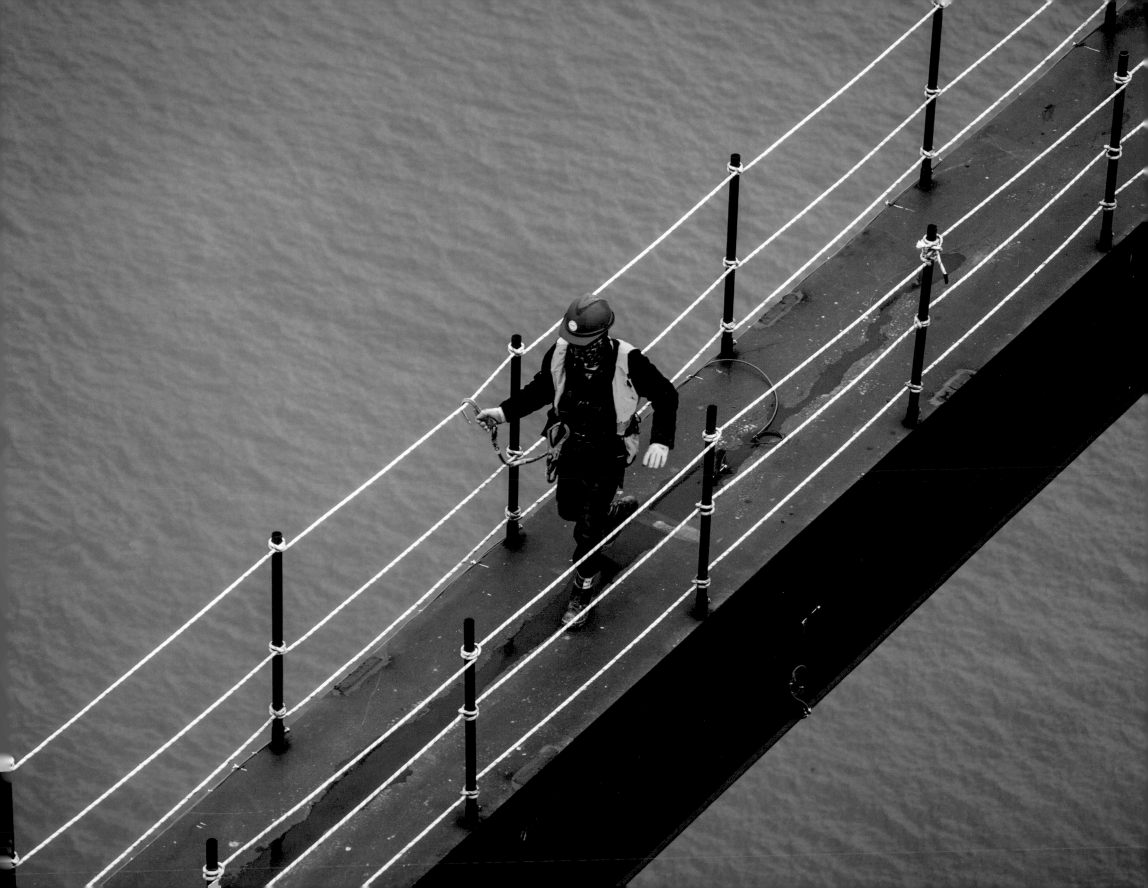

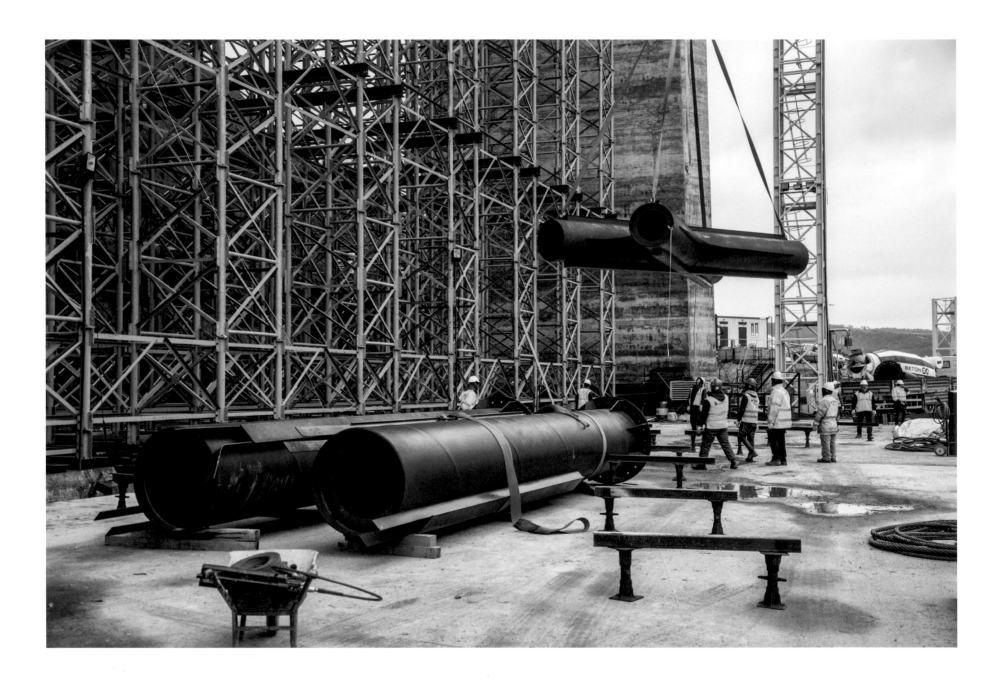

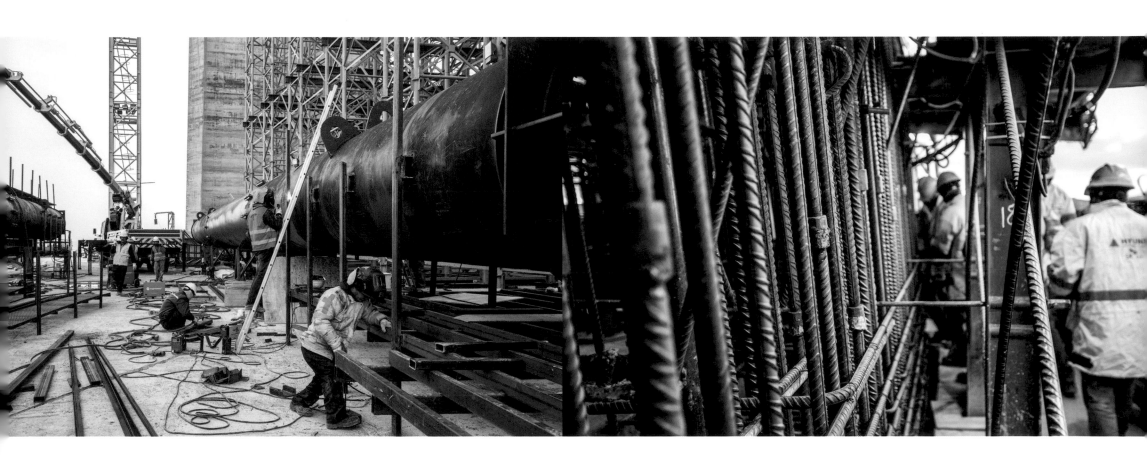

JAN 2014 Construction of the temporary elements in support of the building site.

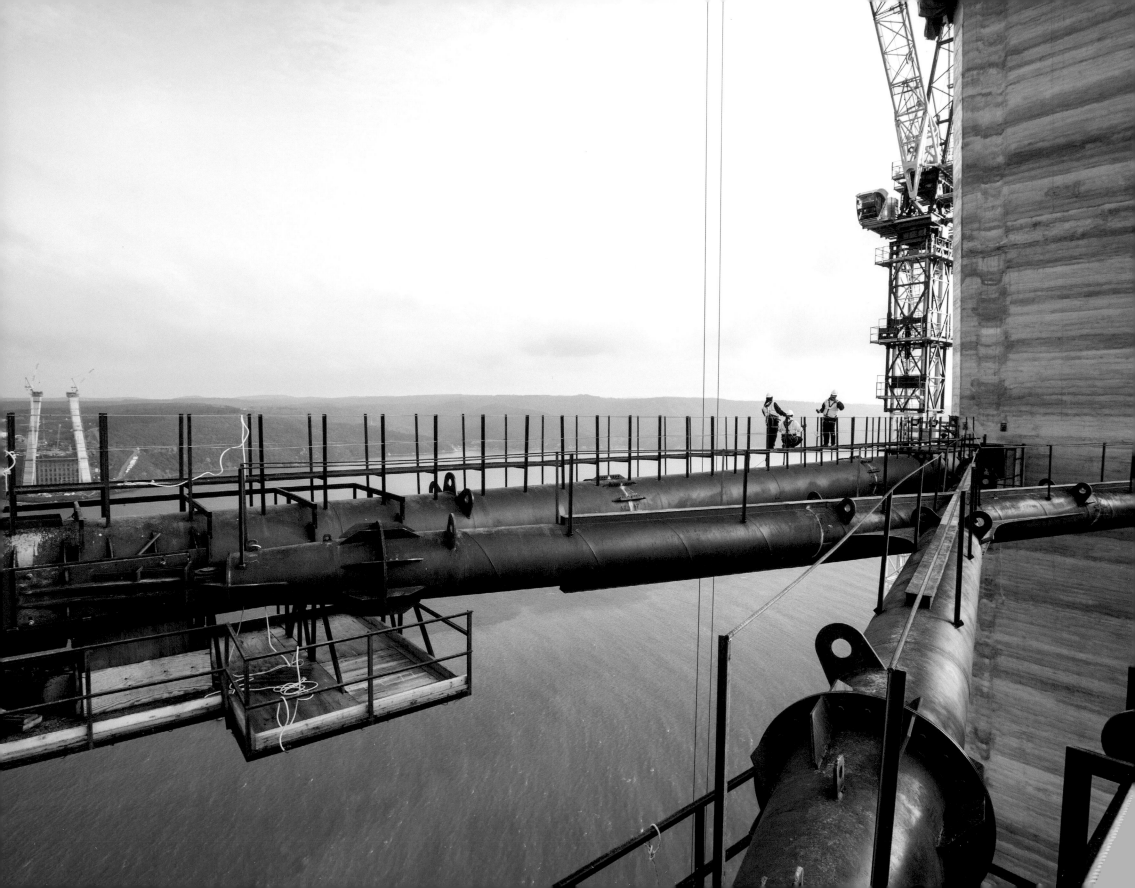

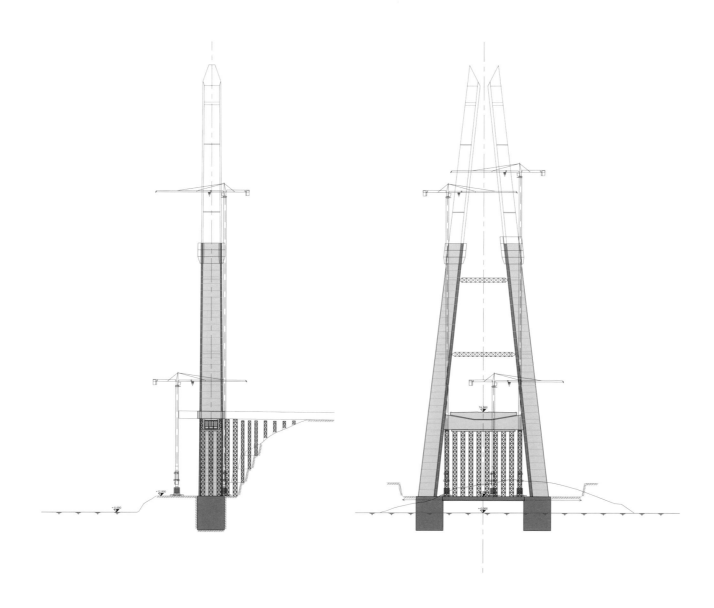

JAN 2014 Slip form continues: installation of temporary strut no. 2.

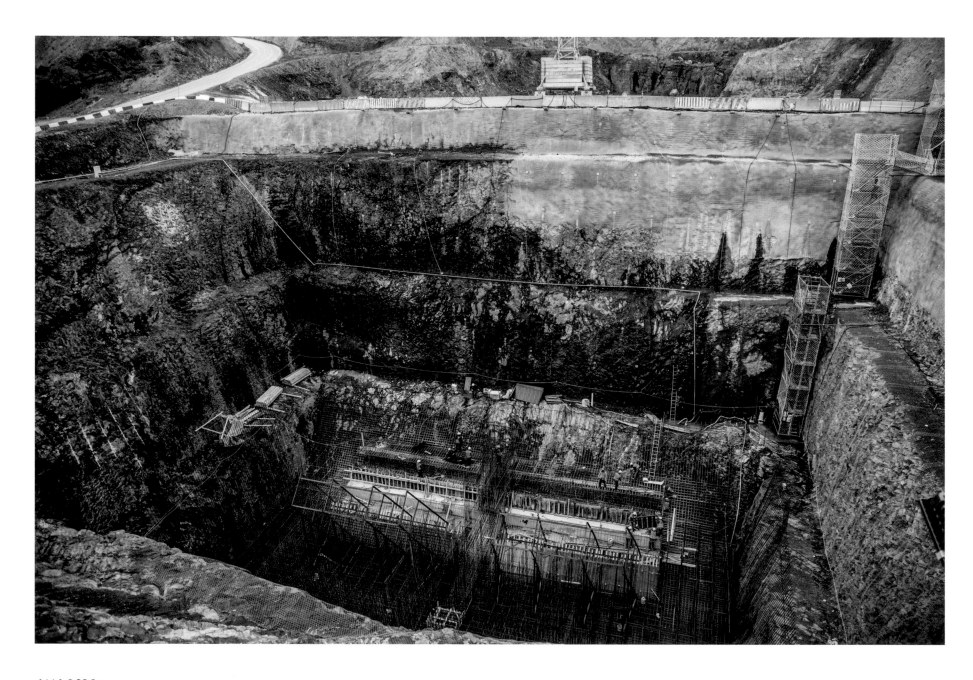

JAN 2014 Two views of the anchorage block.

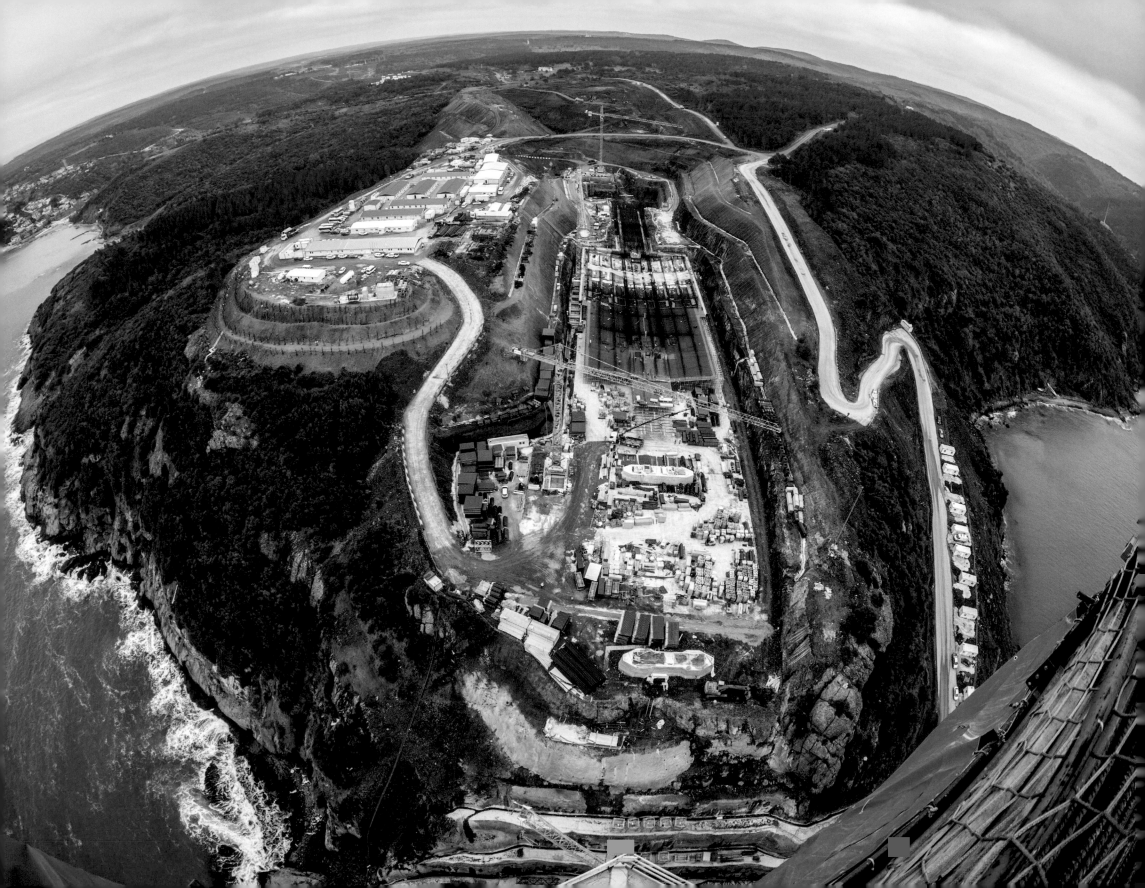

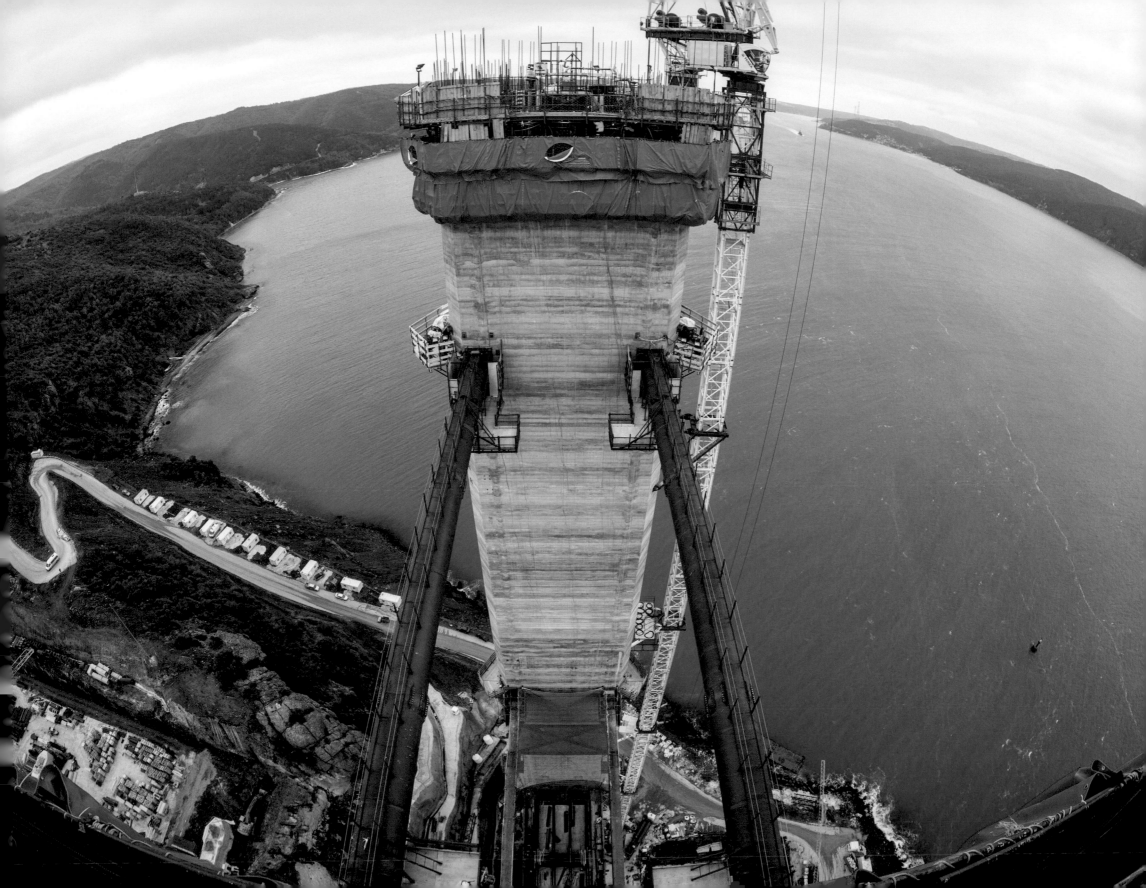

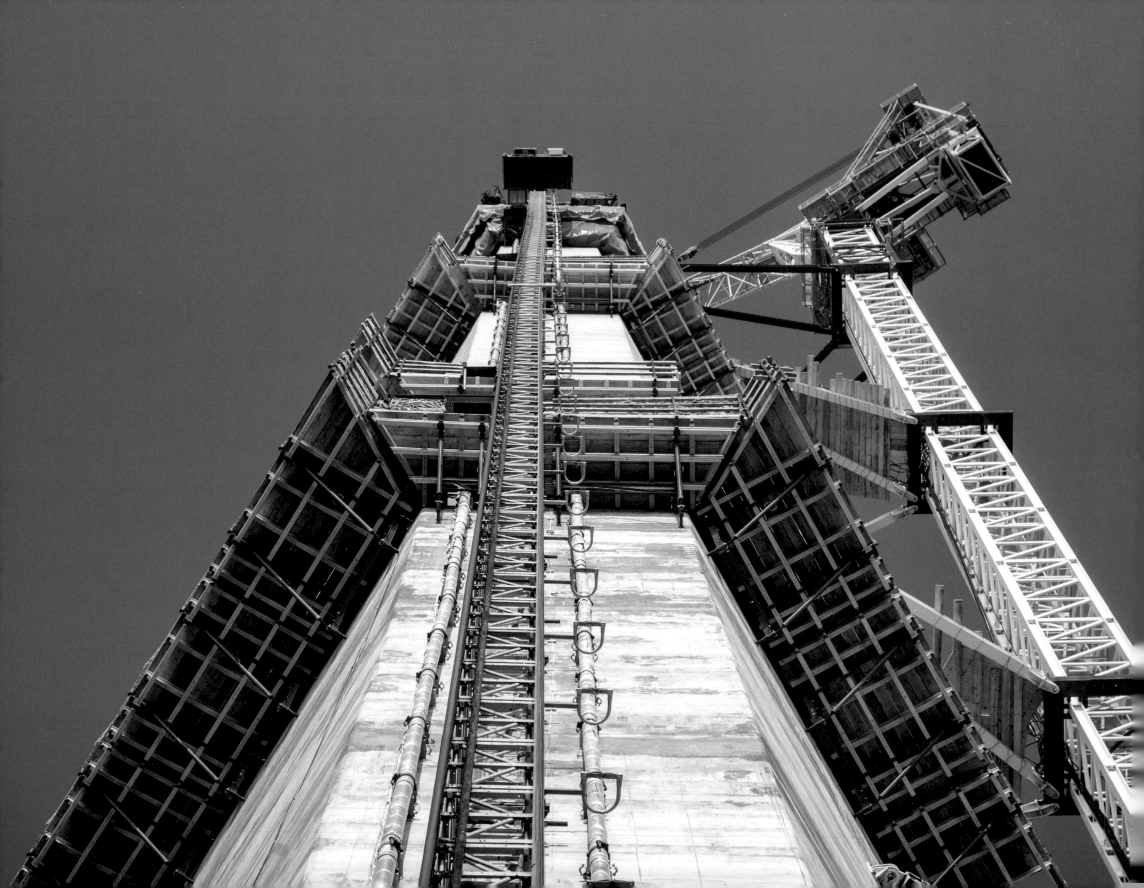

JAN 2014 Left, temporary structures for the construction of the pylons. Right, hollow inside the pylon.

OVER 10,000 PEOPLE
WERE INVOLVED IN THE PROJECT.

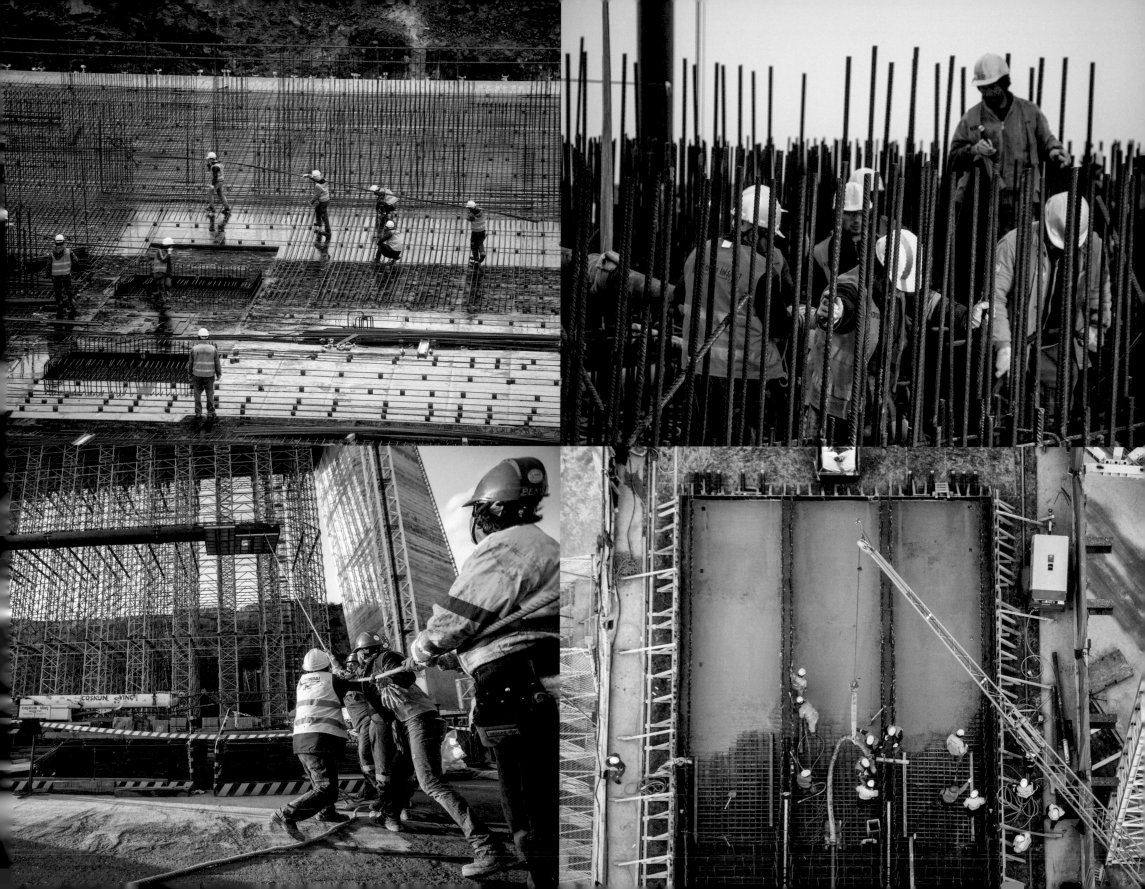

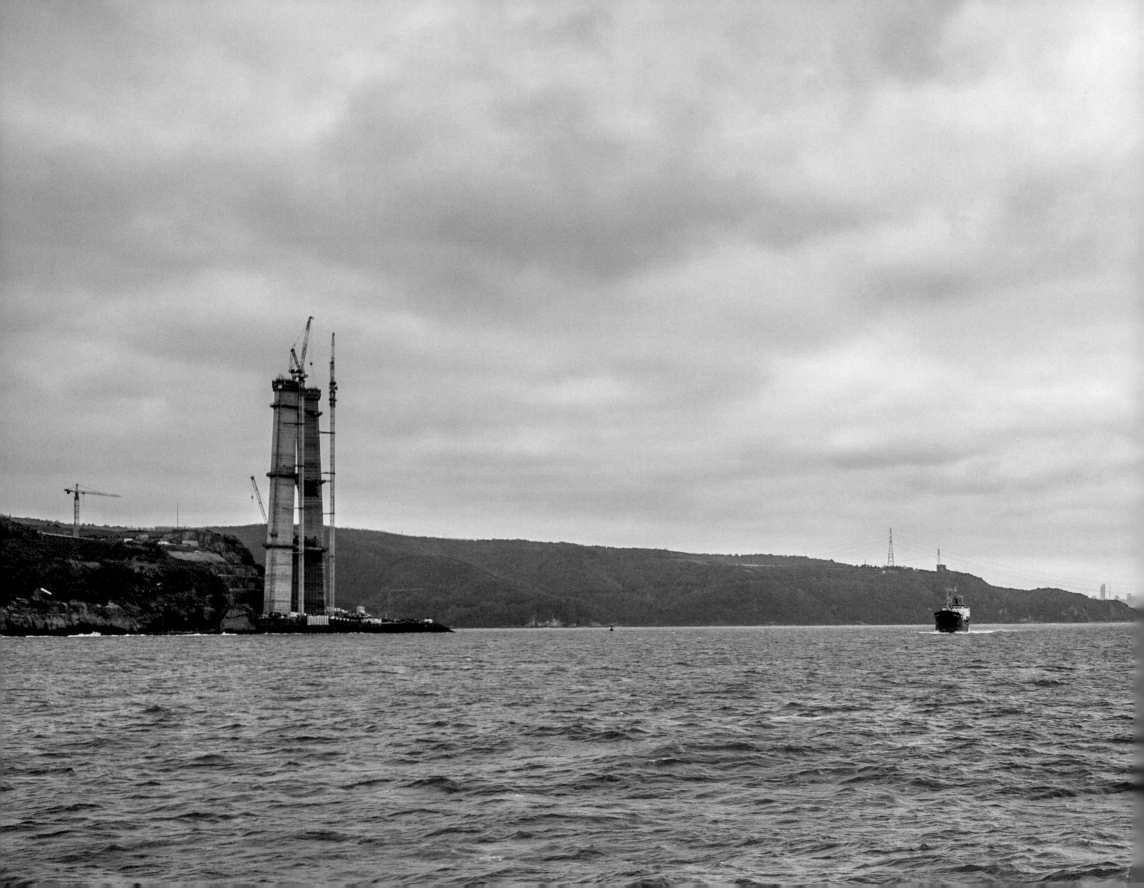

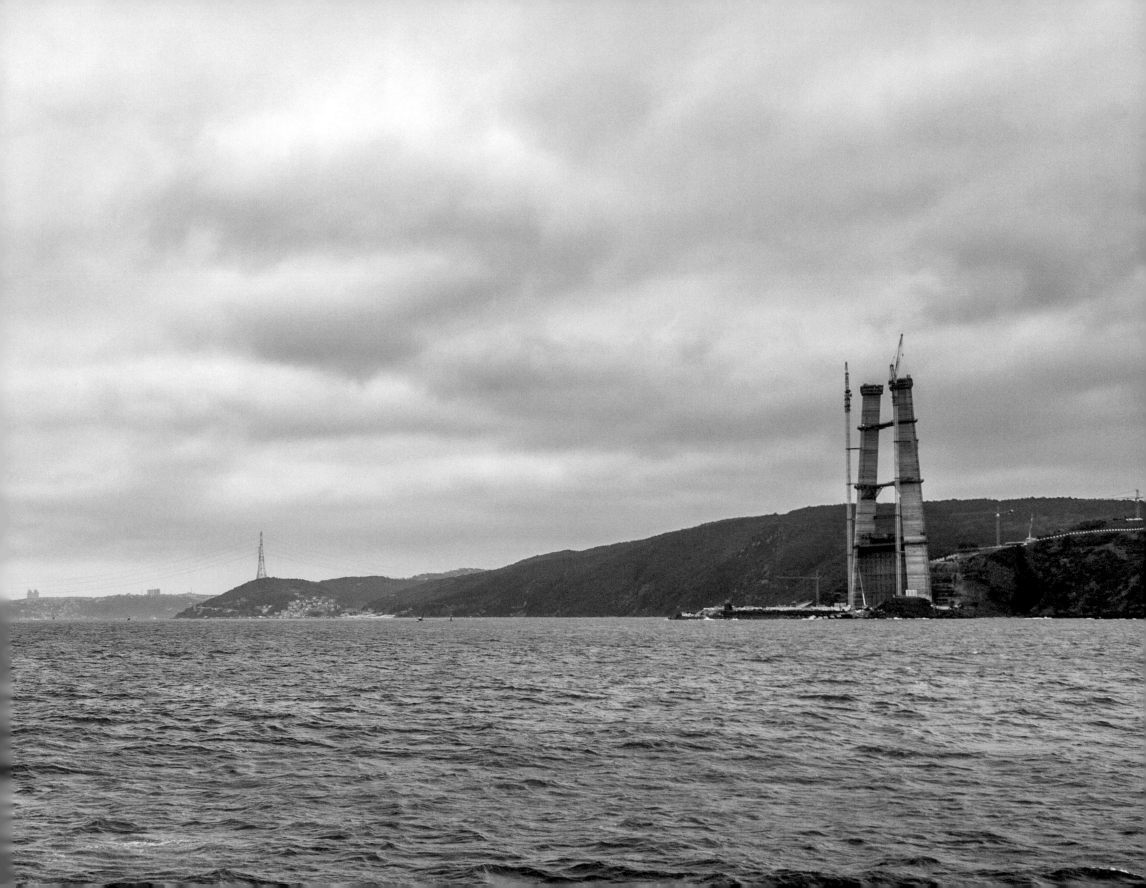

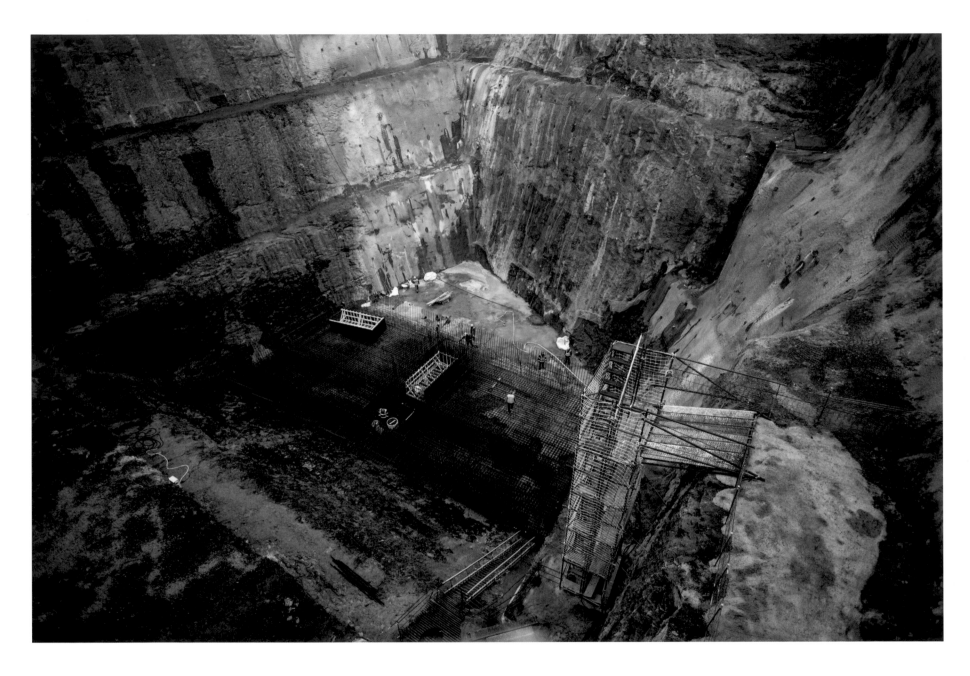

JAN 2014 Excavations for the anchorage block.

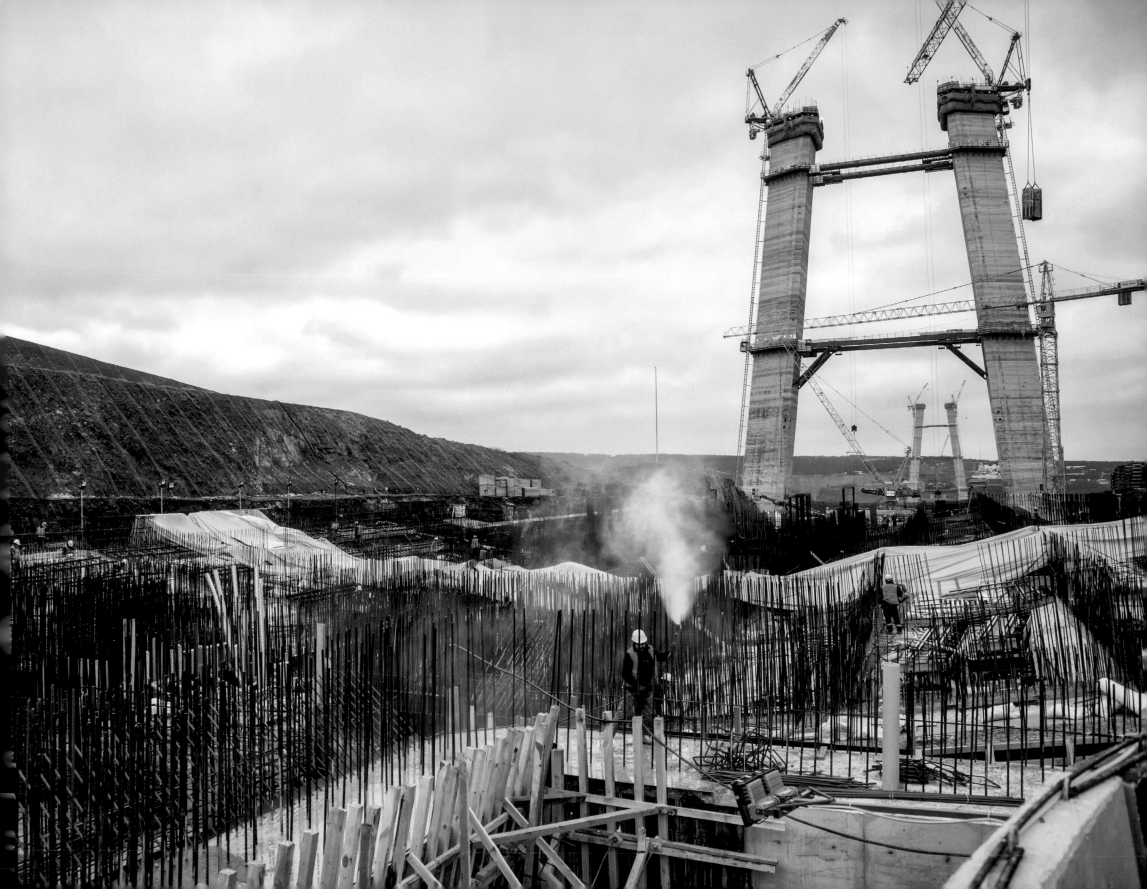

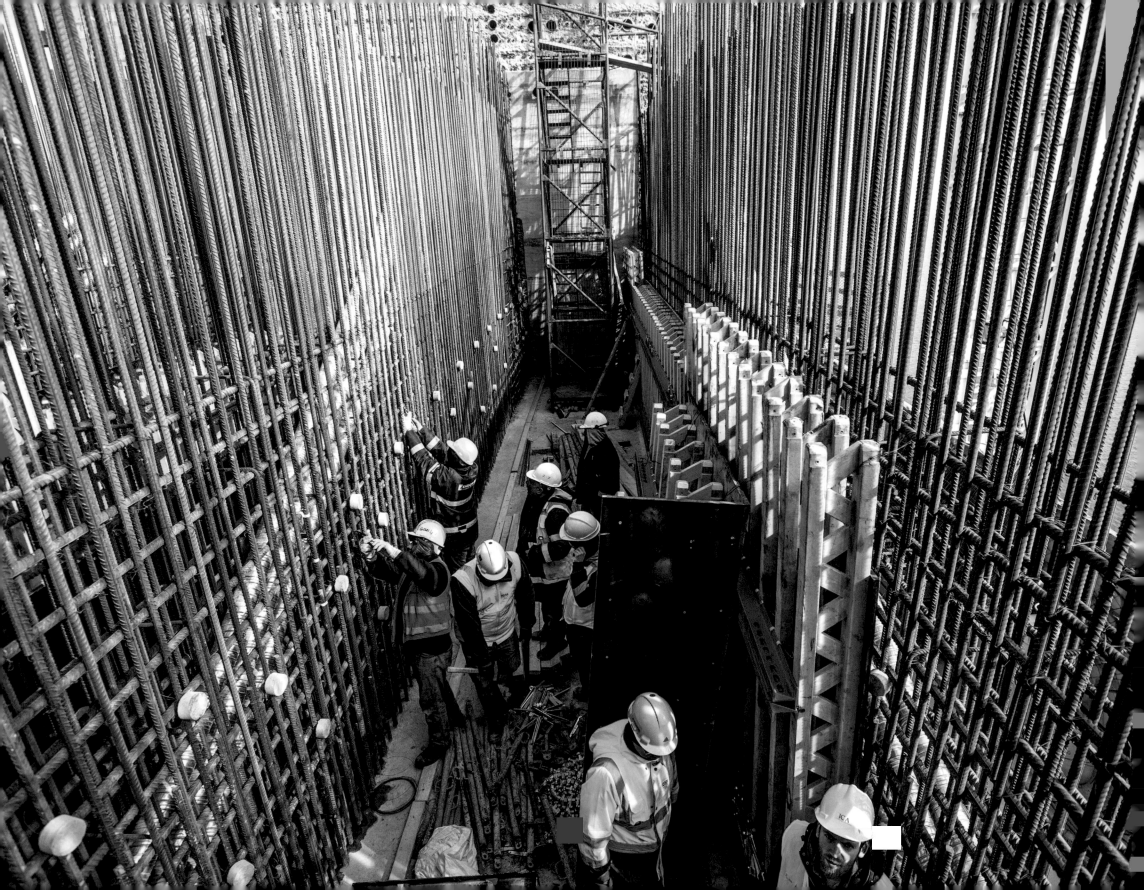

MORE THAN 70,000 TONNES OF STEEL WERE EMPLOYED
FOR THE MAIN, STIFFENING, AND SUSPENSION CABLES,
THE TOWER AND SPLAY SADDLES, THE DECK,
THE ANCHORAGE BOXES, AND TOP BEAMS.

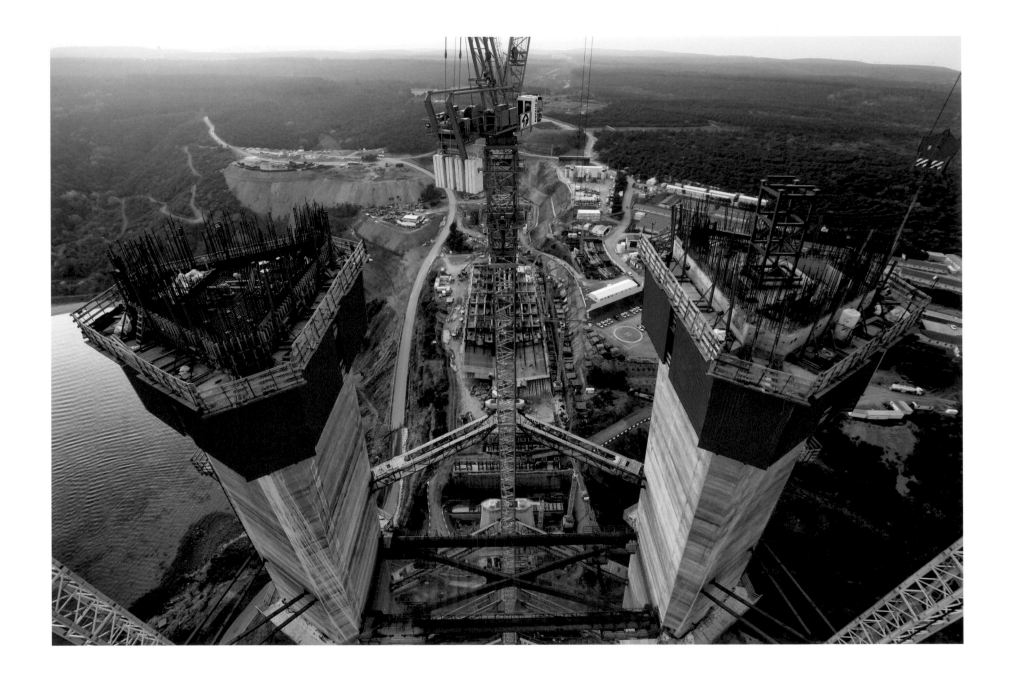

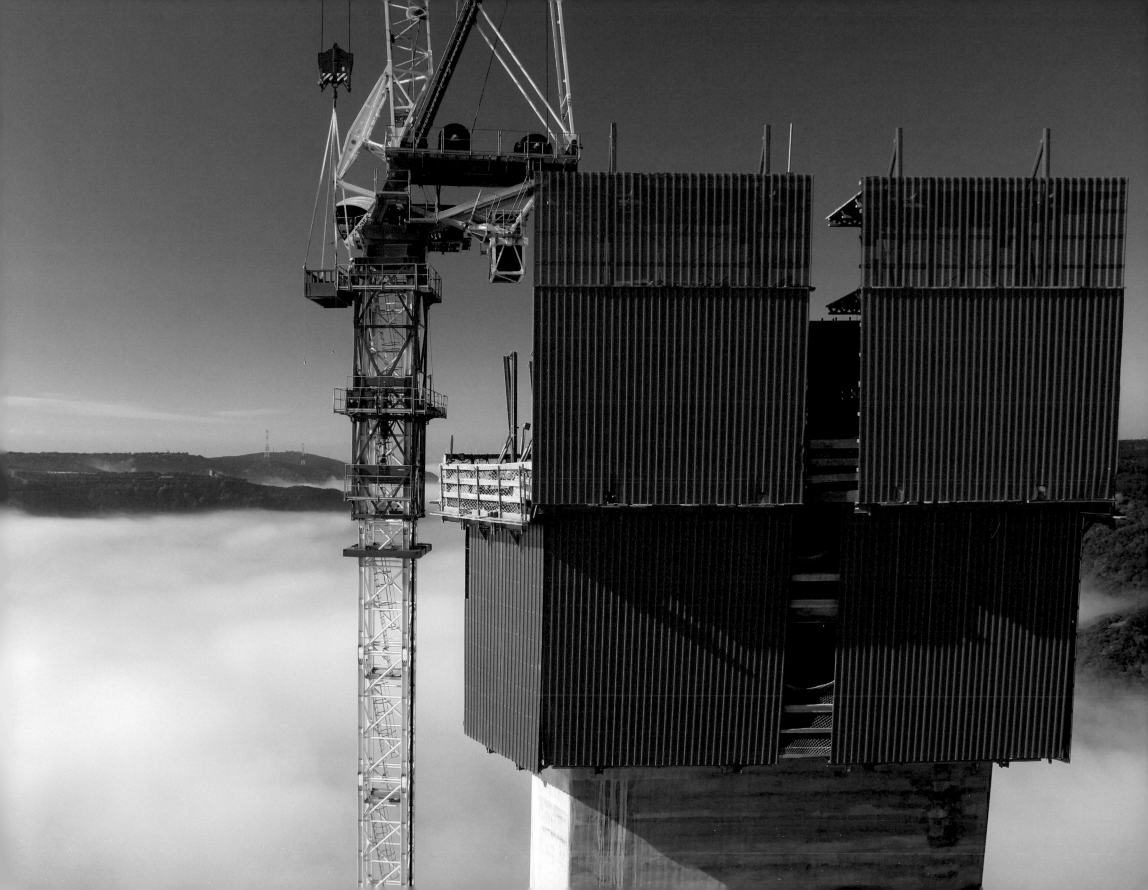

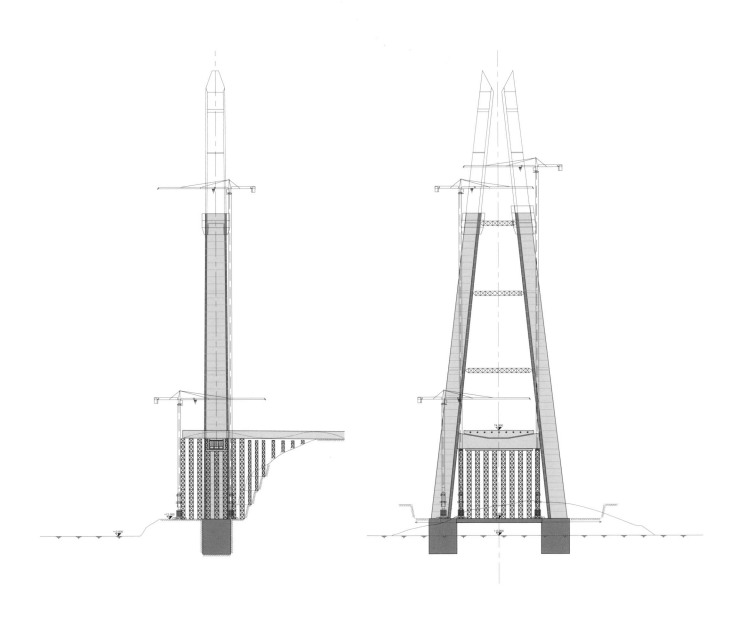

APR 2014 Slip form reaches the tower anchor box installation stage. On the right, a detail of the anchor box on top of the pylon.

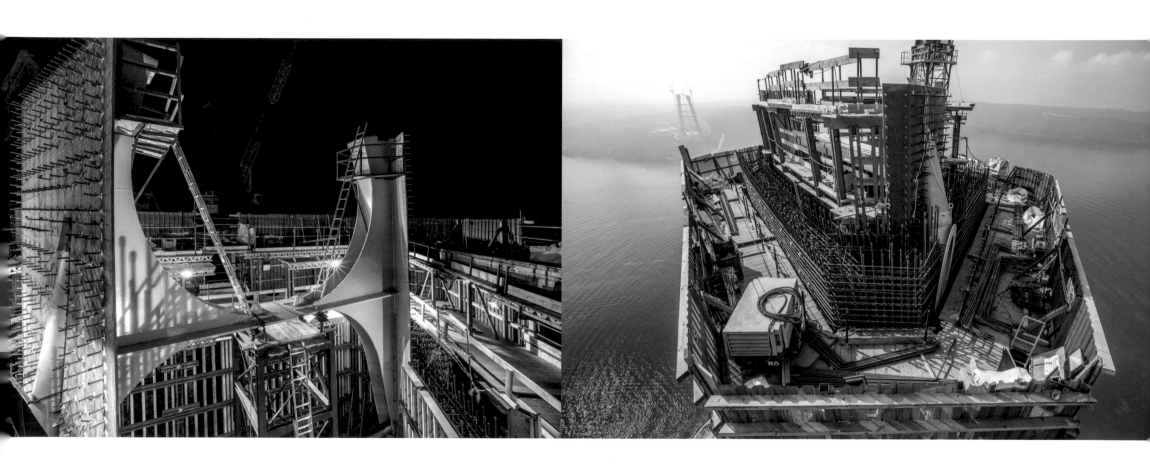

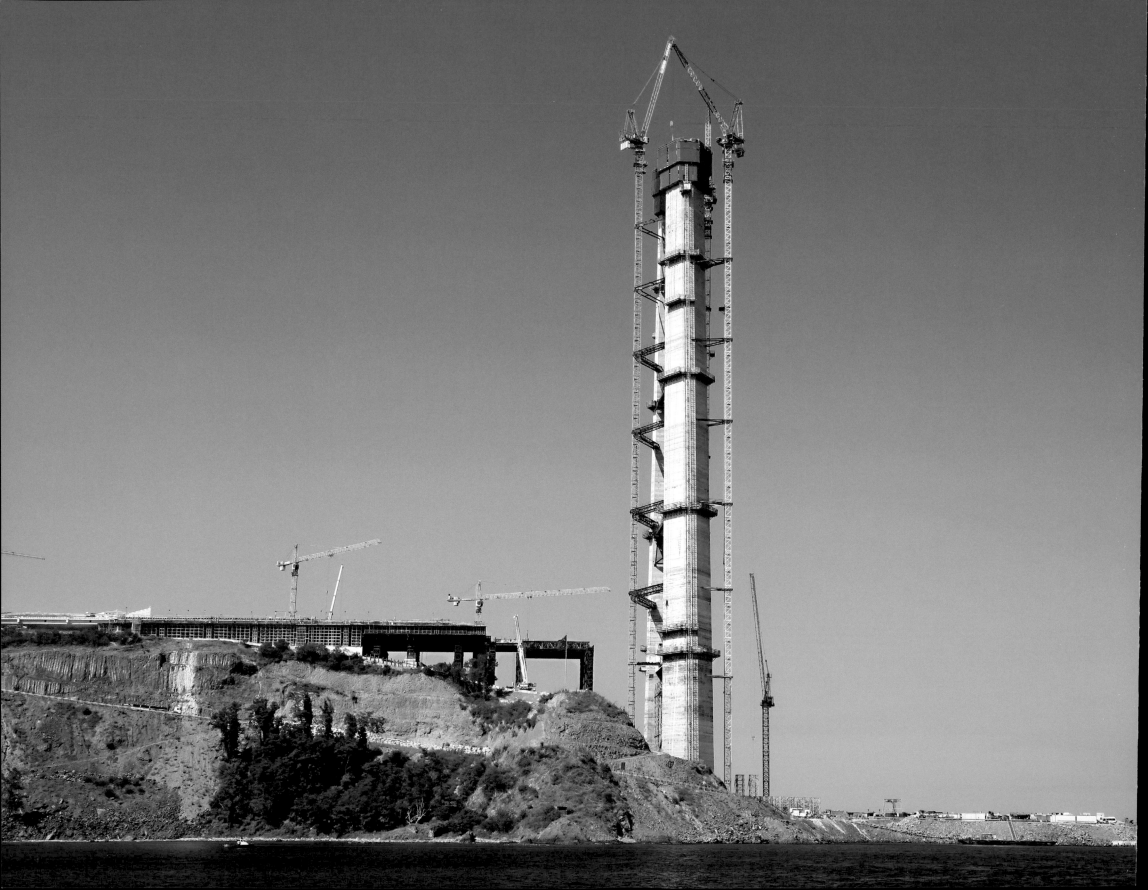

MORE THAN 200,000 CUBIC METRES OF CONCRETE WERE USED
TO BUILD THE TOWERS, THE SIDE SPAN, THE GROUND APPROACHES,
AND THE ANCHORAGE BLOCKS.

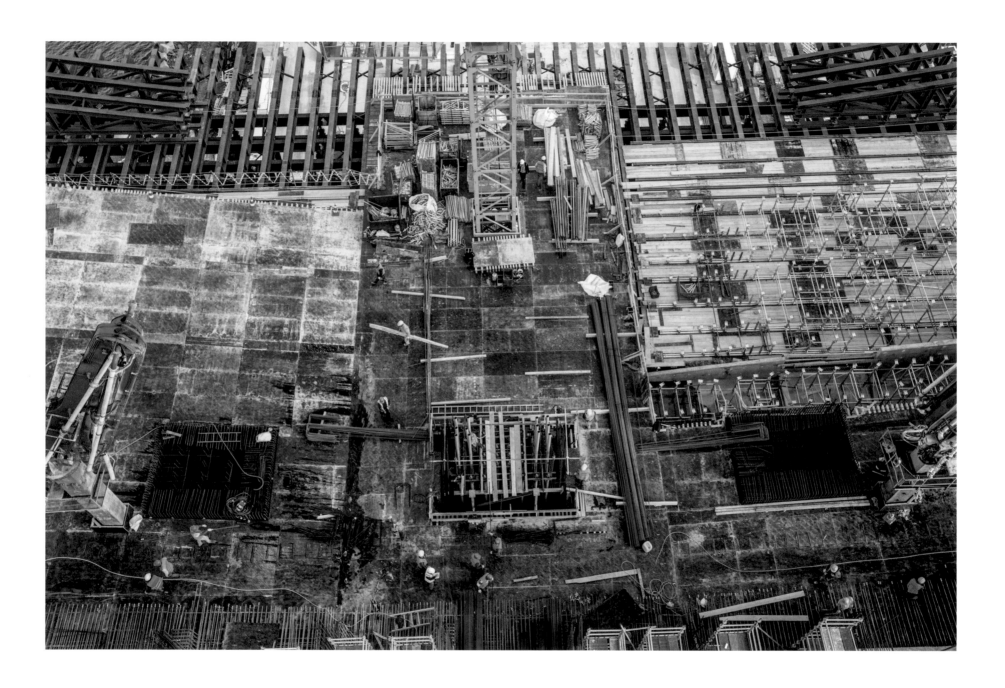

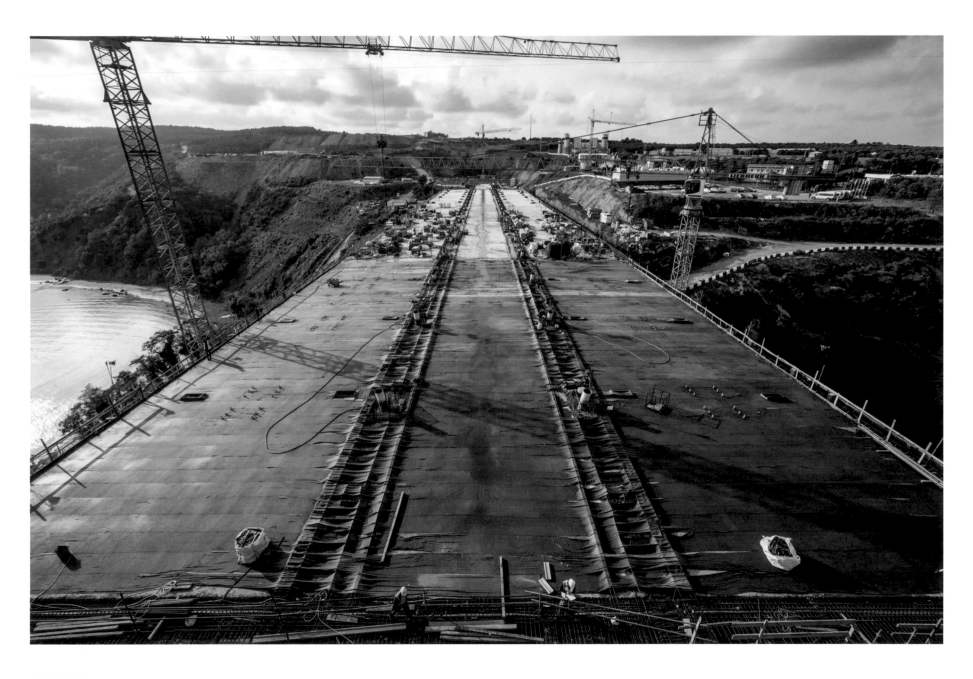

OCT 2014 The concrete viaduct/deck was built in six main segments and each segment was built in three stages.

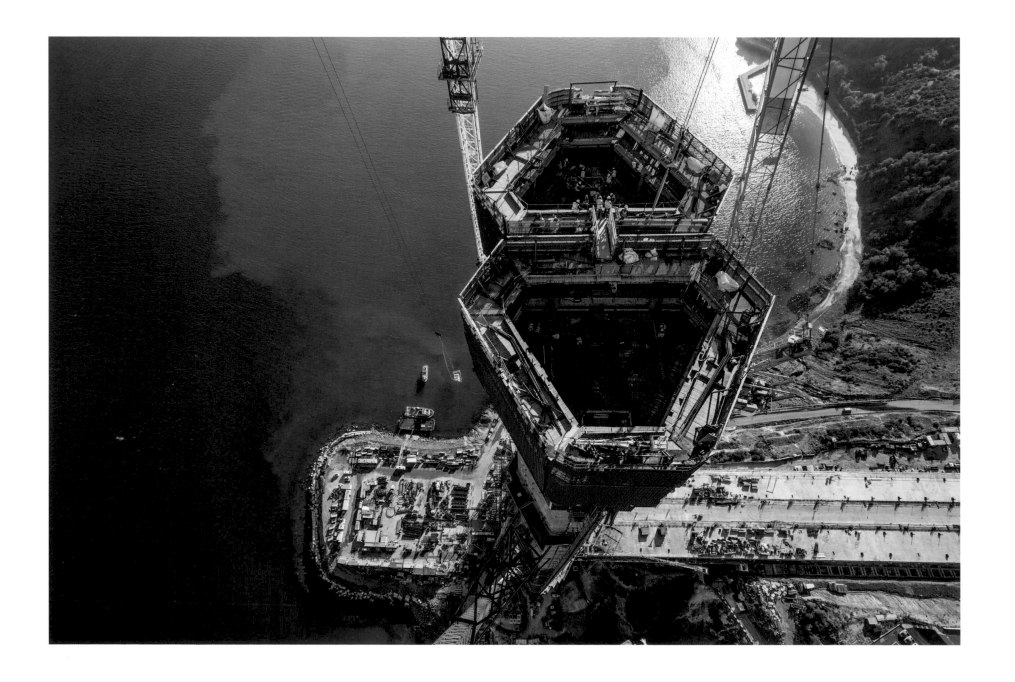

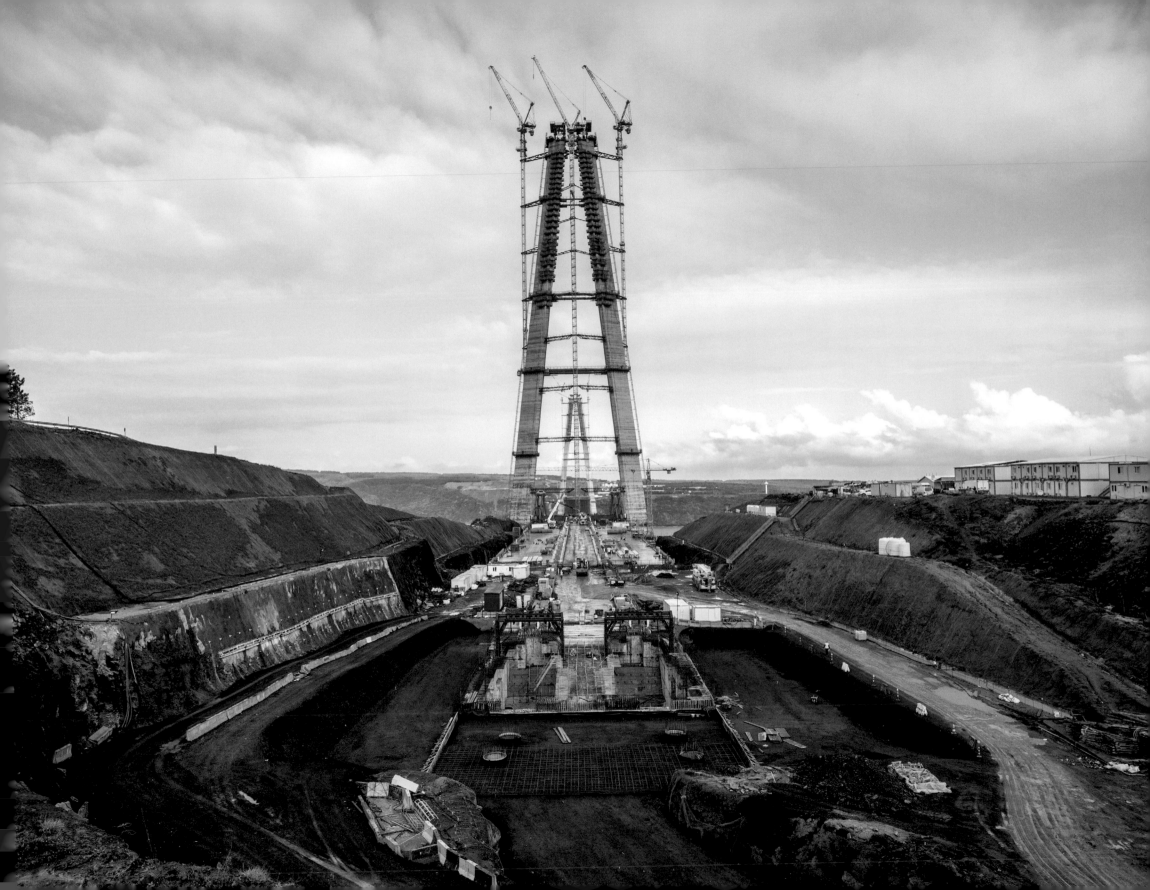

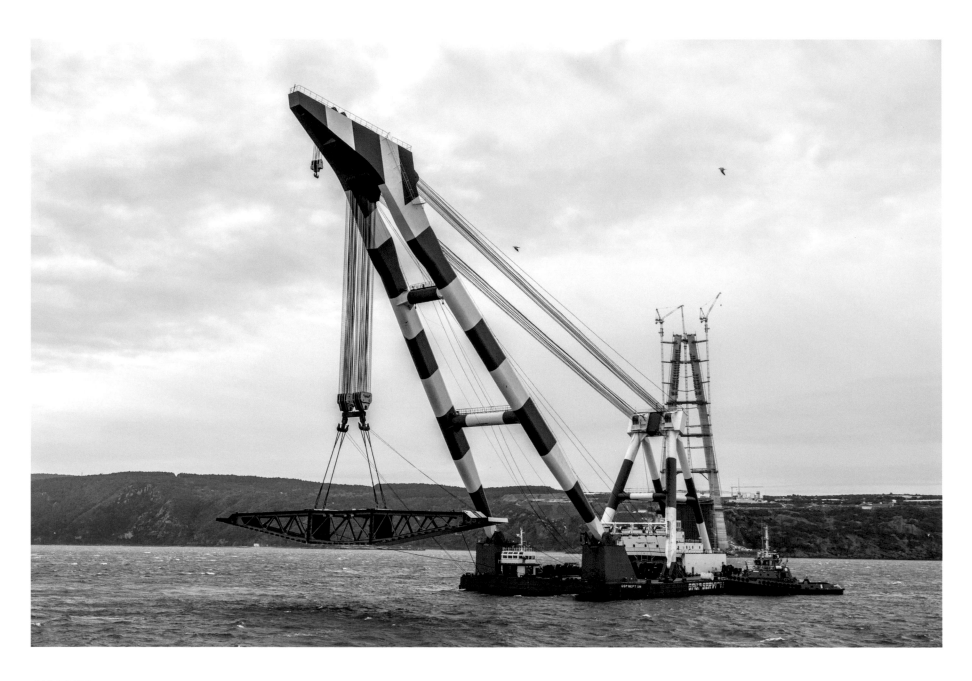

JAN 2015 The enormous floating crane used to position the first deck segments.

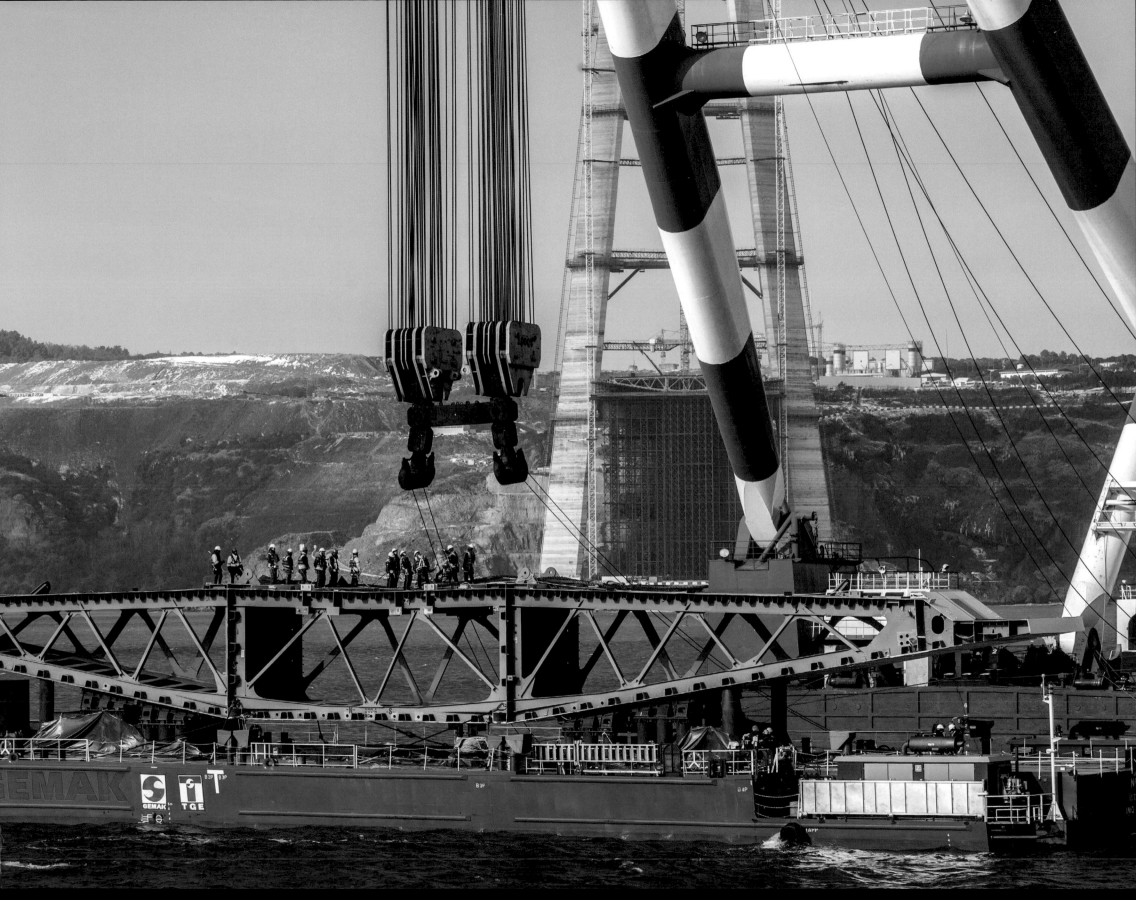

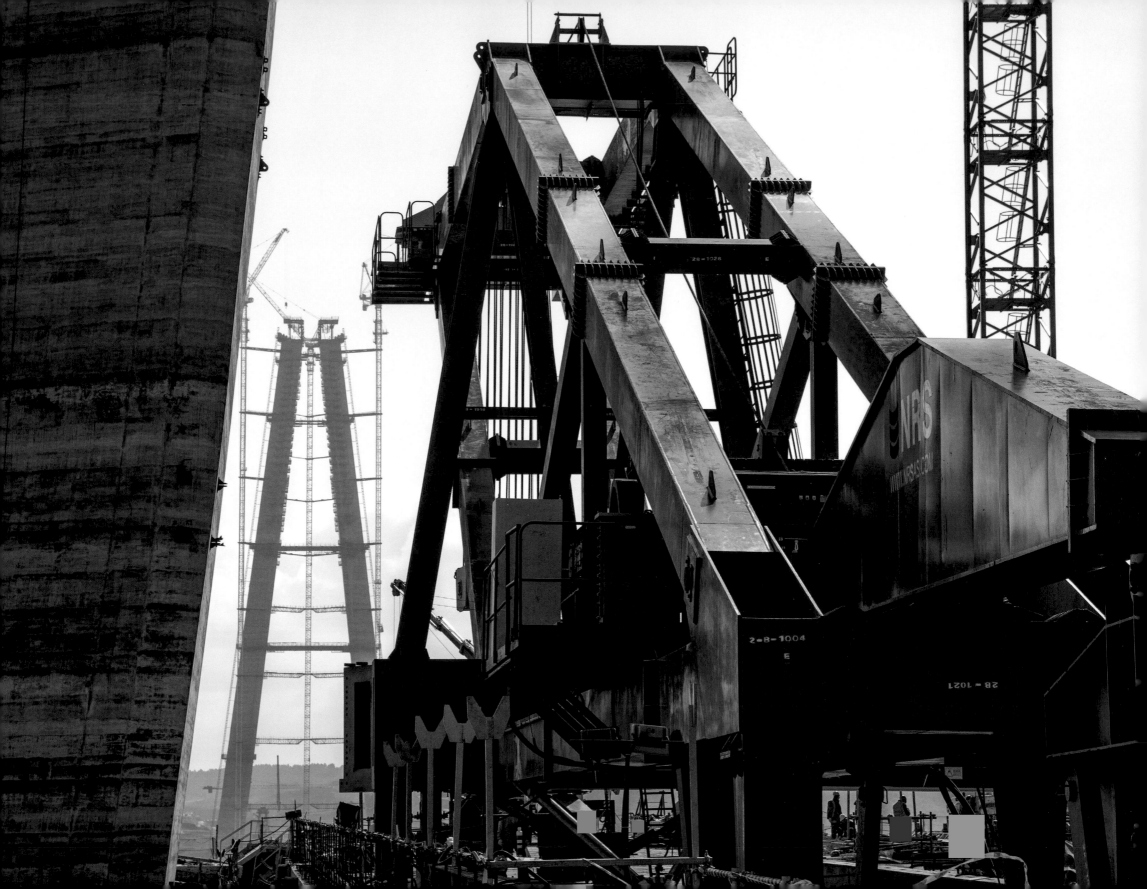

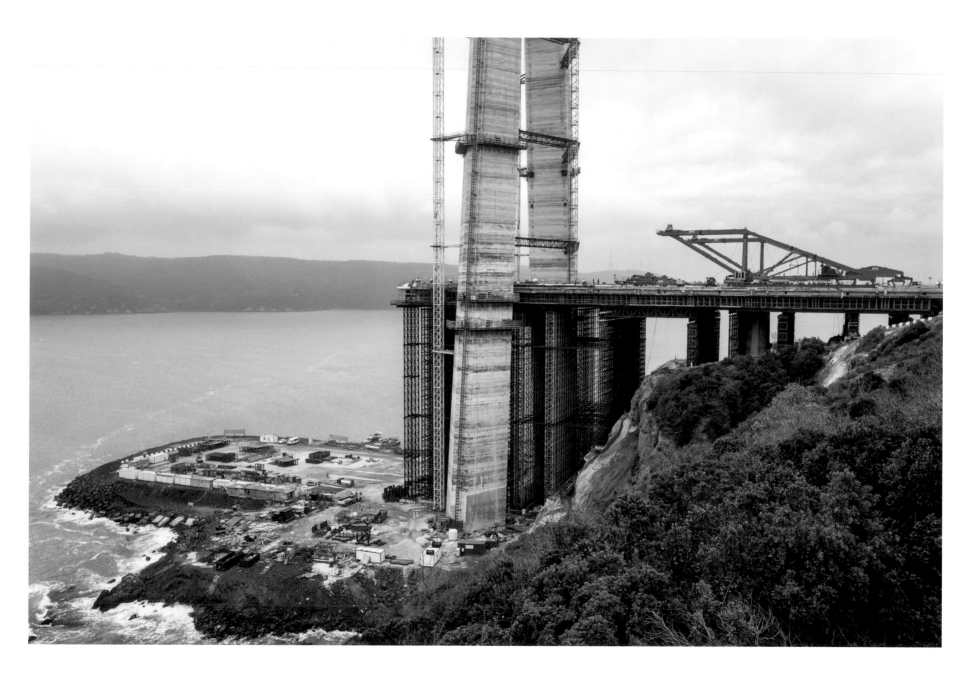

MAR 2015 General view and detail of one of the derrick cranes used to lift the deck segments, weighing up to 1,000 tonnes.

THE WORLD'S LONGEST INCLINED SUSPENSION/STIFFENING CABLE,
MEASURING APPROXIMATELY 600 METRES AND WEIGHING 120 TONNES.

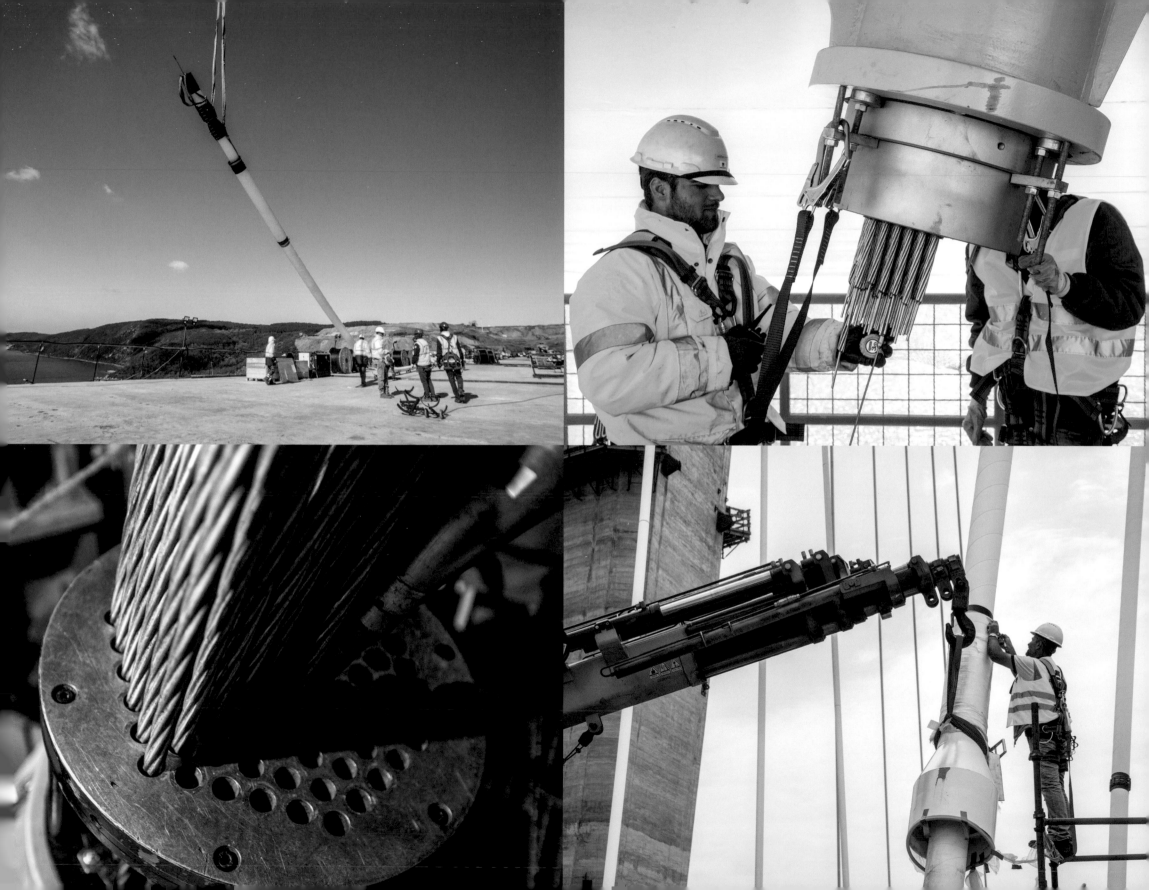

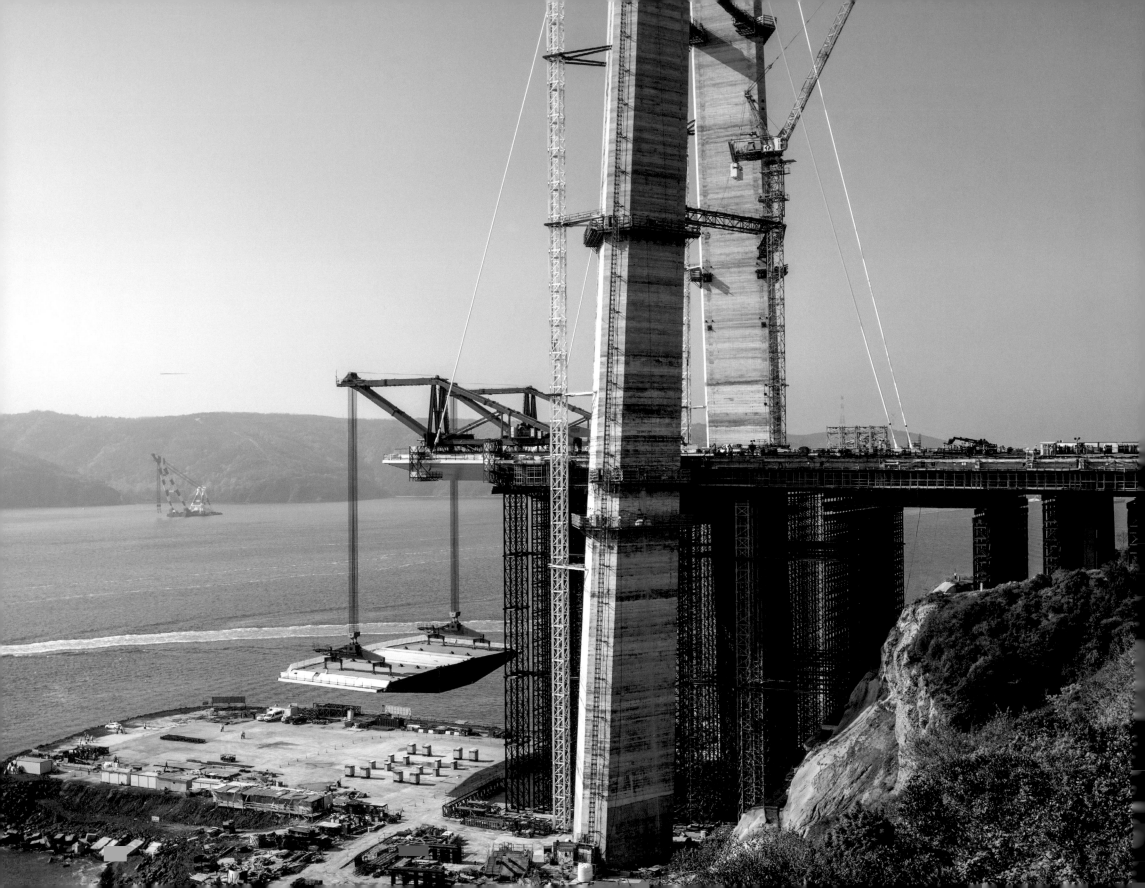

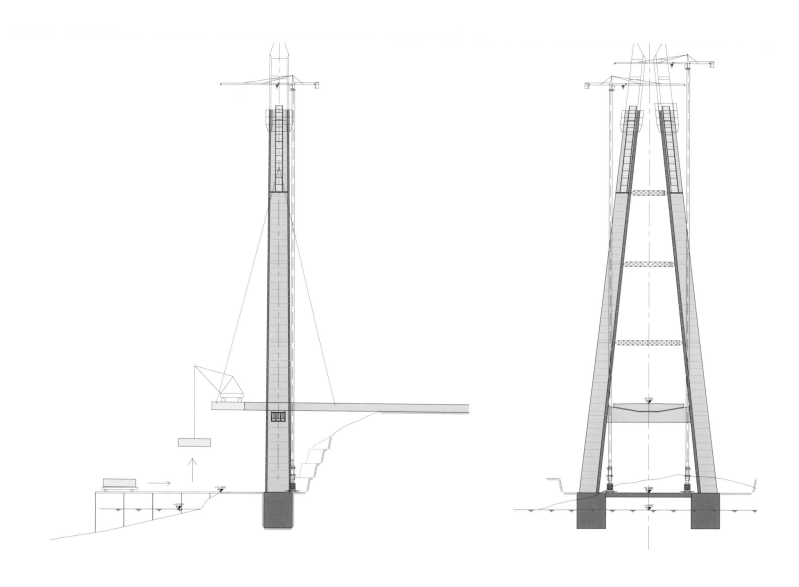

APR 2015 Installation of first stiffening cables.

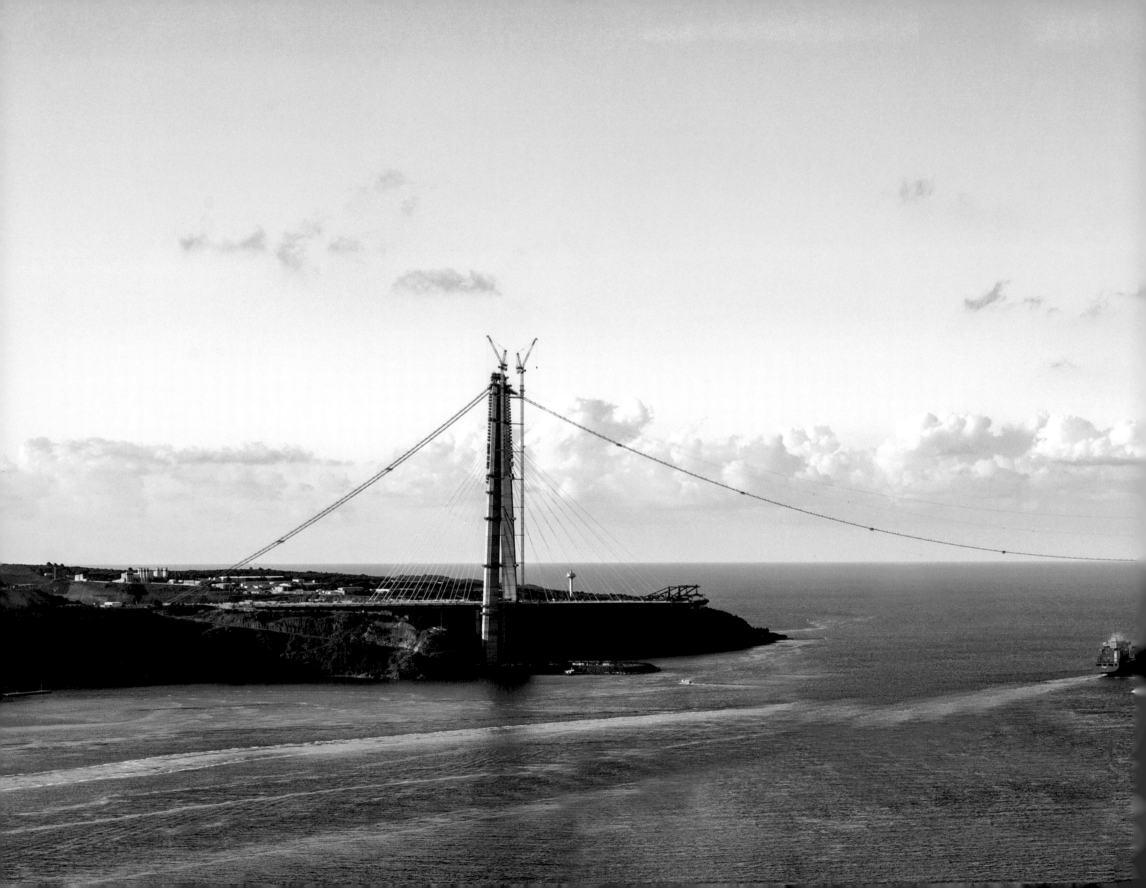

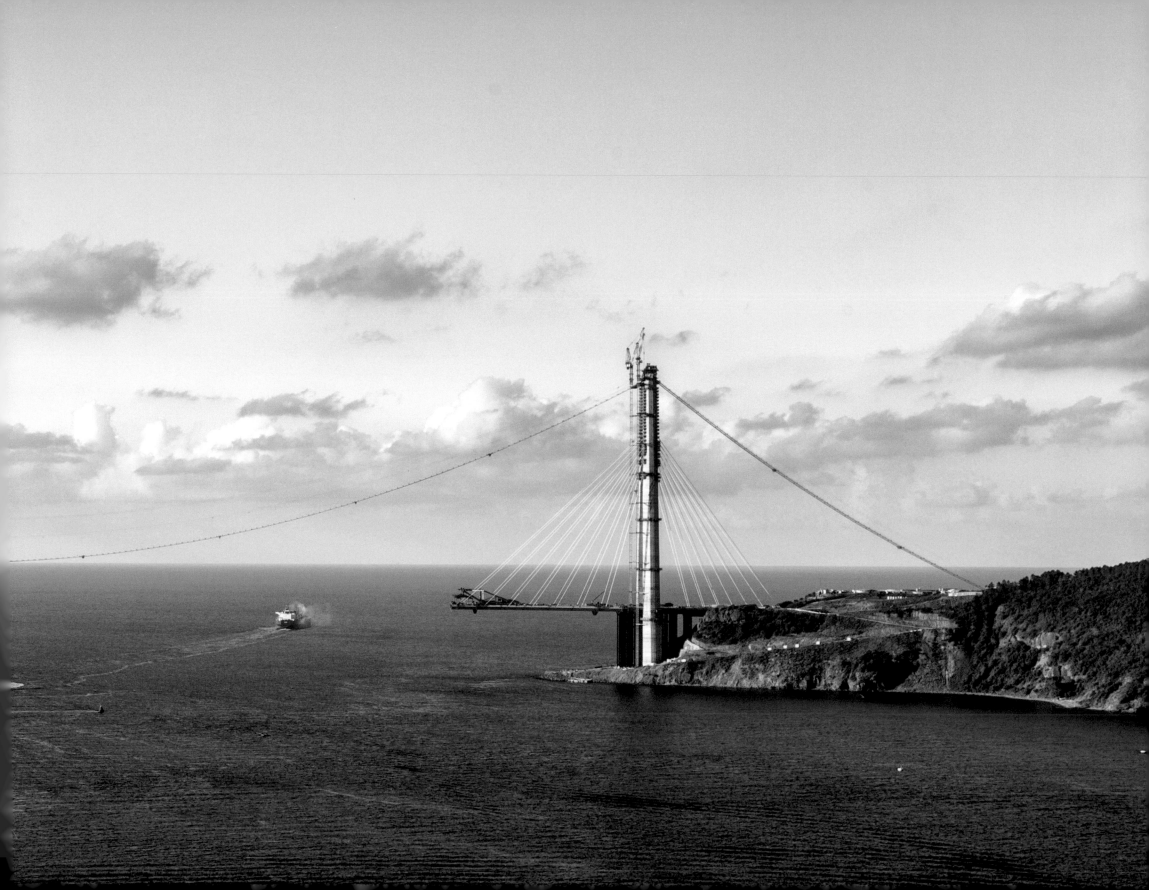

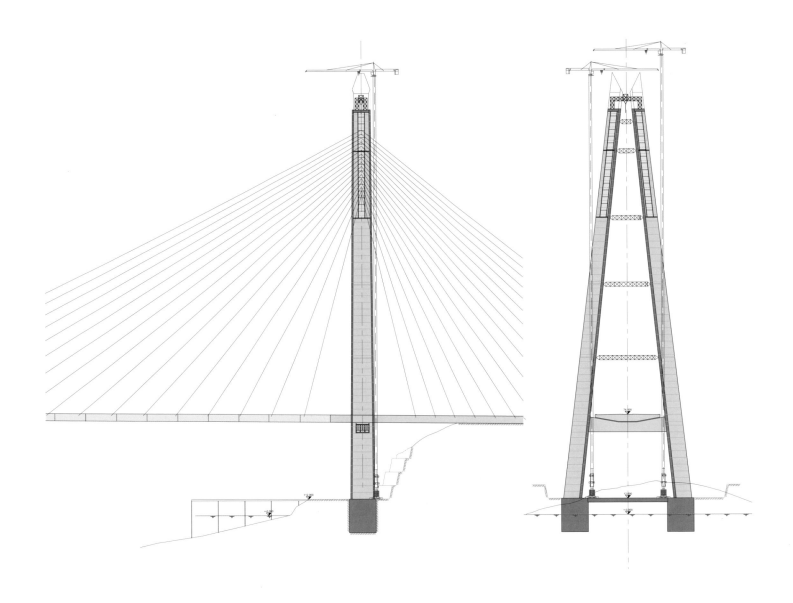

JUN 2015 Installation of catwalk system.

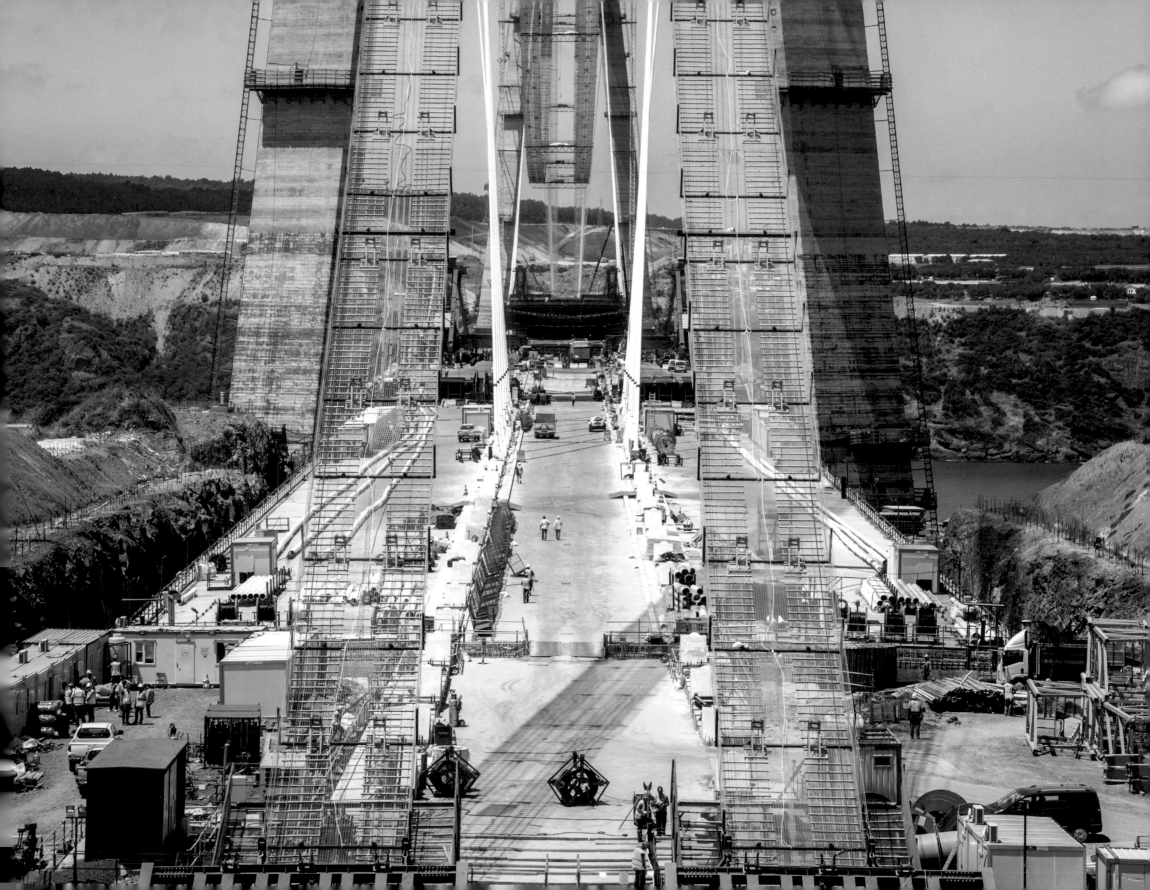

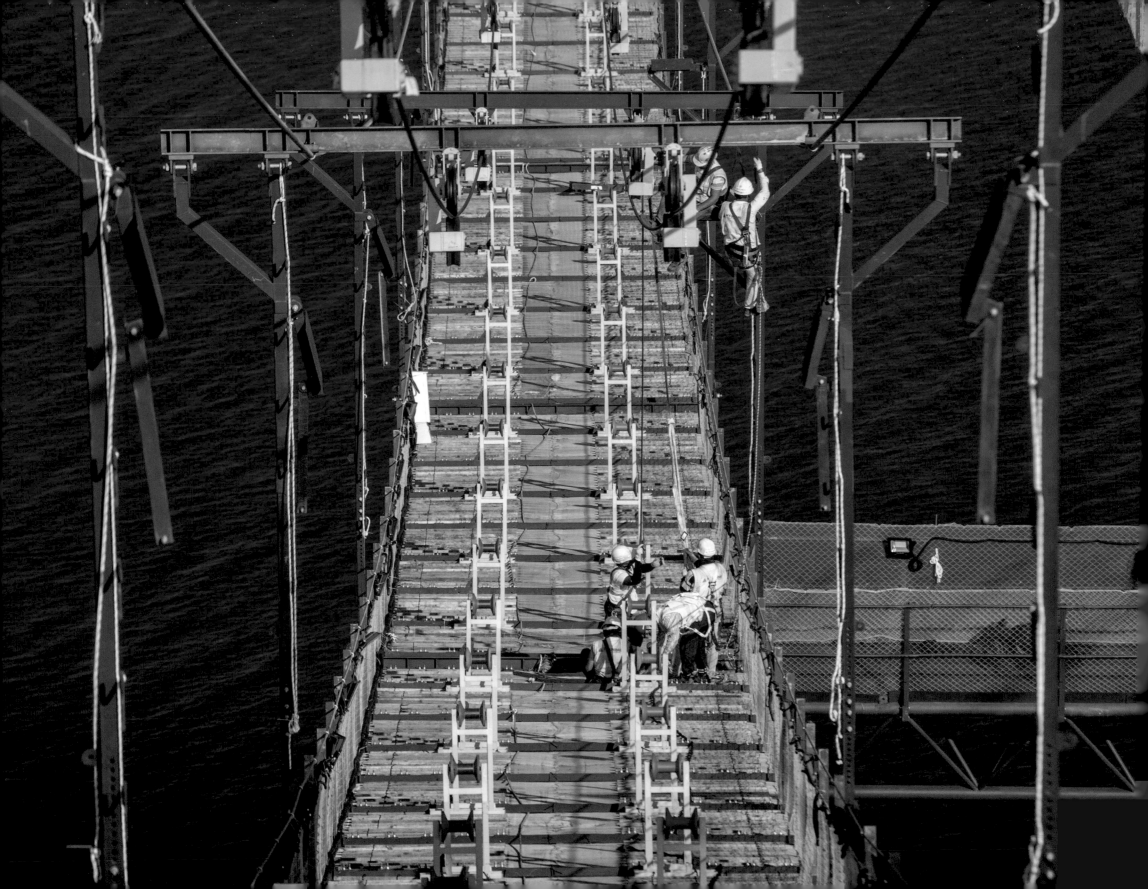

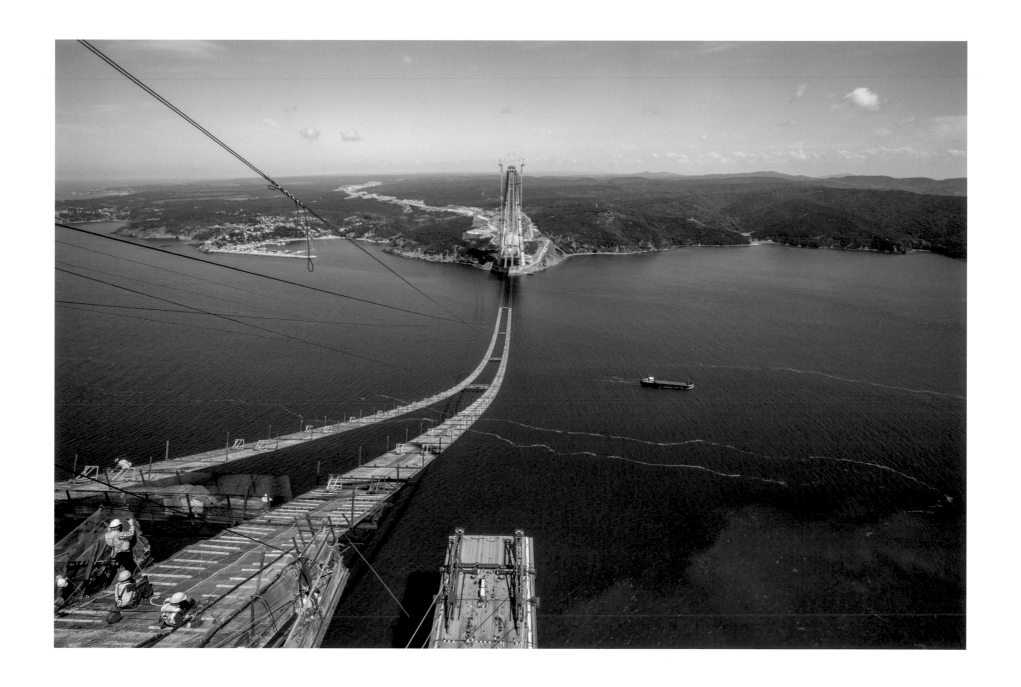

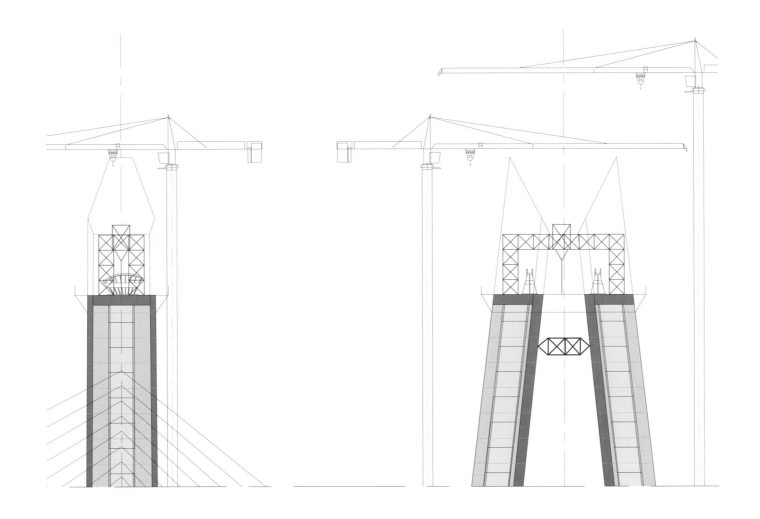

JUL 2015 Installation of tower top saddles. Left, detail of the saddle placement. Saddles were placed from ground to the top of the tower. Right, positioning of saddle on the top of the tower.

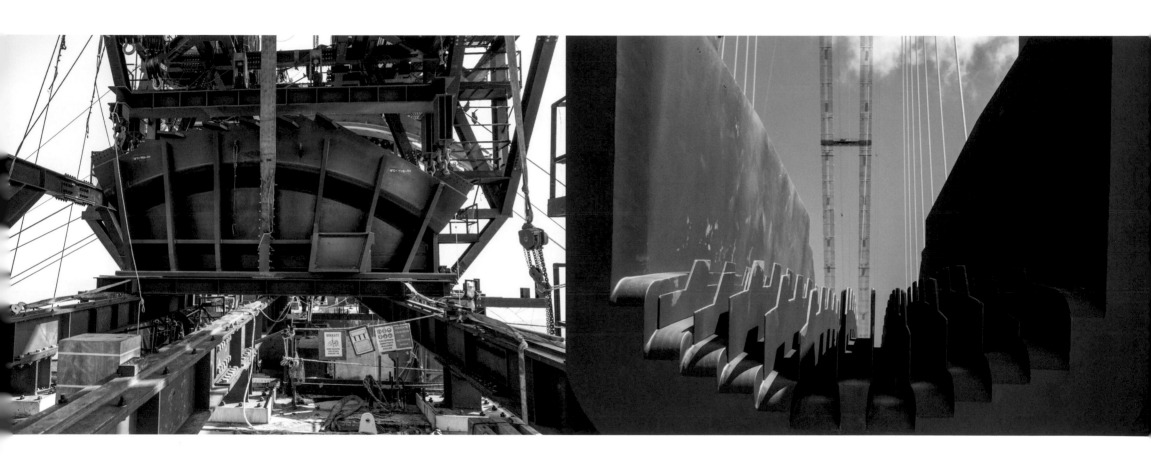

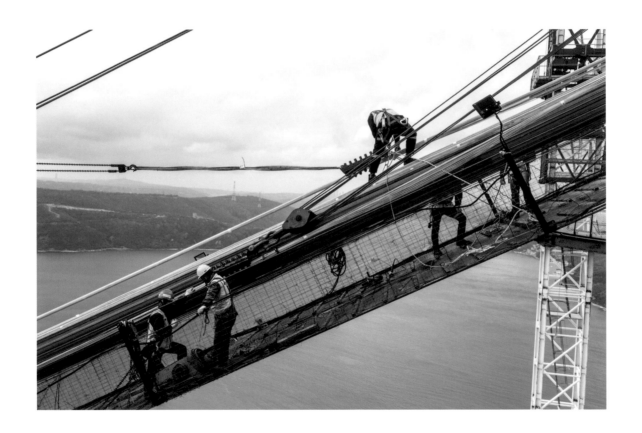

OCT 2015 Remarkable metallic structures were used during the construction phase and for the main cable.

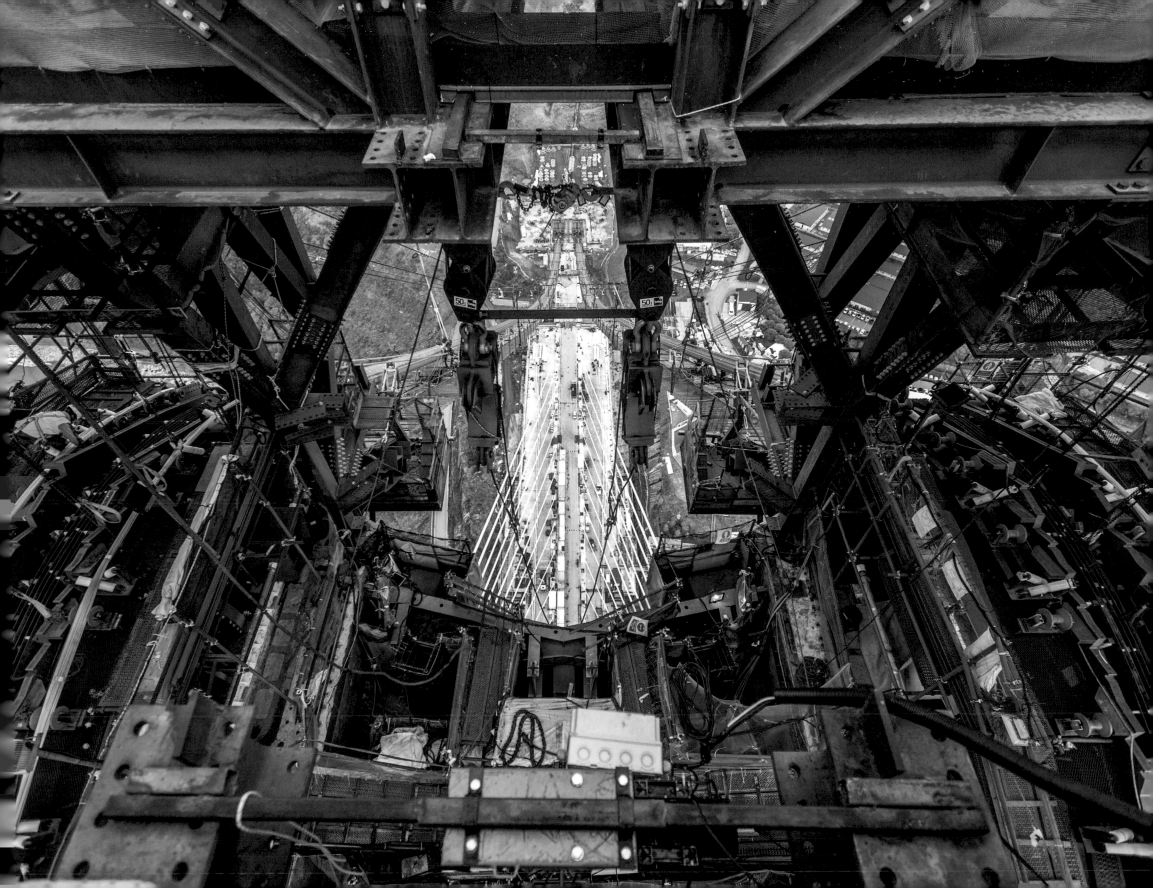

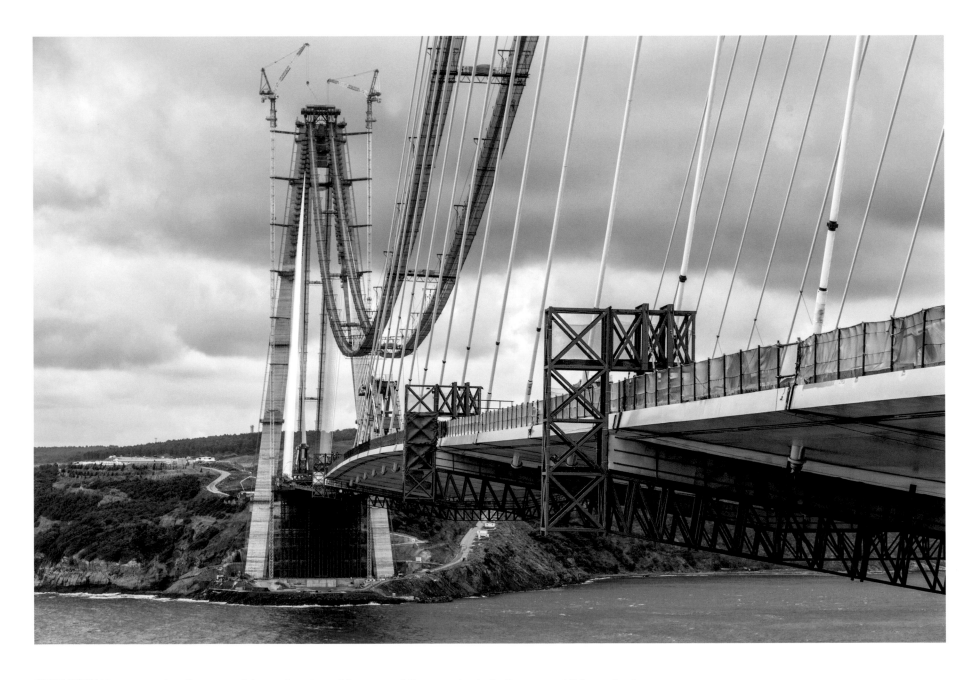

OCT 2015 Erection of stiffening cable and main cable: one of the greatest challenges of this project.

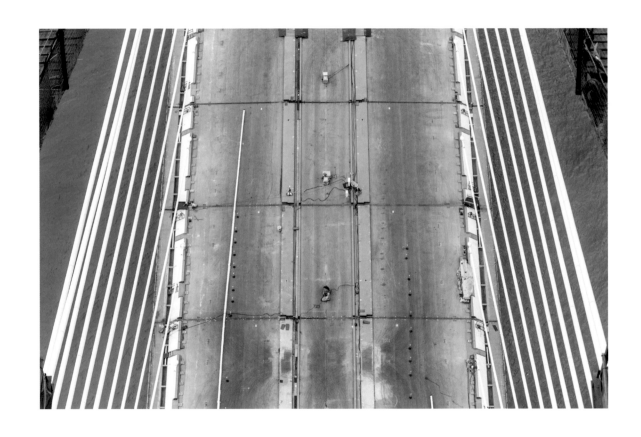

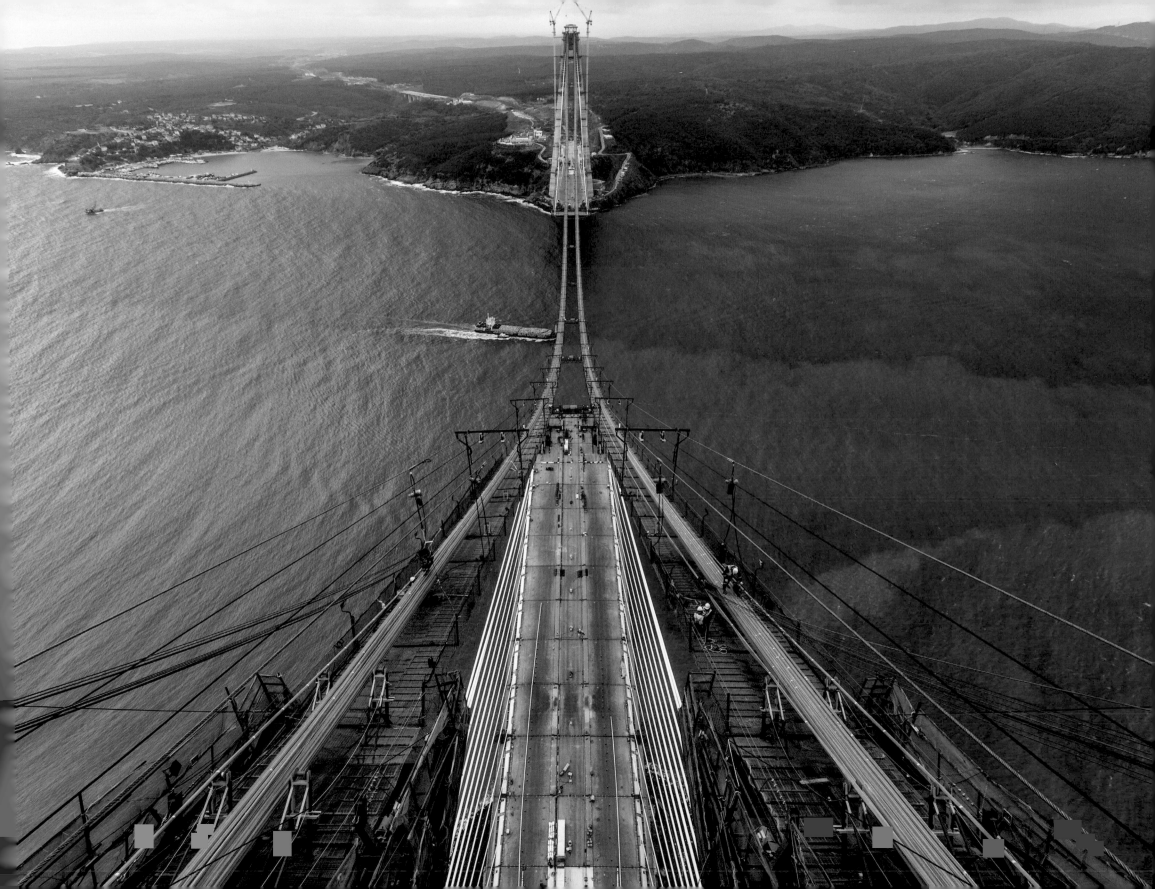

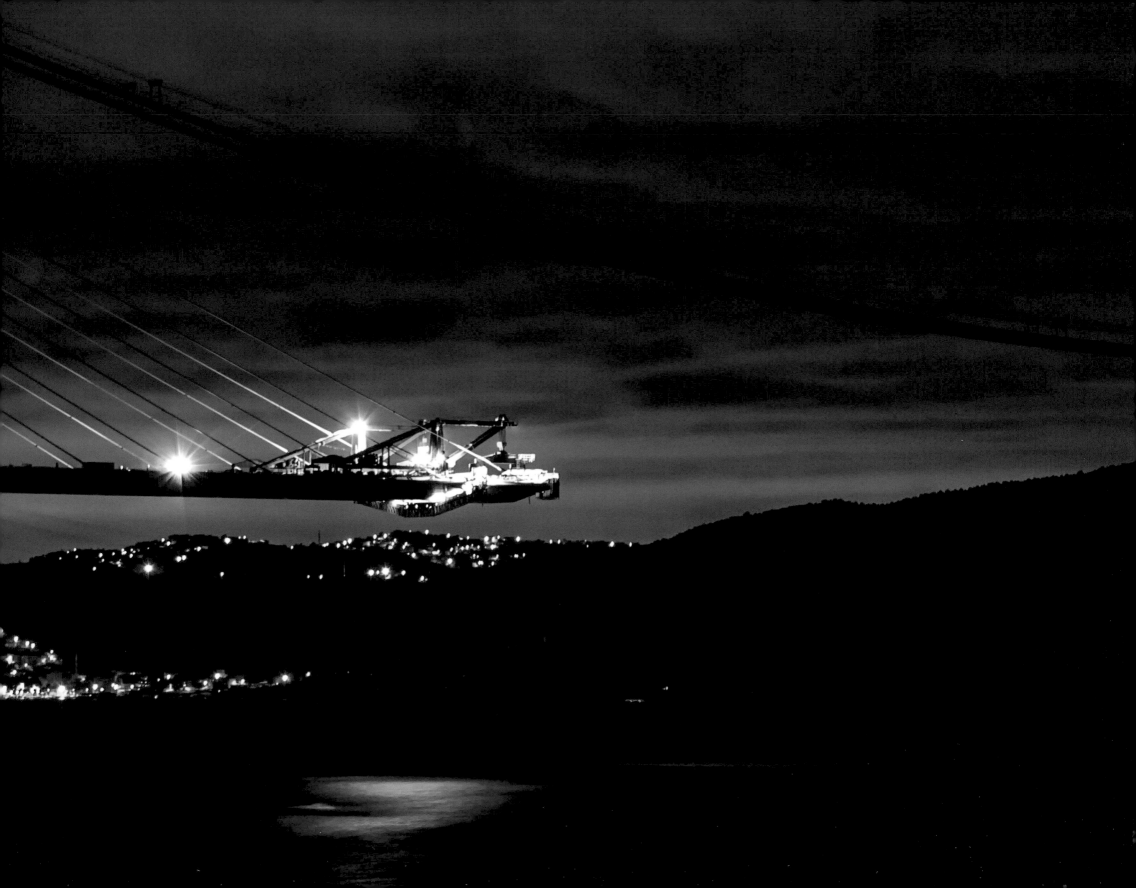

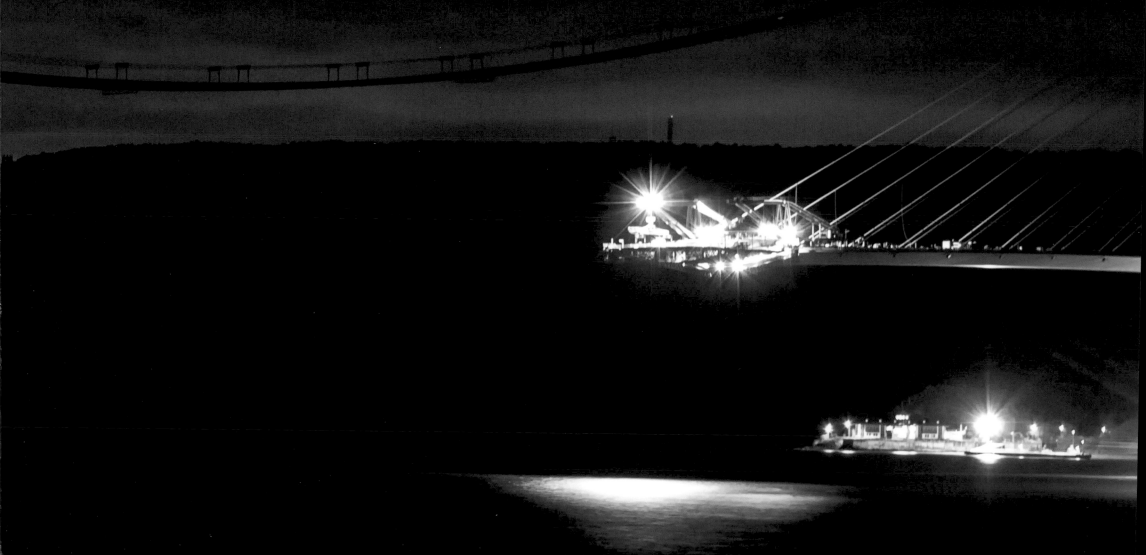

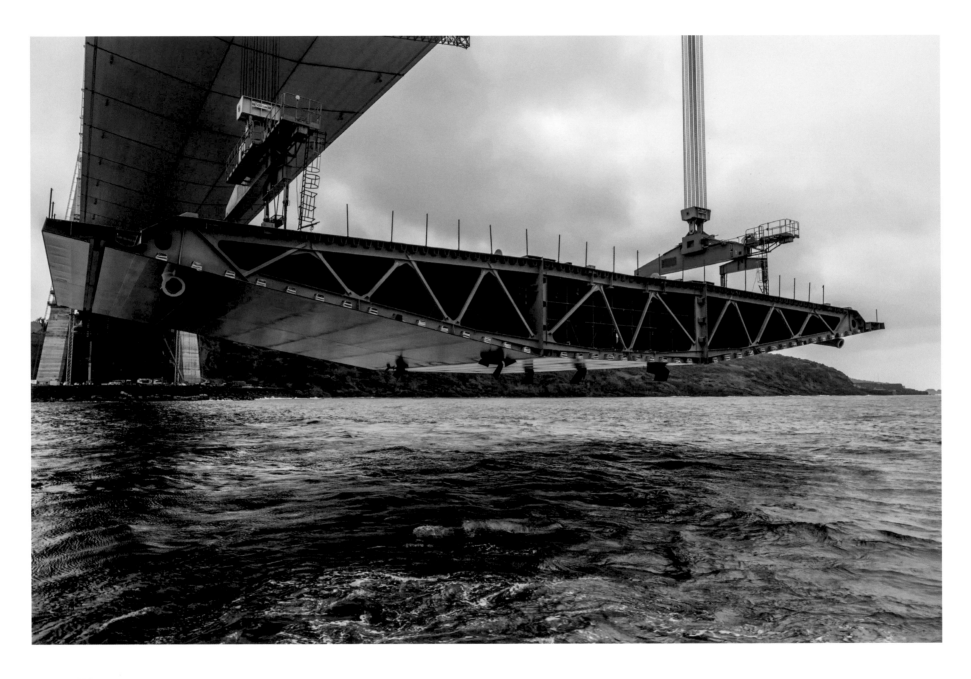

OCT 2015 The steel decks of the stiffened and transition sections were lifted by derrick cranes.

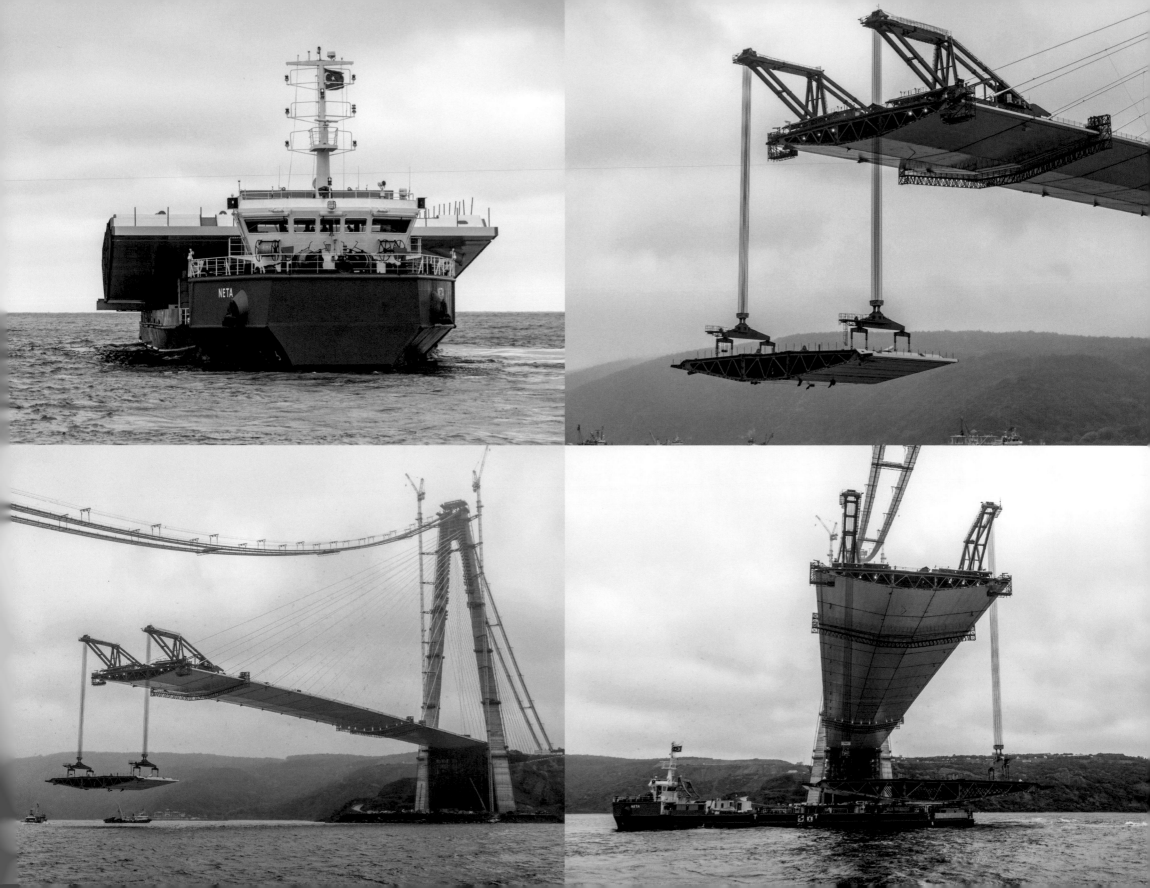

CONSTRUCTION AND INSTALLATION OF THE MAIN CABLE DETERMINED
A COMPLEX SYSTEM REQUIRING SPECIFIC MACHINERY
AND TEMPORARY STRUCTURES.

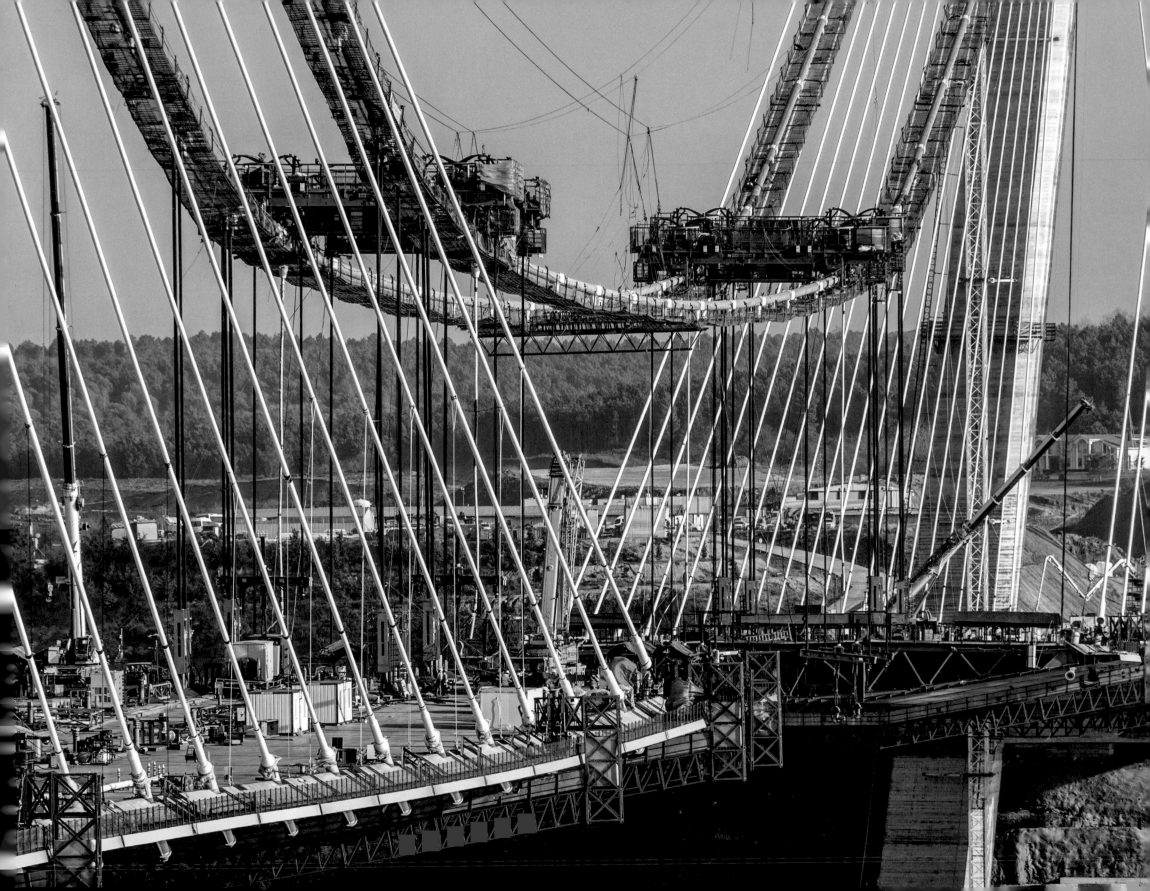

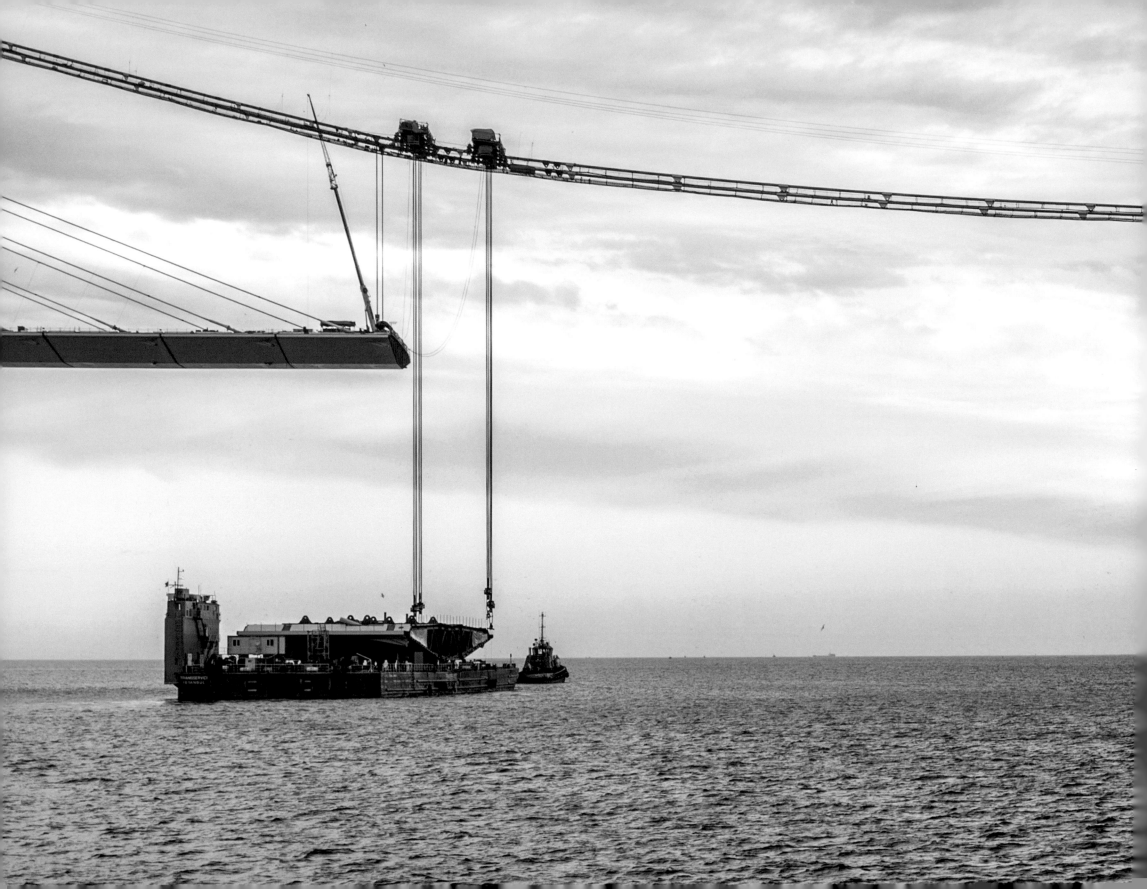

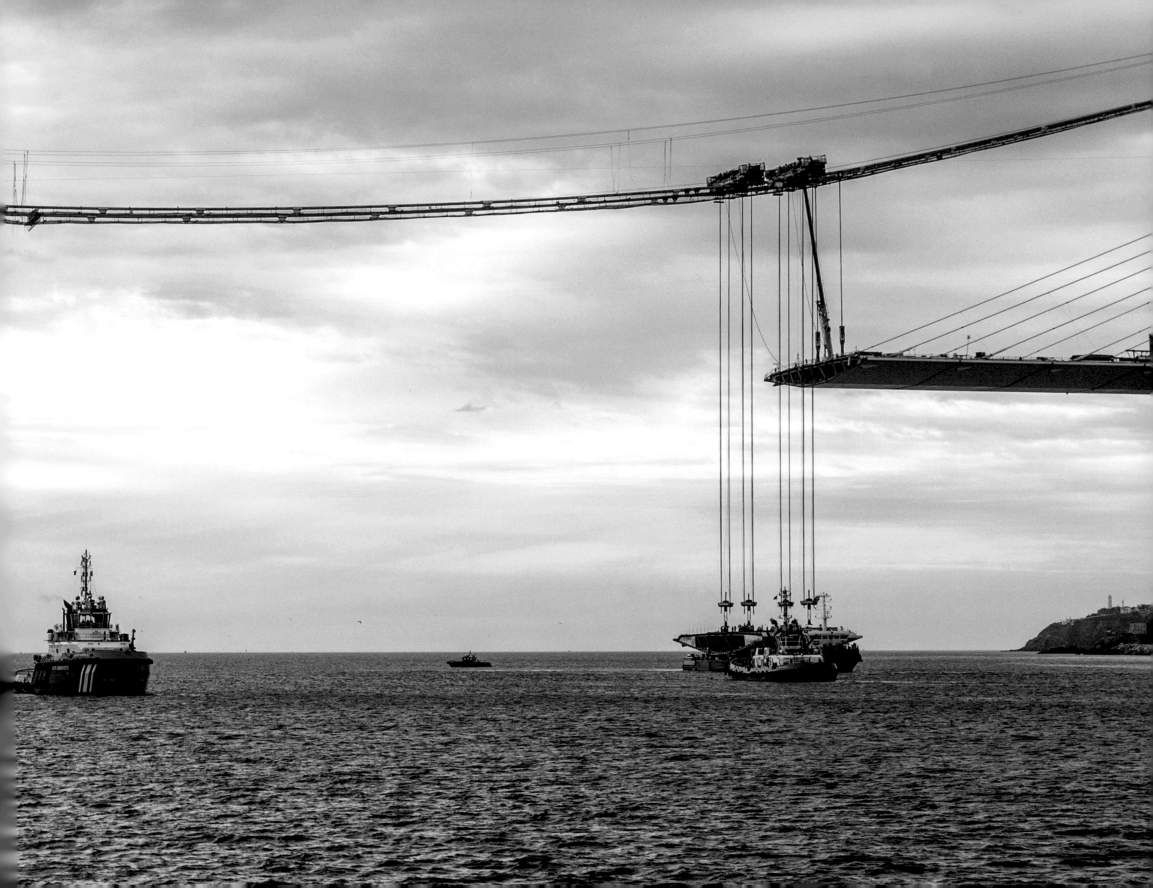

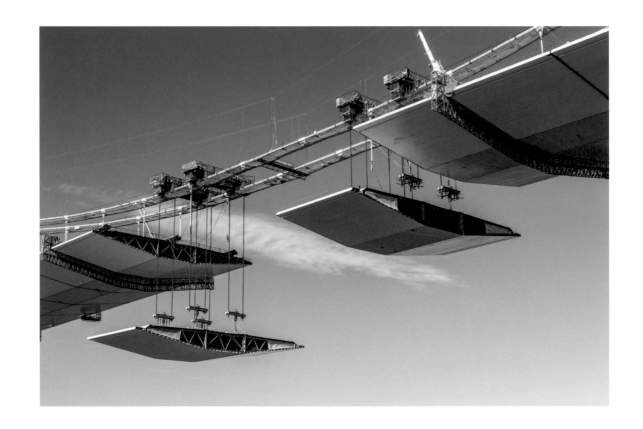

FEB 2016 Simultaneous lifting due to the complicated behaviour of the main cable.

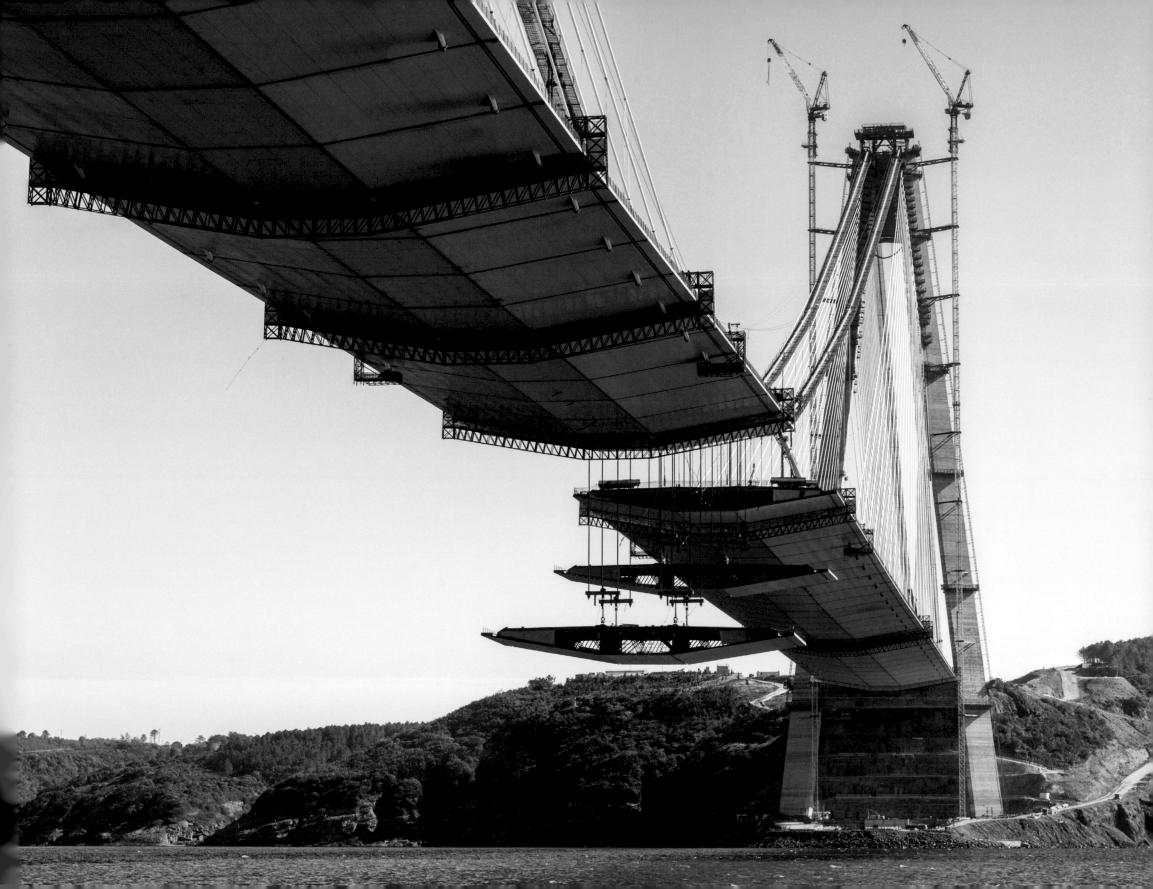

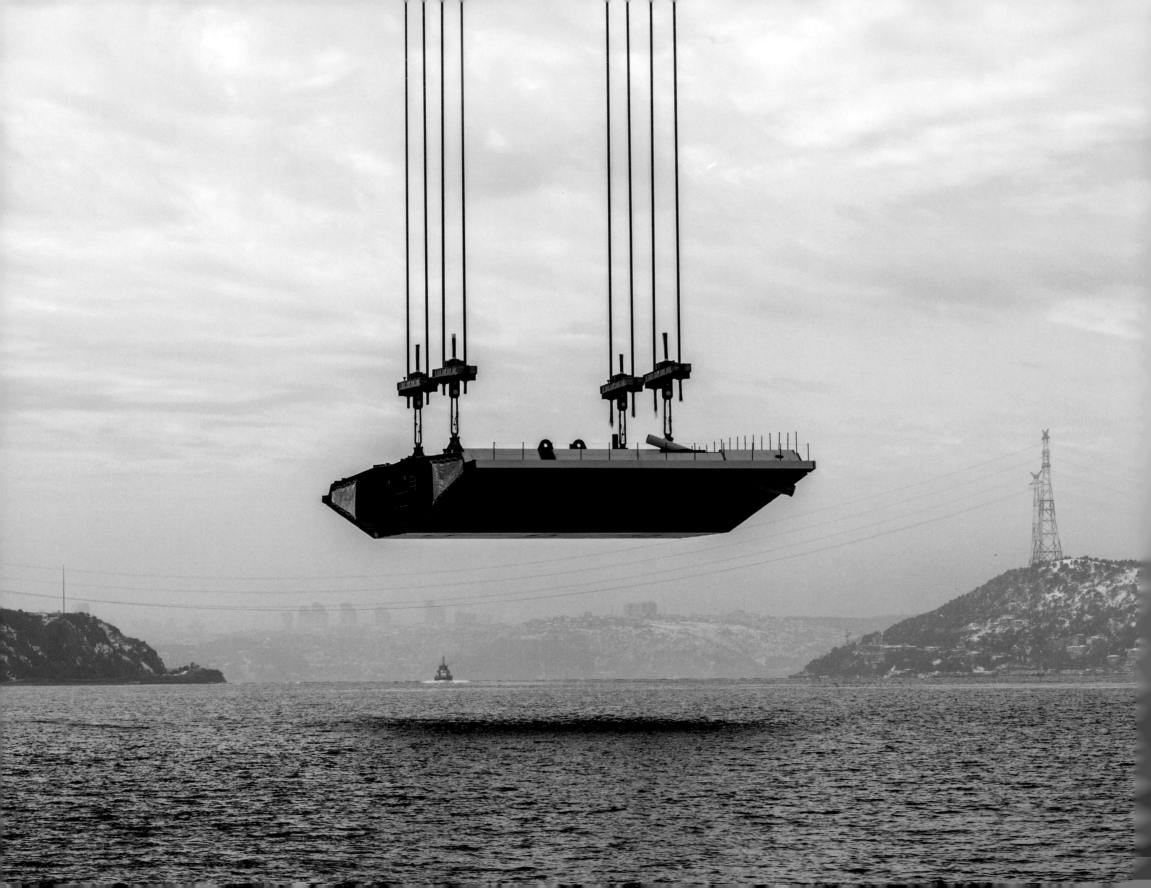

THE STEEL DECK CONSISTS OF 59 PREFABRICATED SEGMENTS;
ALL APART FROM FIVE HAVE AN OVERALL DIMENSION OF
5.50 × 24 × 58.50 METRES.

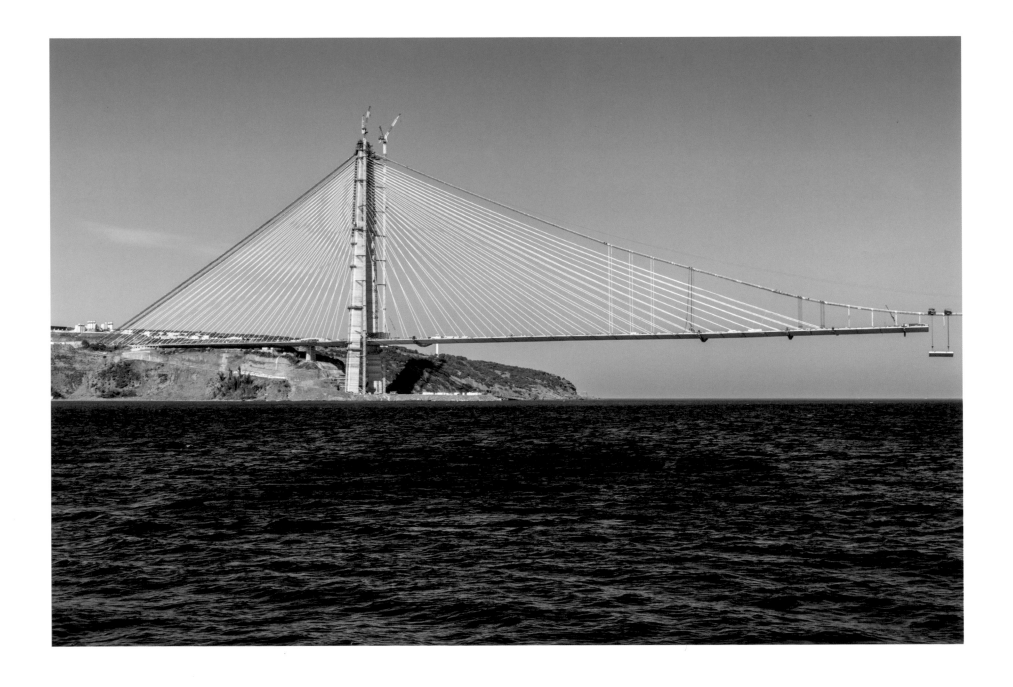

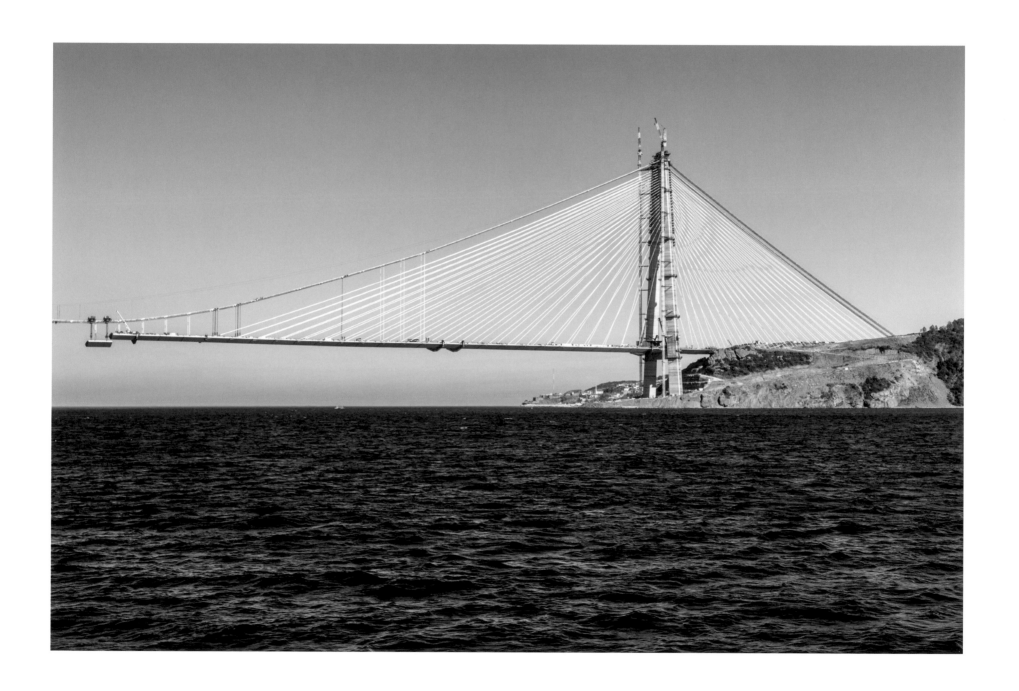

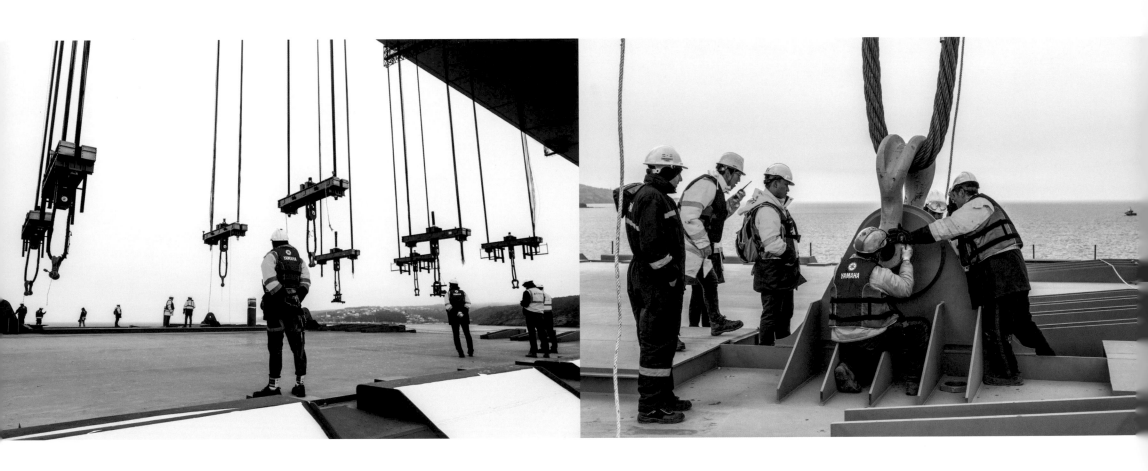

FEB 2016 Lifting the deck: the last segment.

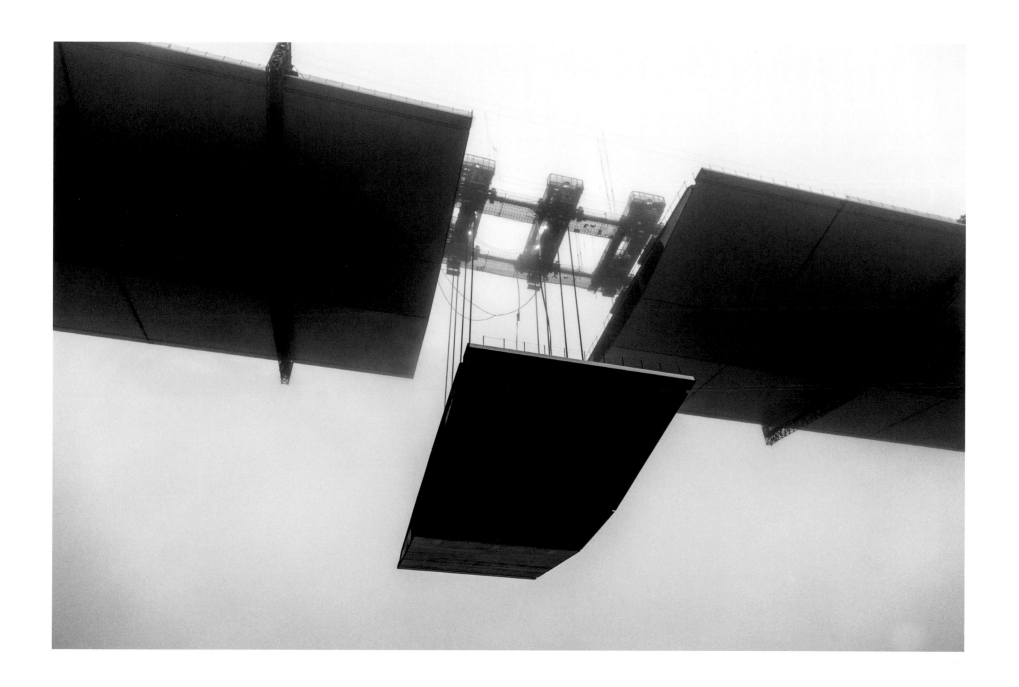

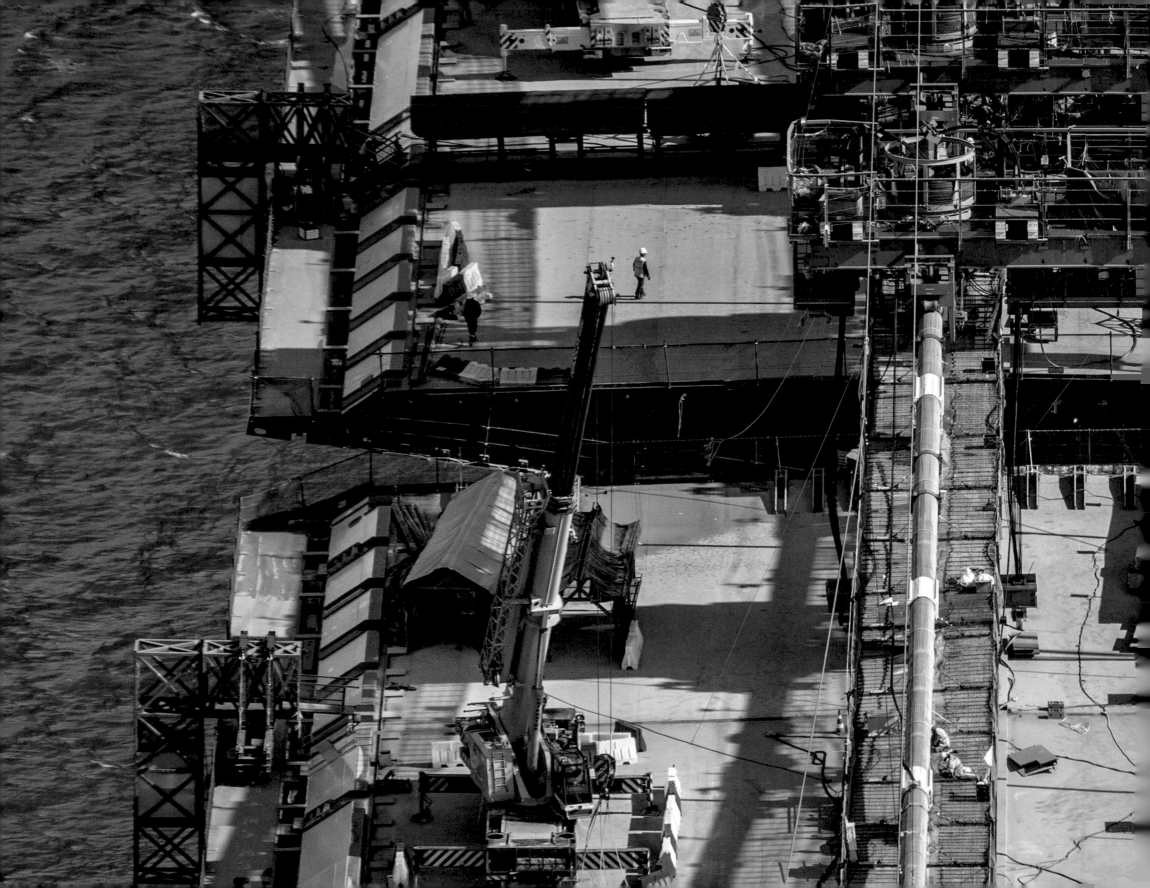

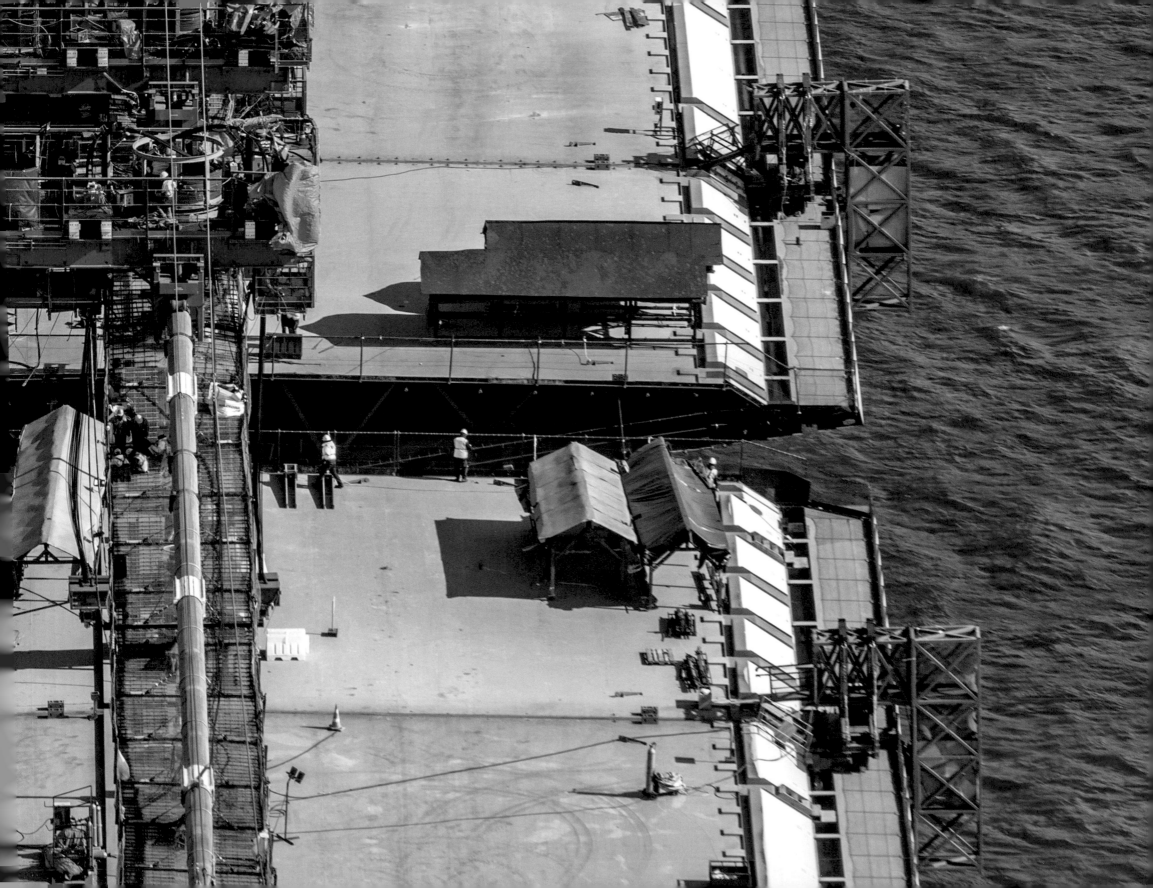

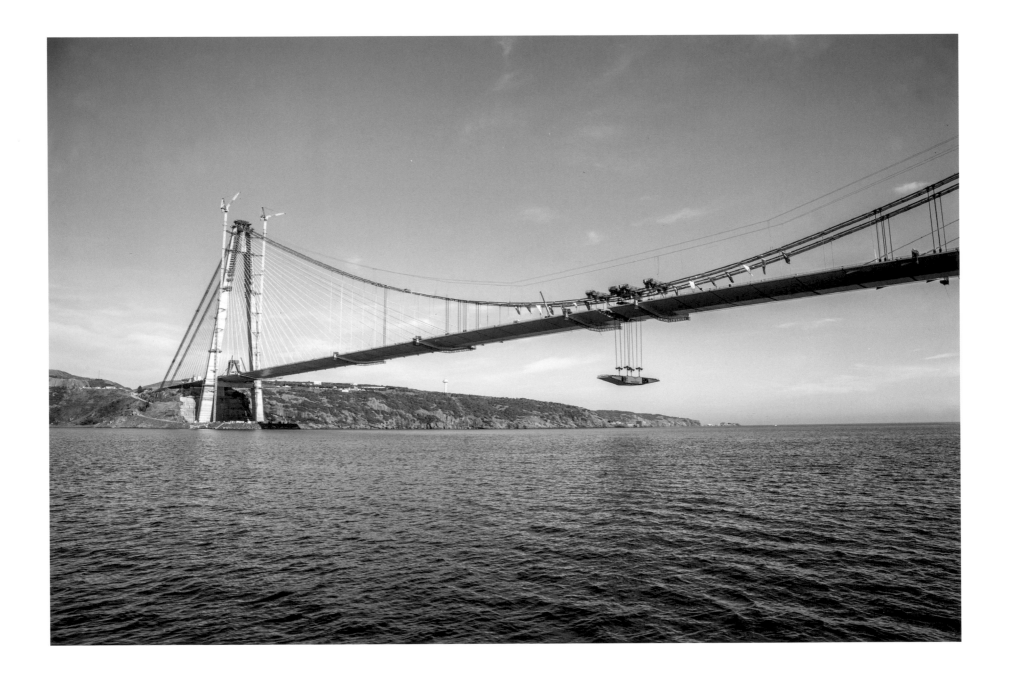

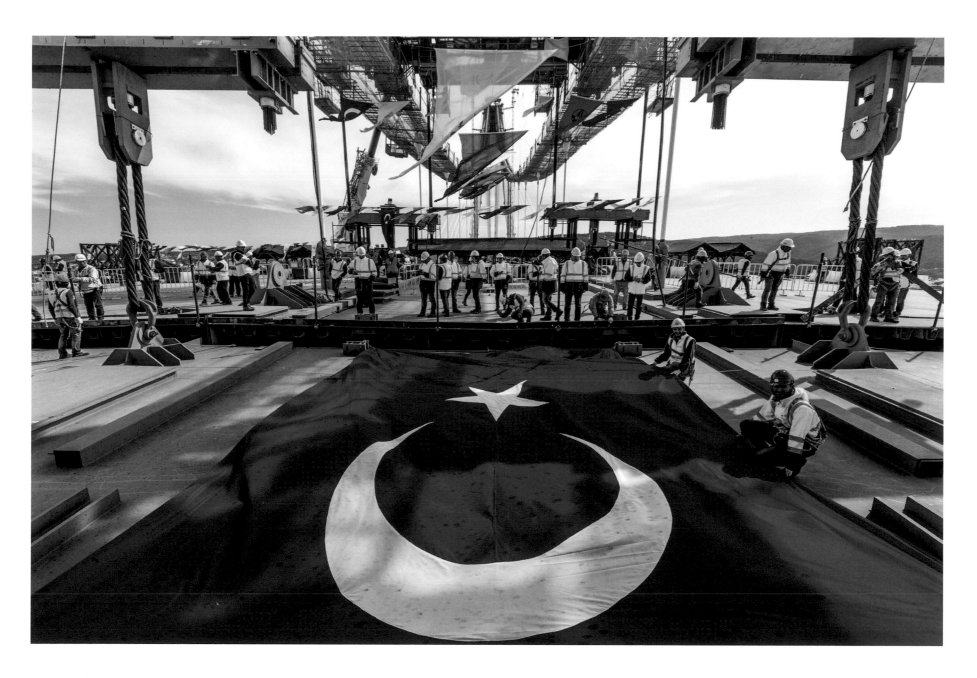

MAR 2016 Lifting of final deck section and completion of deck erection.

WITH A 1,408-METRE MAIN SPAN, IT IS THE WORLD'S LONGEST BRIDGE
WITH AN INTEGRATED RAILWAY SYSTEM.
AT 322 METRES, IT IS ALSO THE WORLD'S HIGHEST
TOWER SUSPENSION BRIDGE.

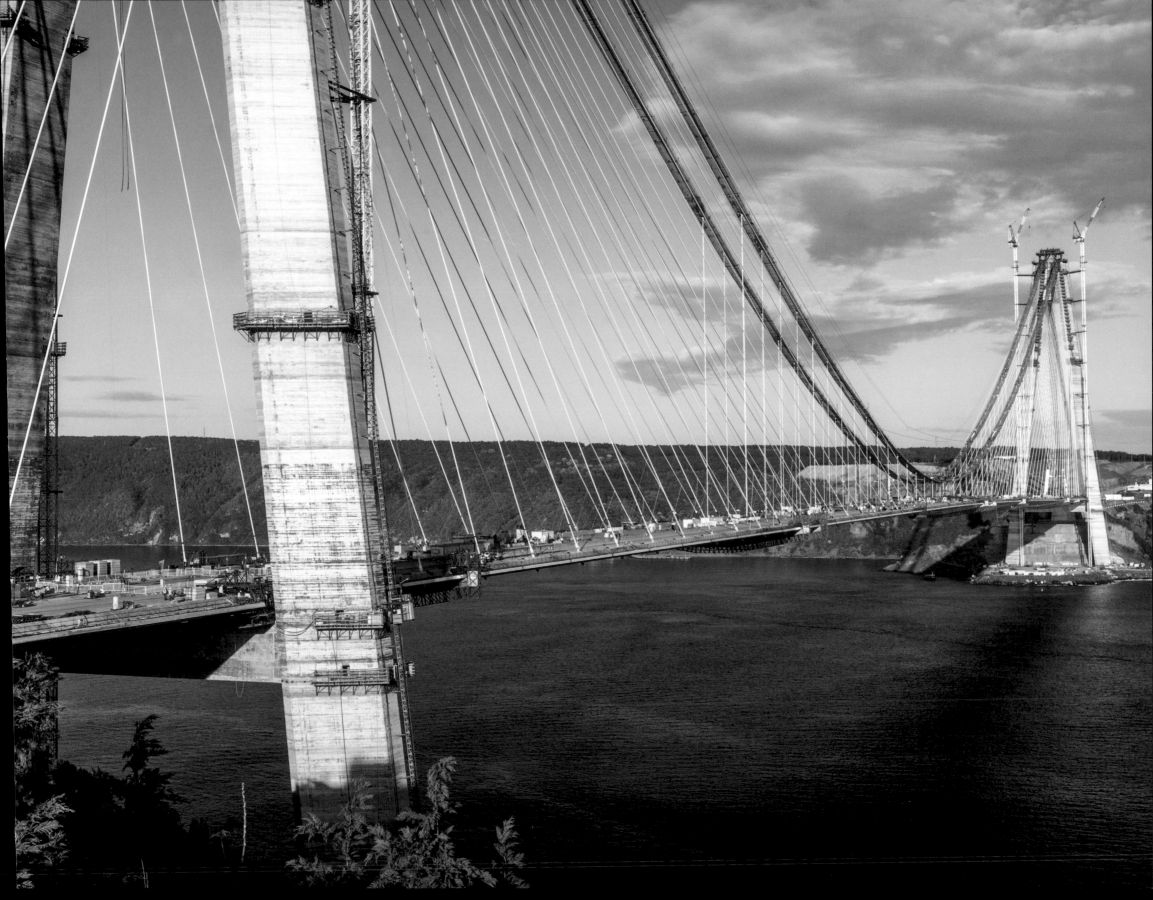

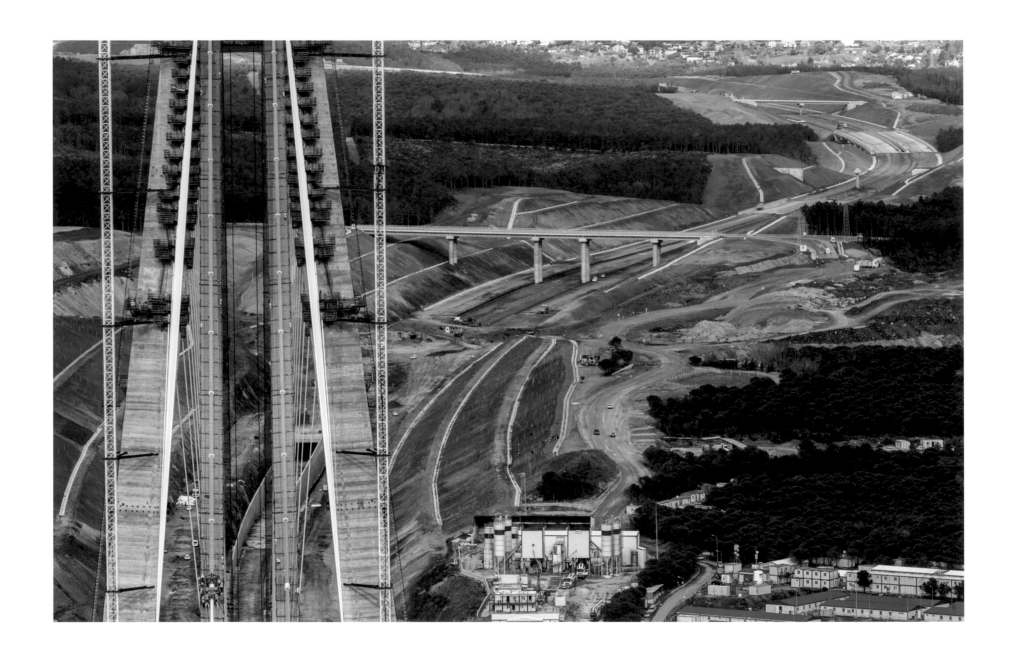

MAR 2016 A new landscape: the bridge, the motorway, and the natural environment.

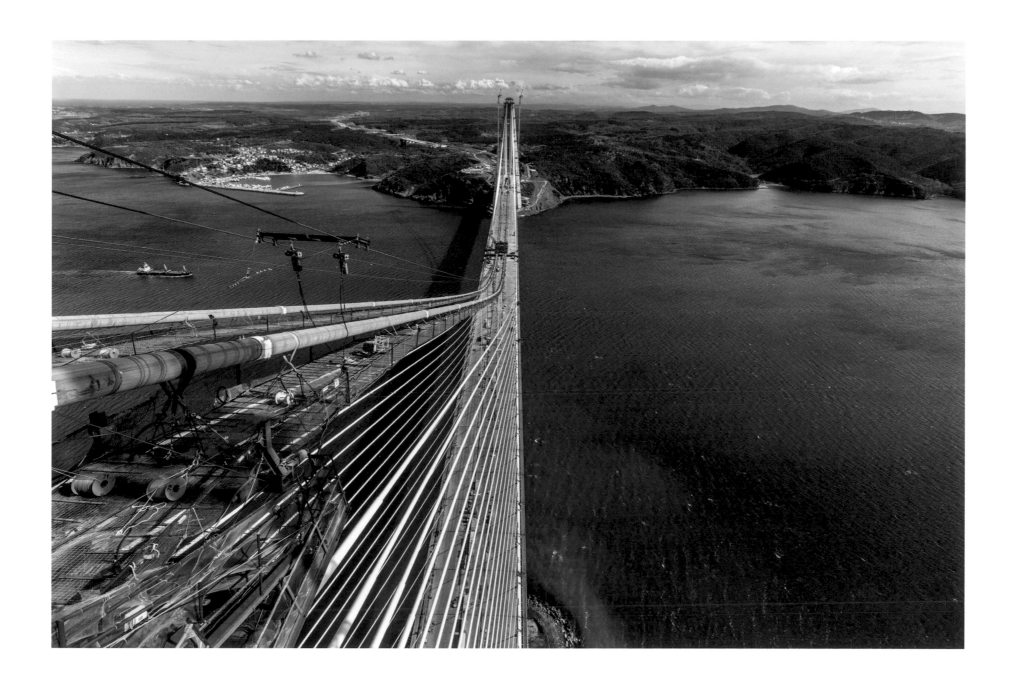

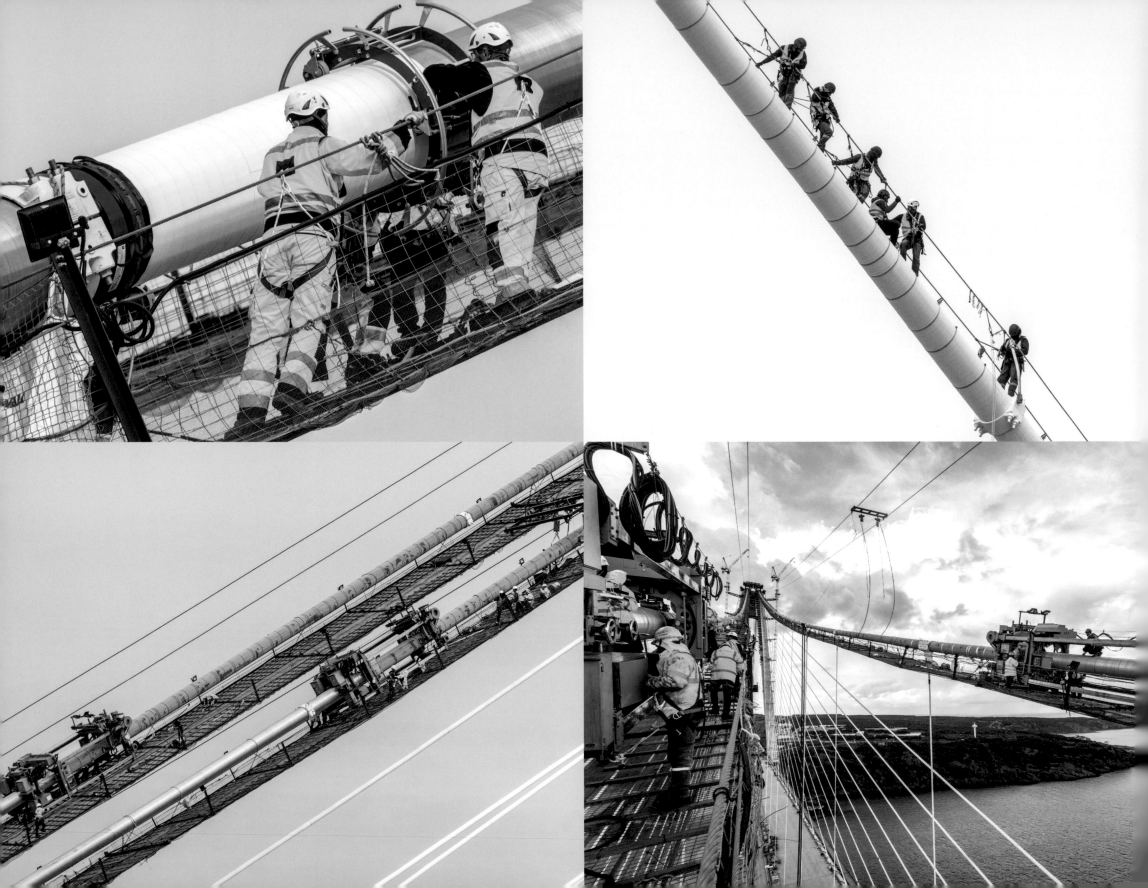

COMPACTING AND WATERPROOFING WORKS ON THE MAIN CABLE,
MADE UP OF 113 PRE-FABRICATED PARALLEL WIRE STRANDS,
WITH NINE ADDITIONAL EXTRA STRANDS IN THE SIDE SPANS,
AND WEIGHING ALMOST 13,000 TONNES IN TOTAL.

LAST OPERATIONS BEFORE THE OPENING:
GETTING READY FOR TRUCKS TO CROSS.
THE BRIDGE IS THE FIRST TO FEATURE EIGHT MOTORWAY LANES
AND TWO RAILWAY LANES ON THE SAME LEVEL.

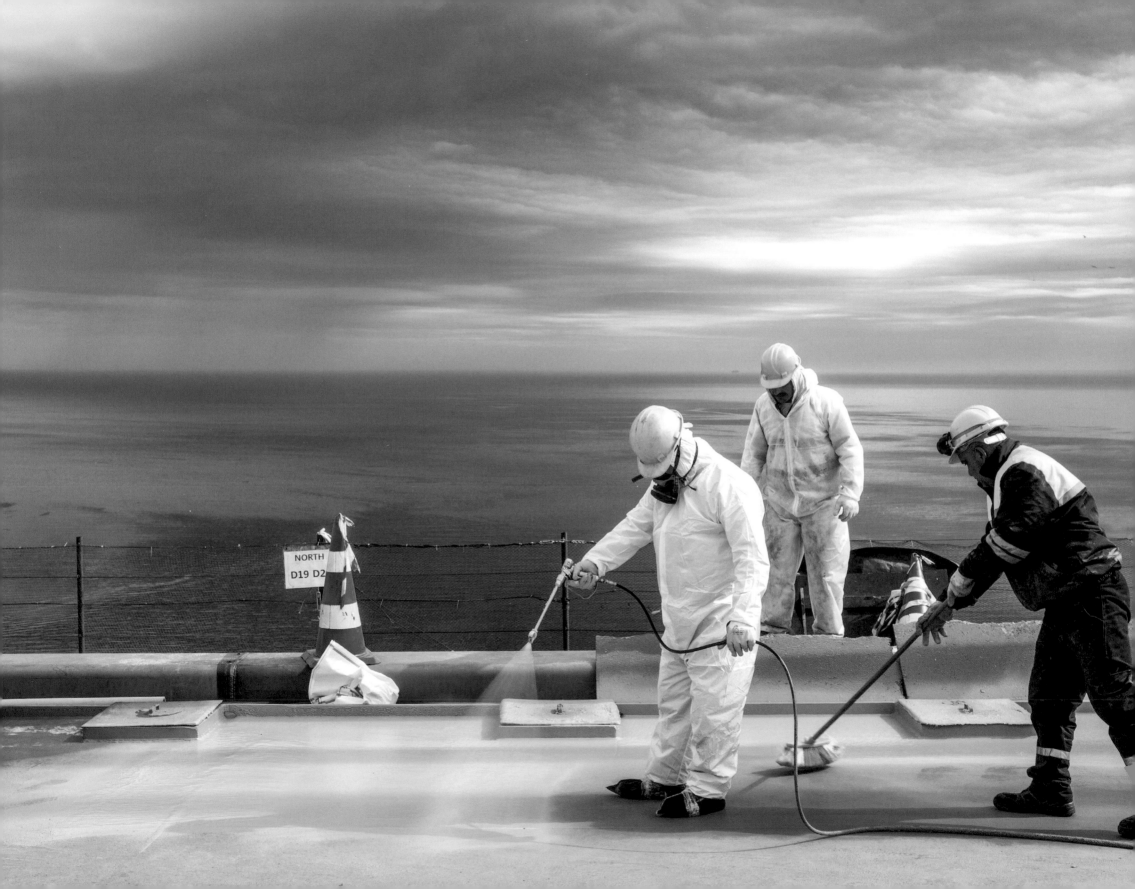

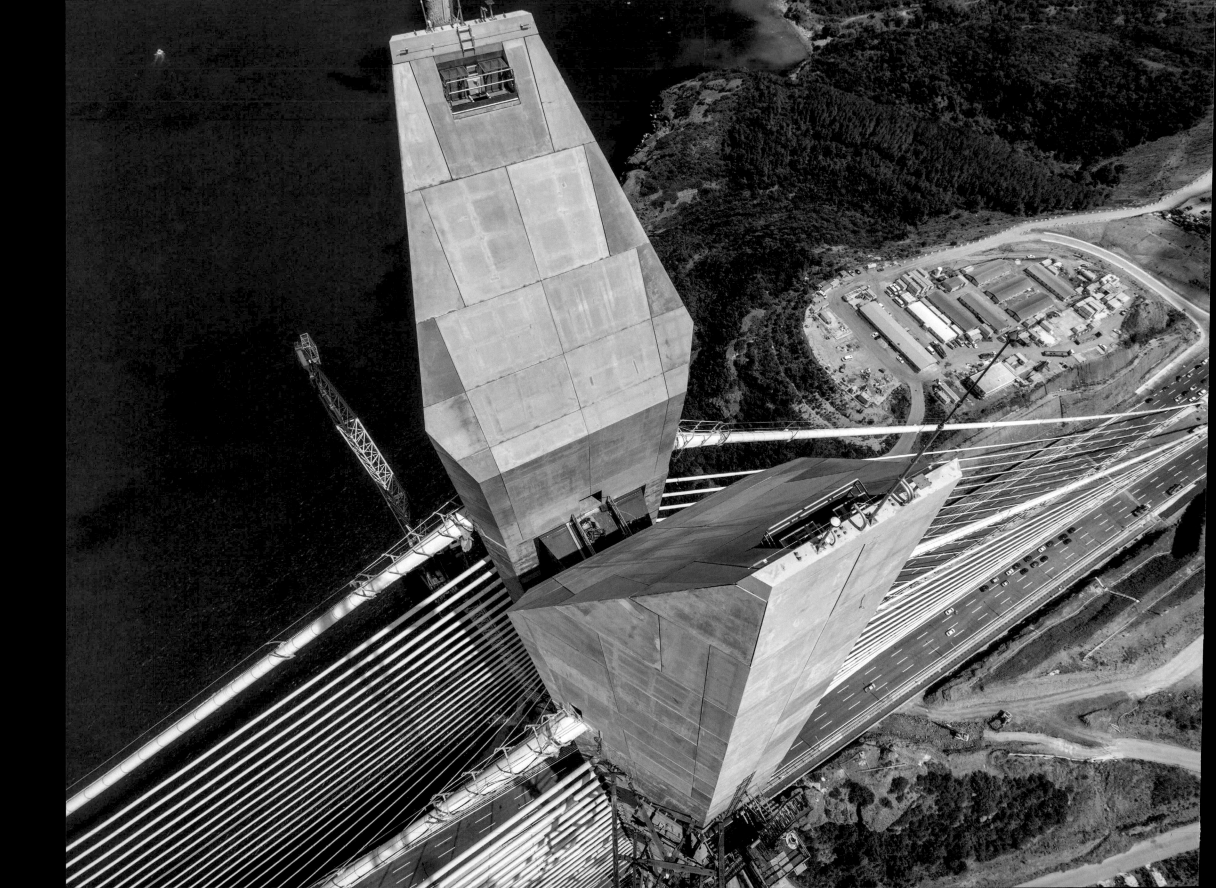

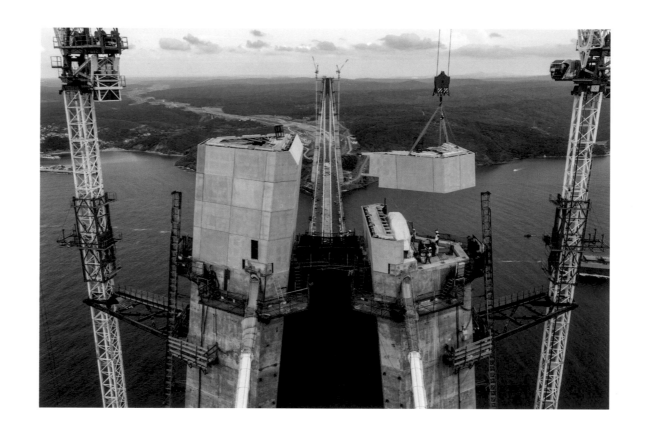

JUL 2016 Pylons and their sculptural tops converge to achieve a world record.

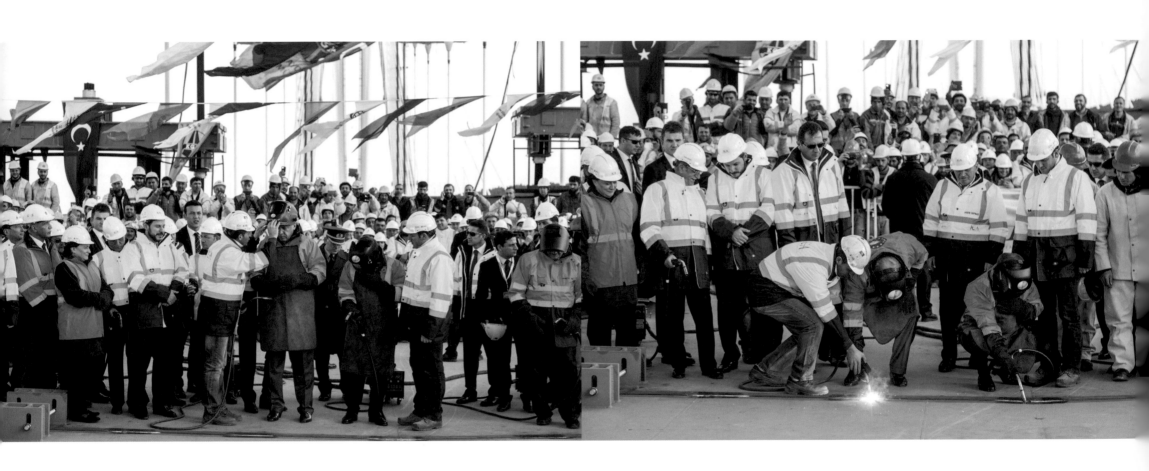

From left to right: installing the final deck segment, 6 March 2016; the groundbreaking ceremony, 29 May 2013; the opening ceremony, 26 August 2016.

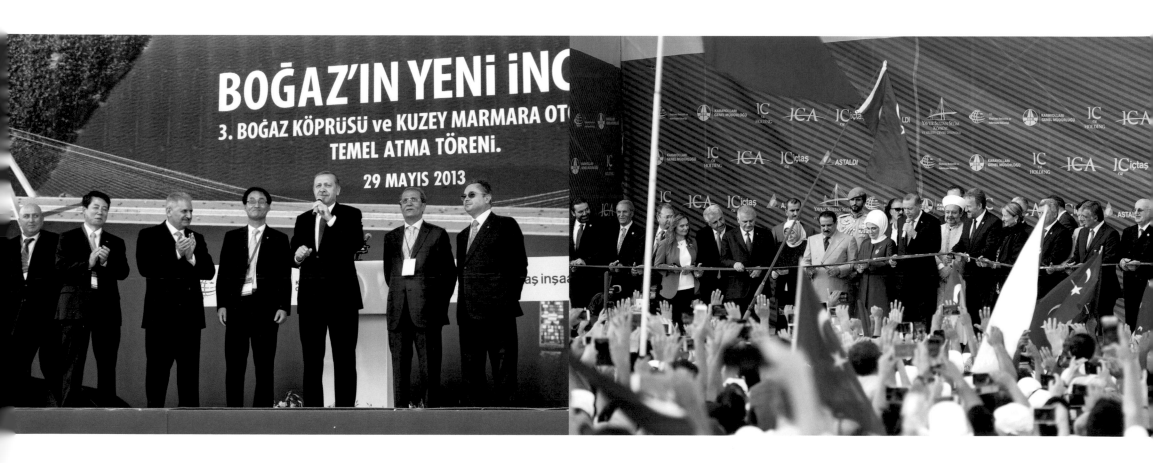

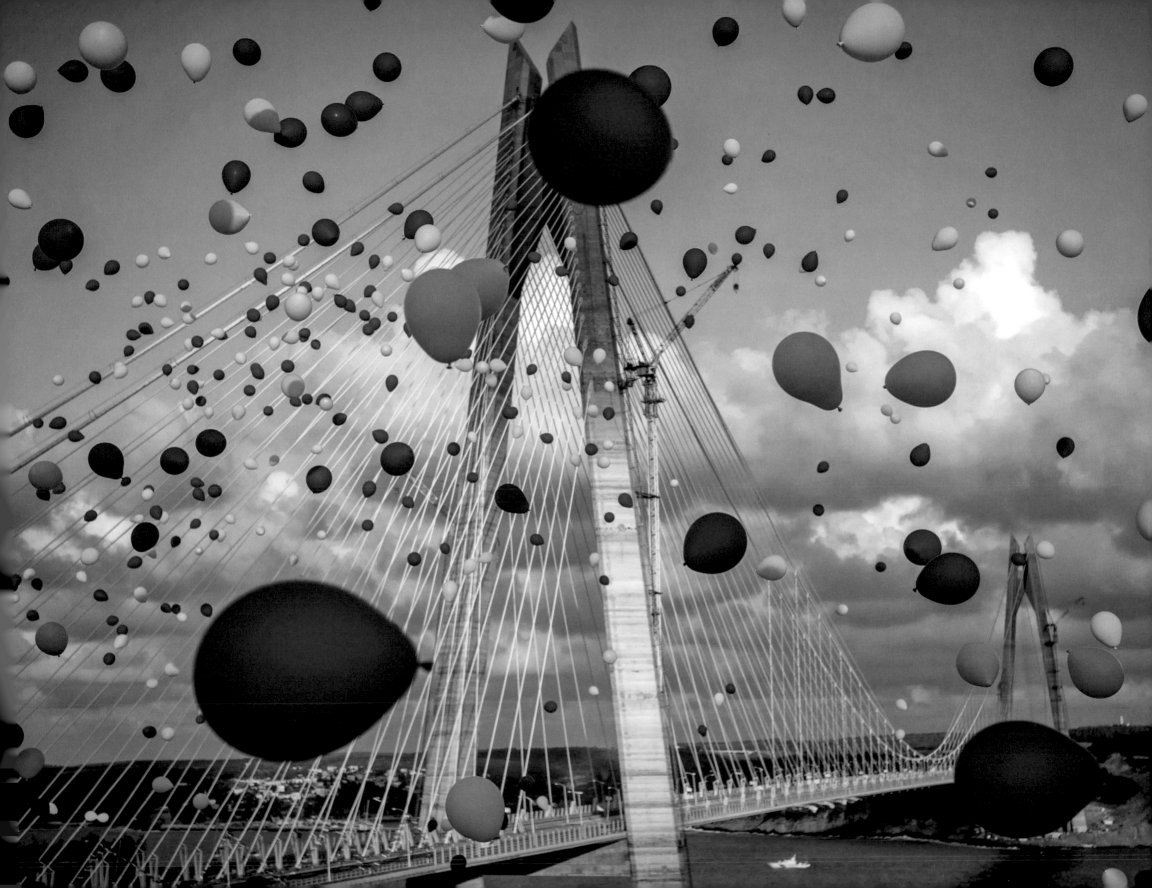

LANDMARK

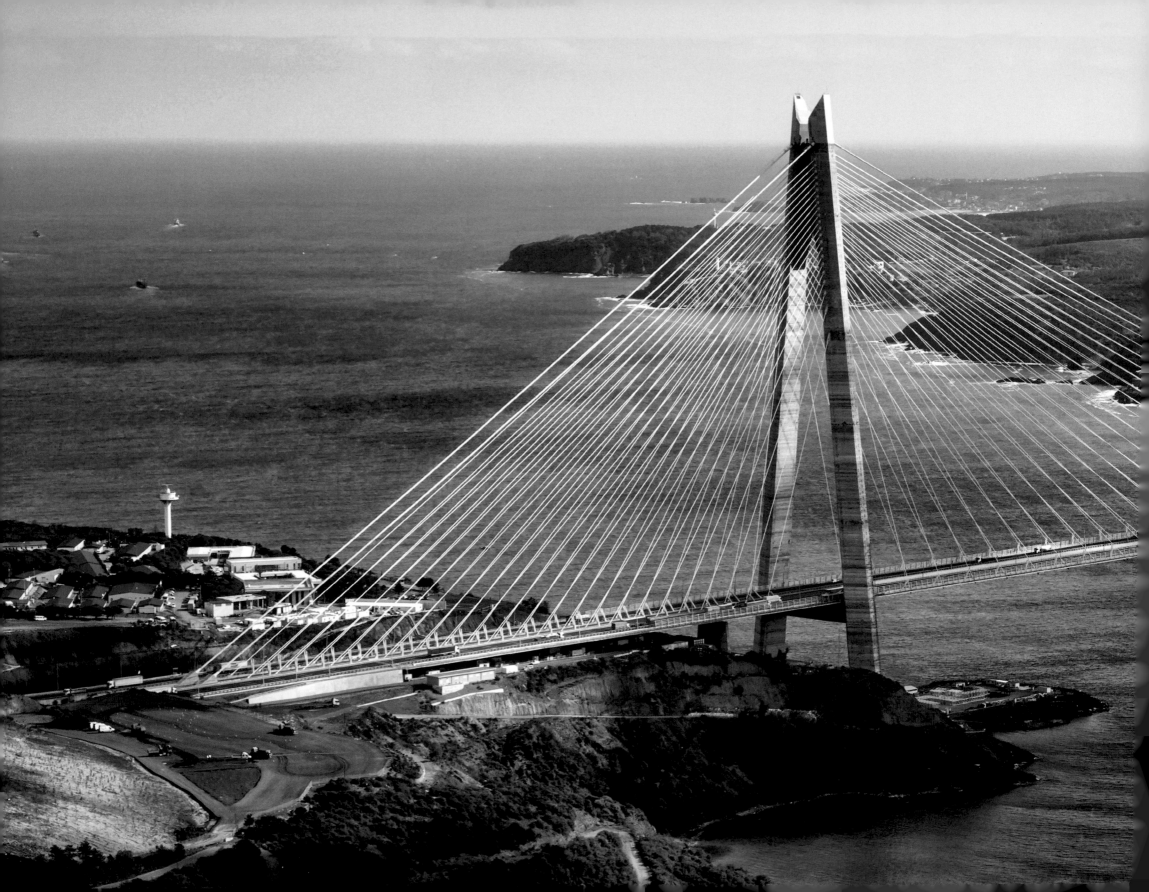

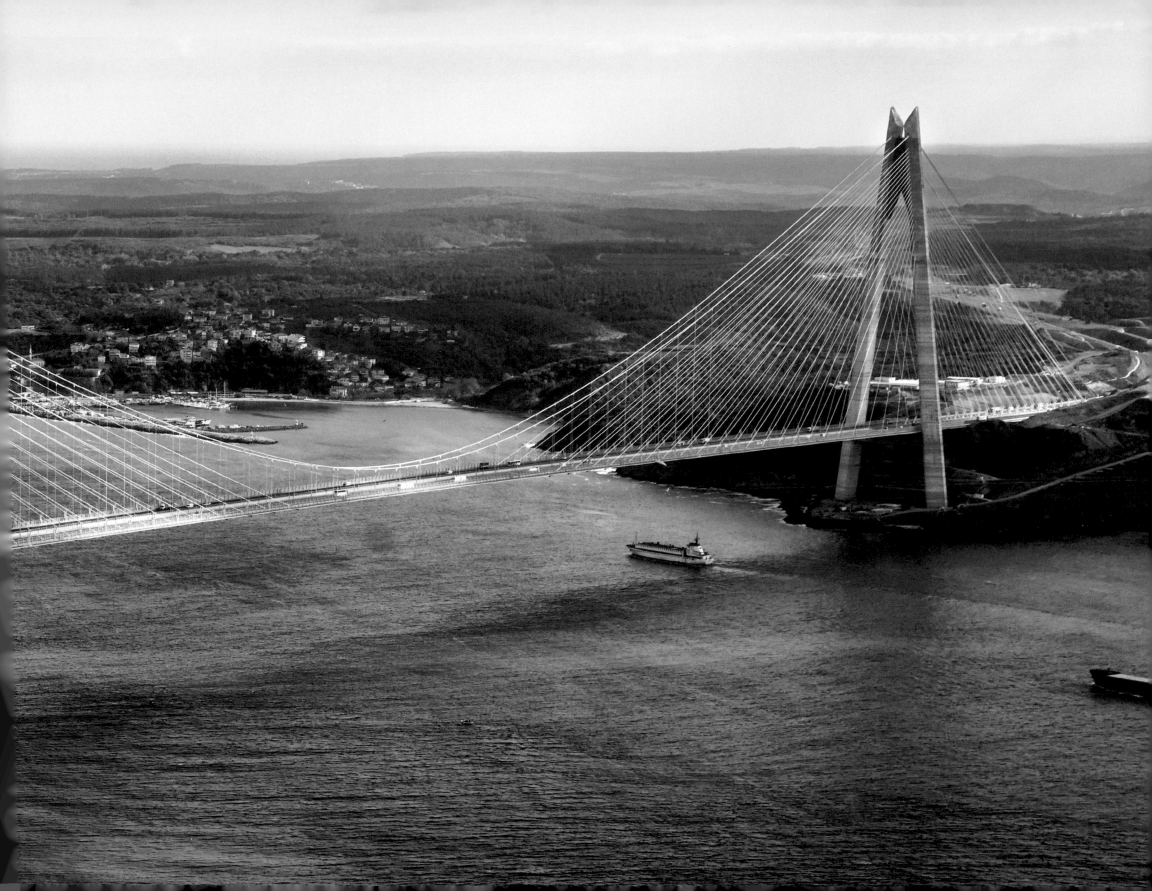

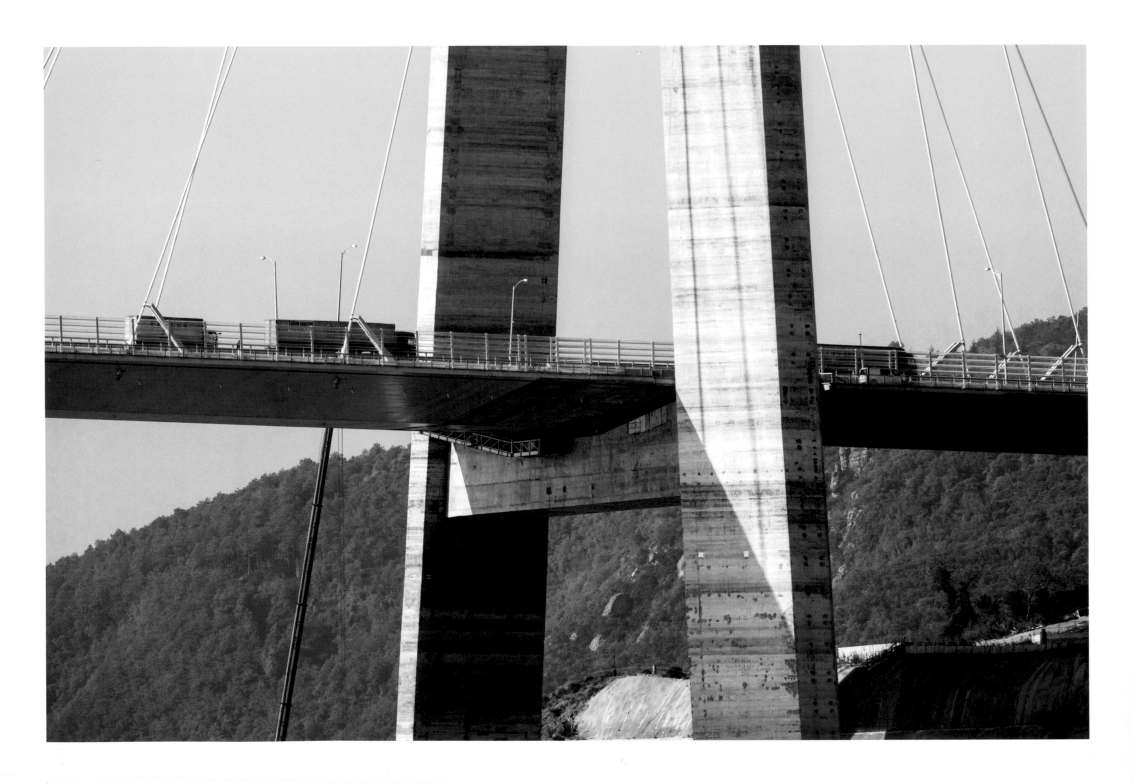

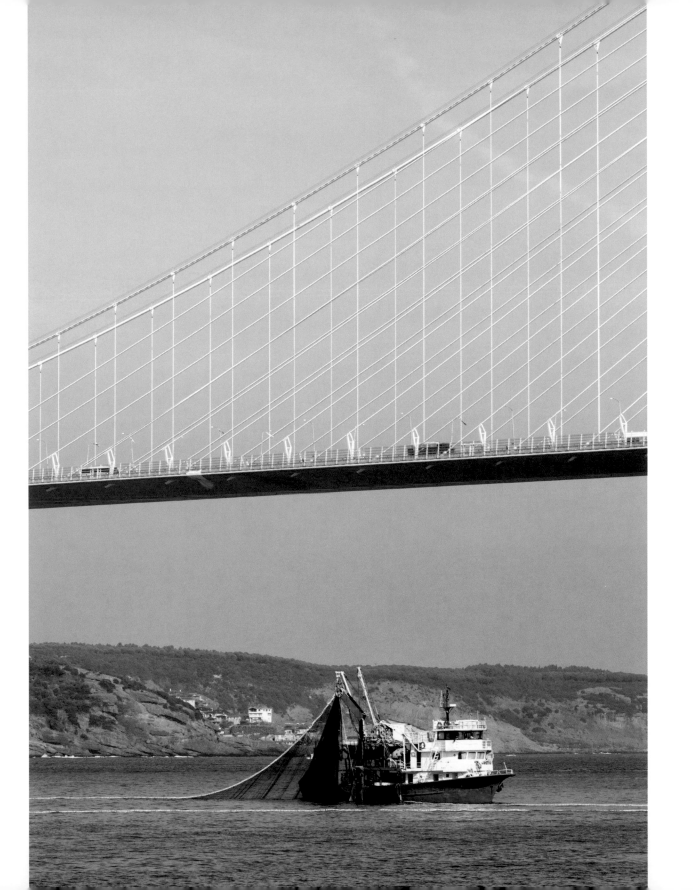

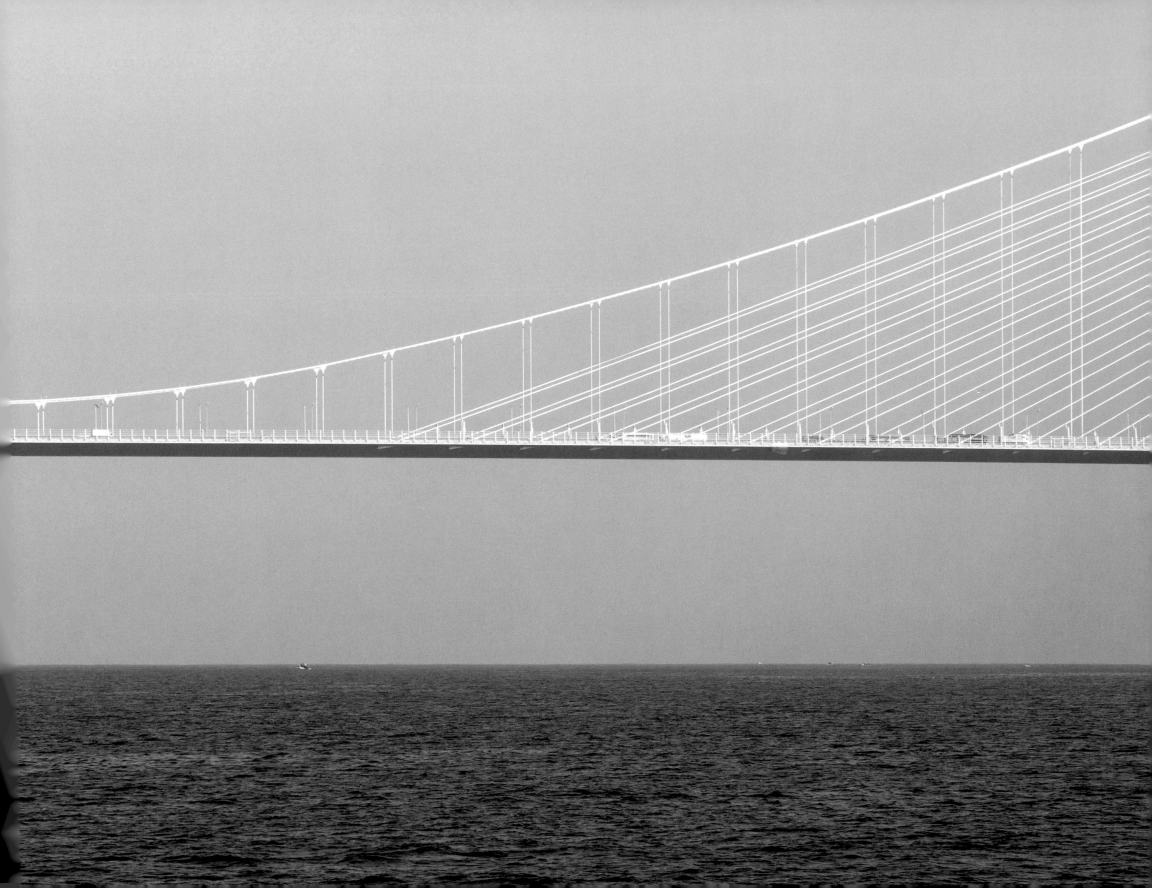

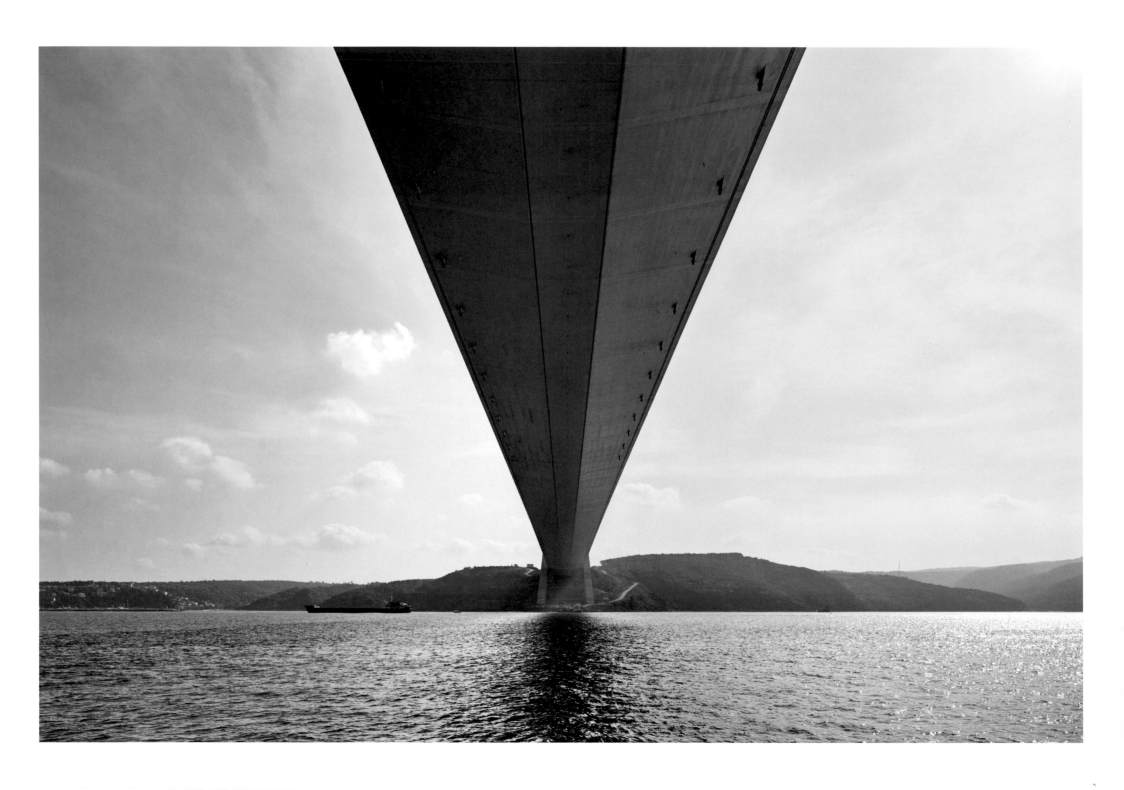

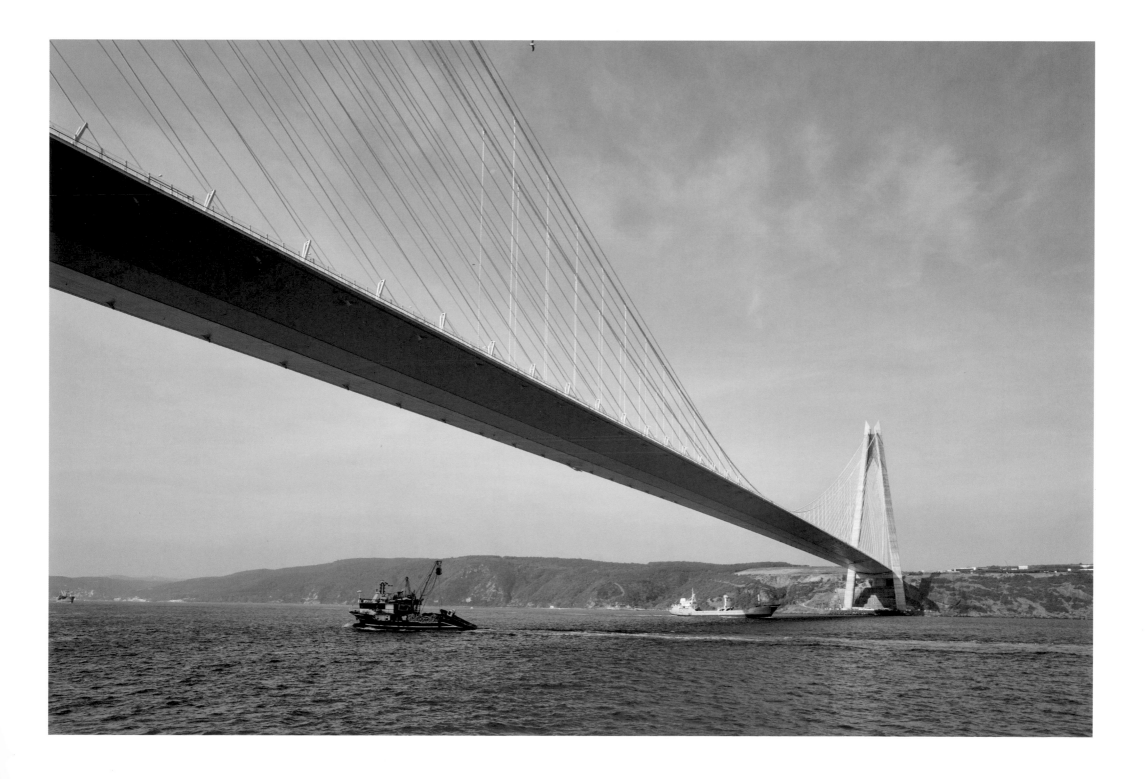

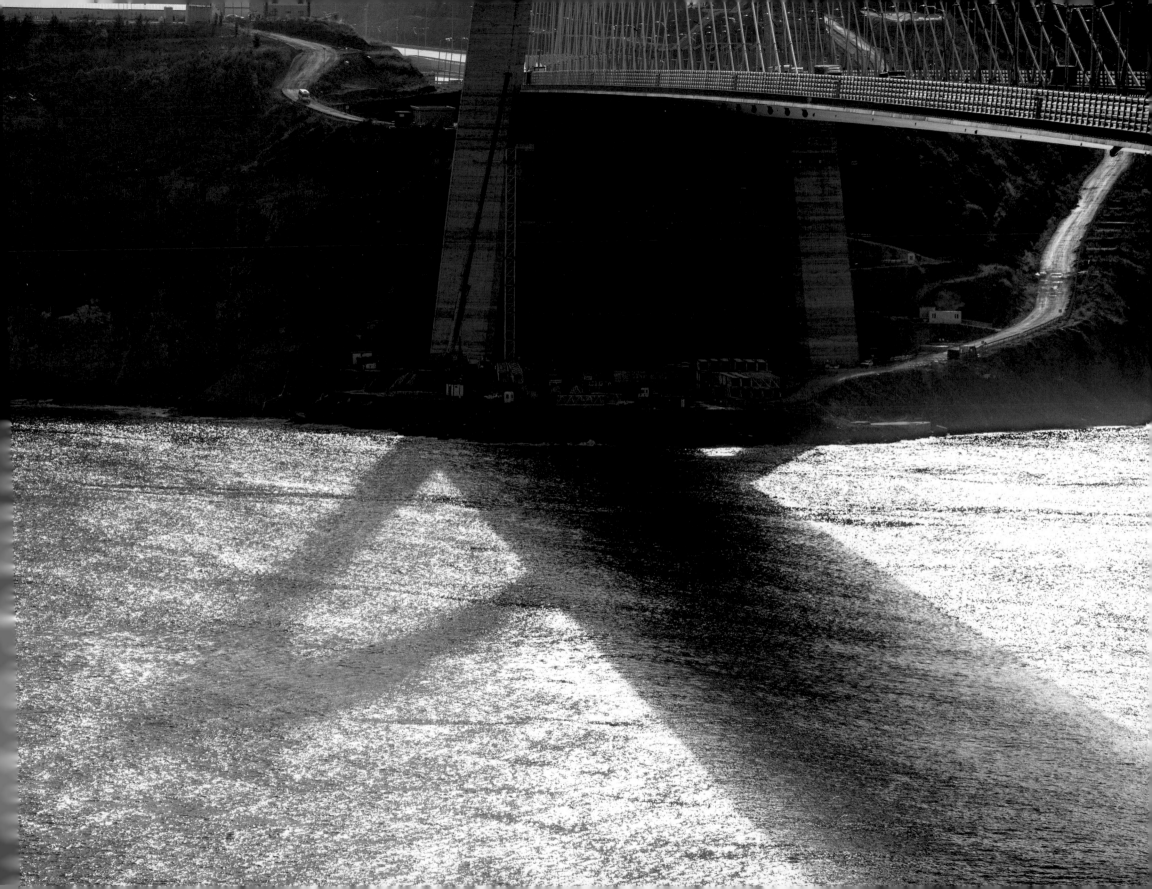

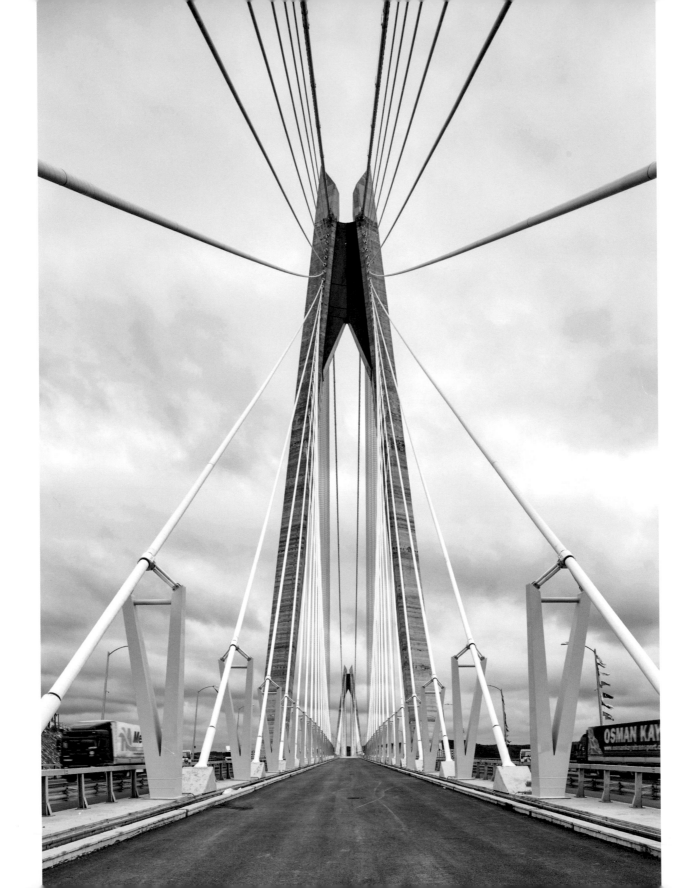

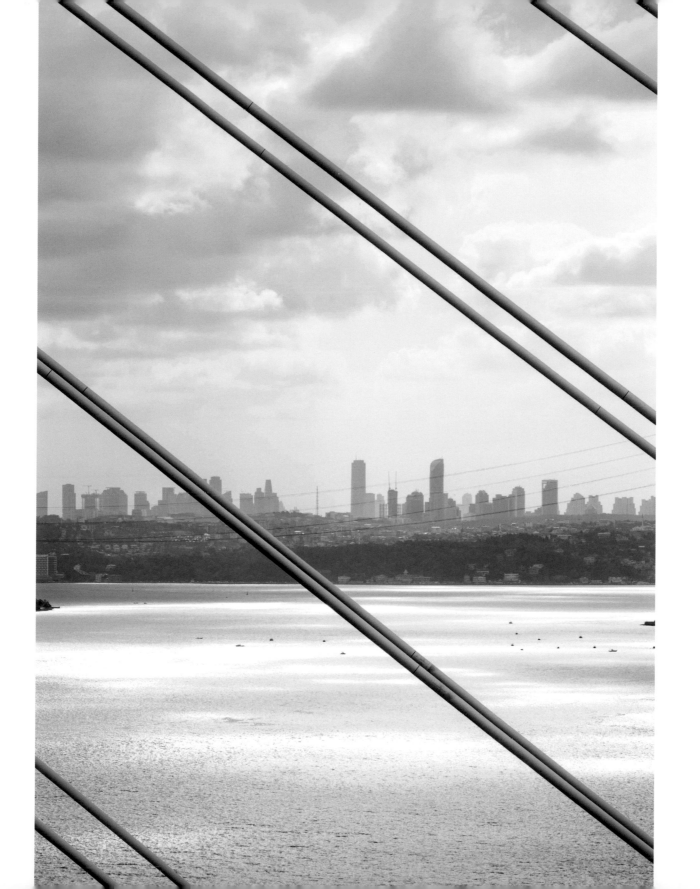

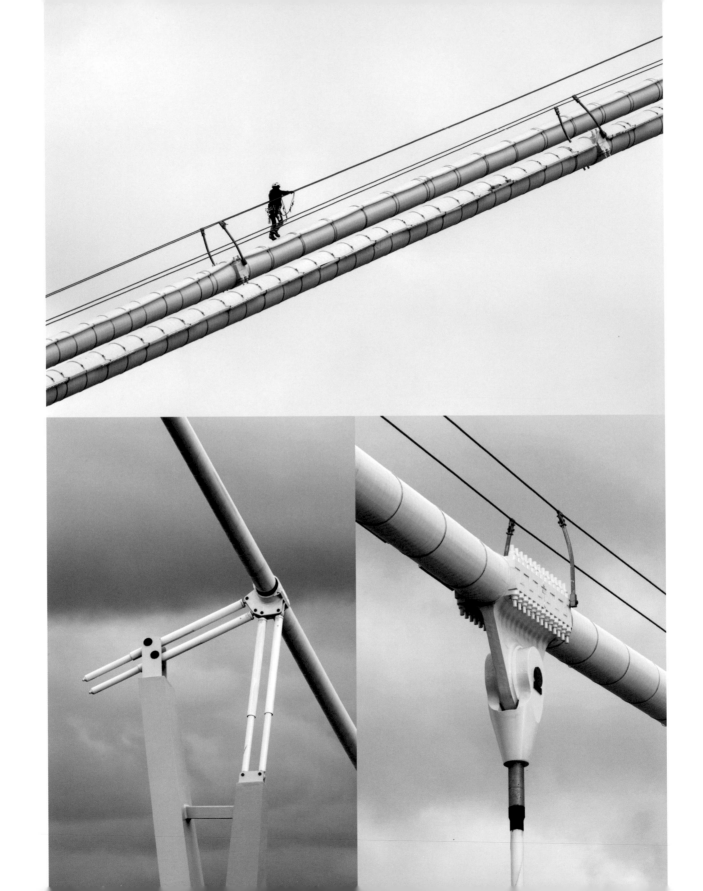

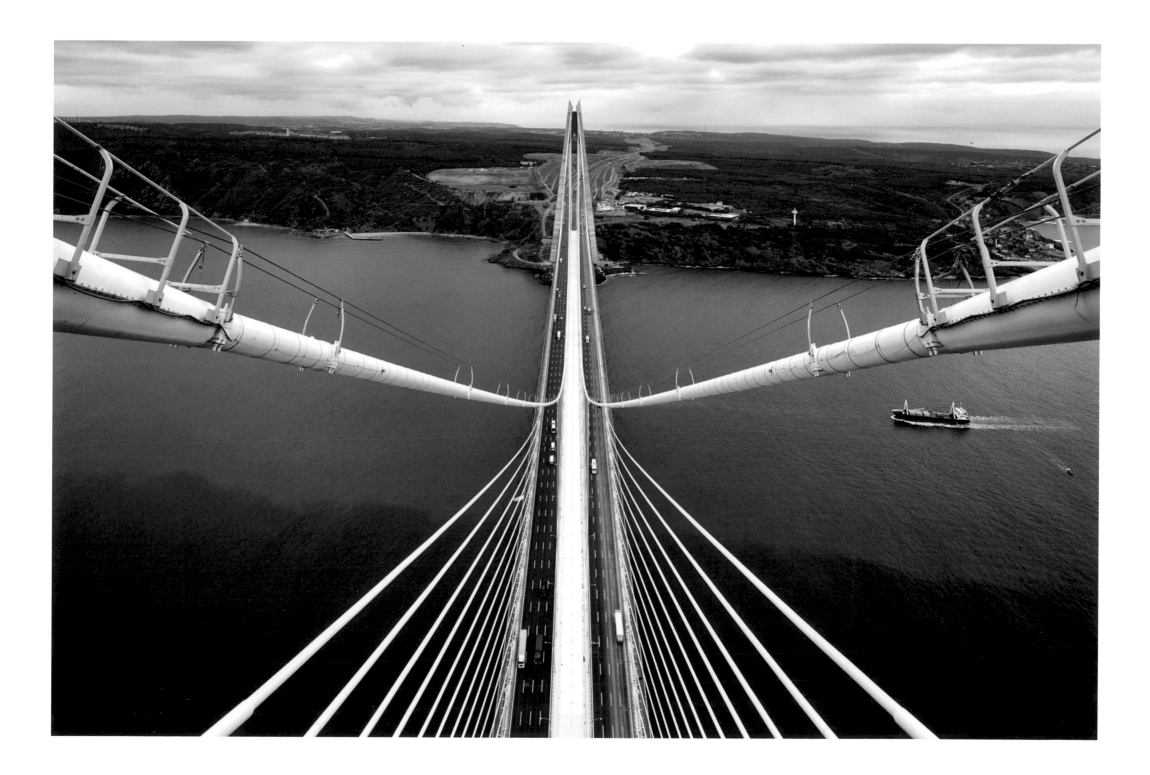

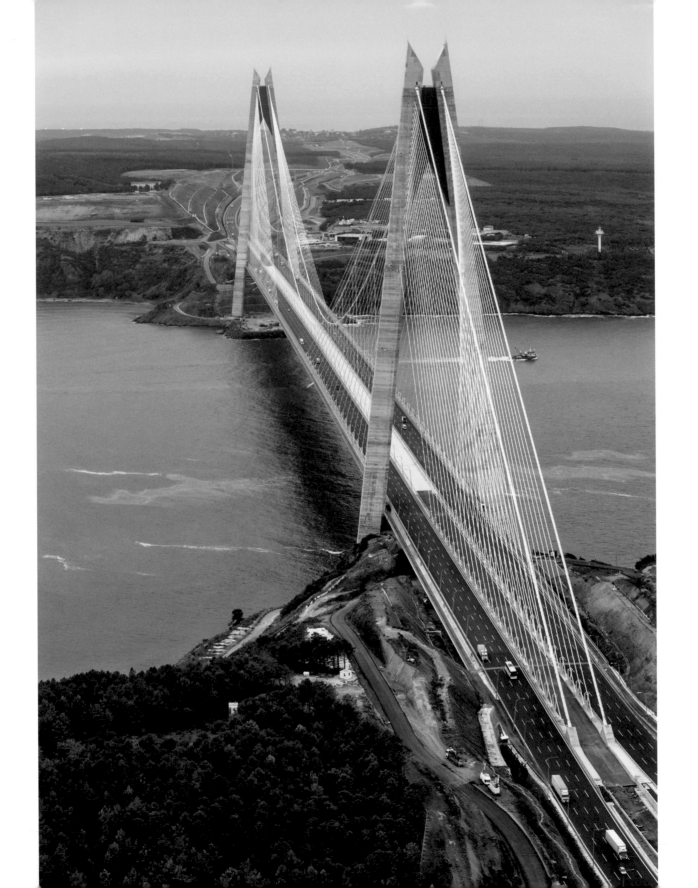

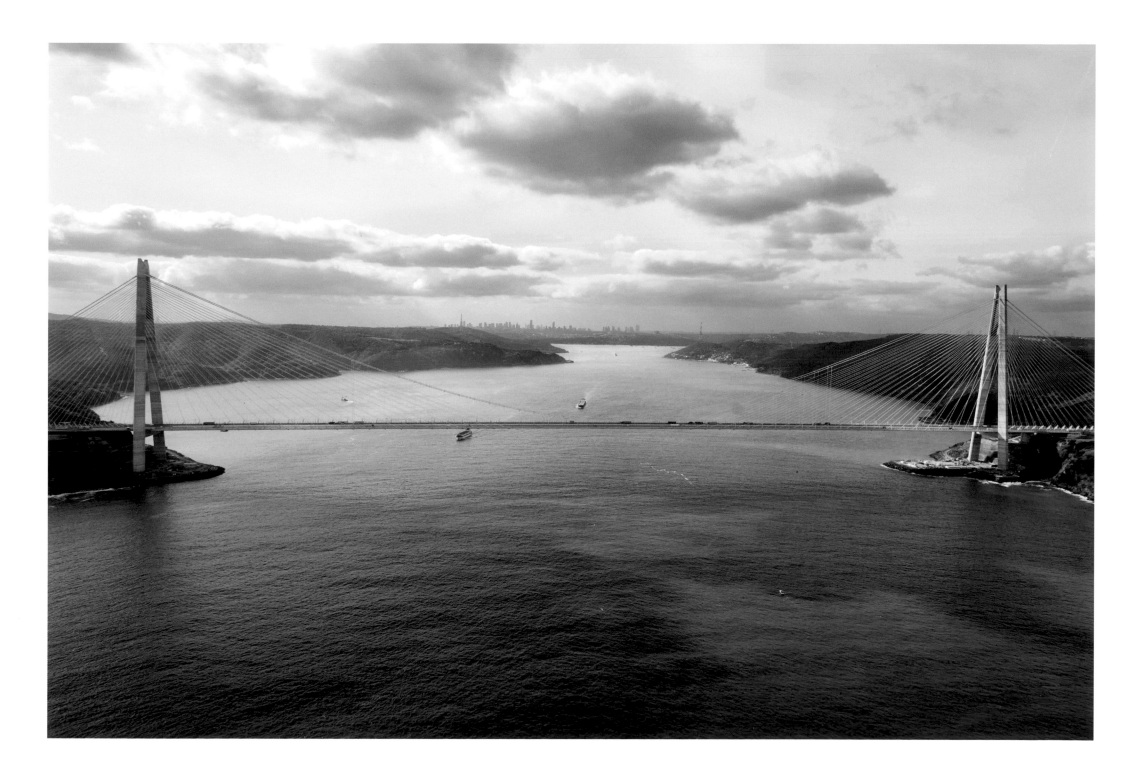

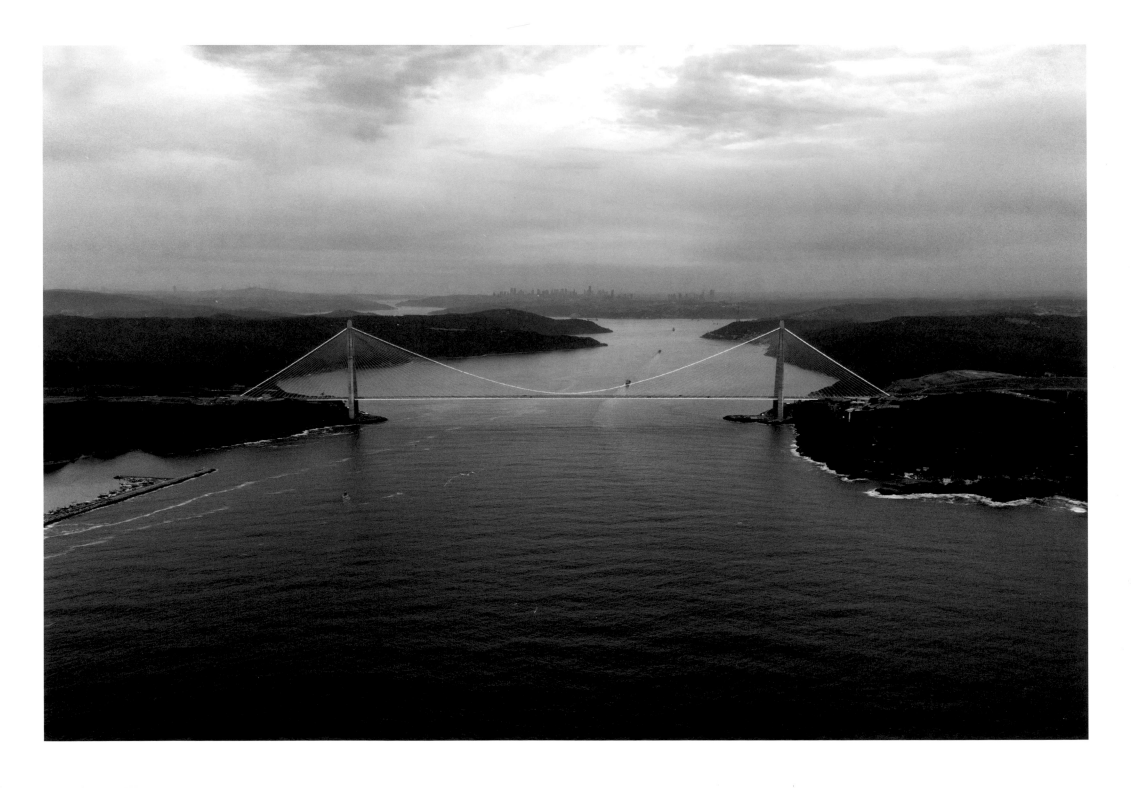

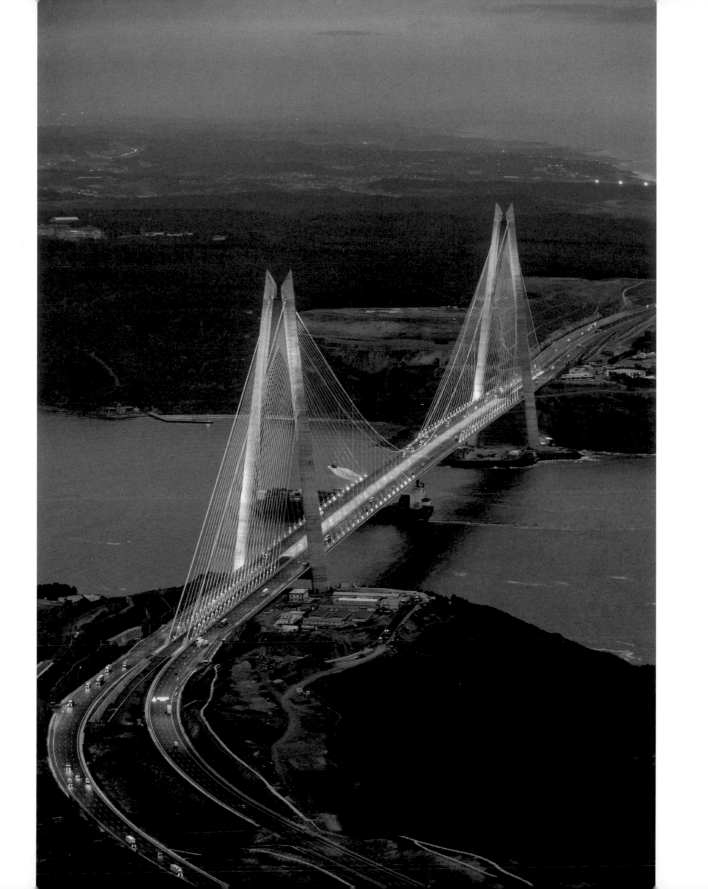

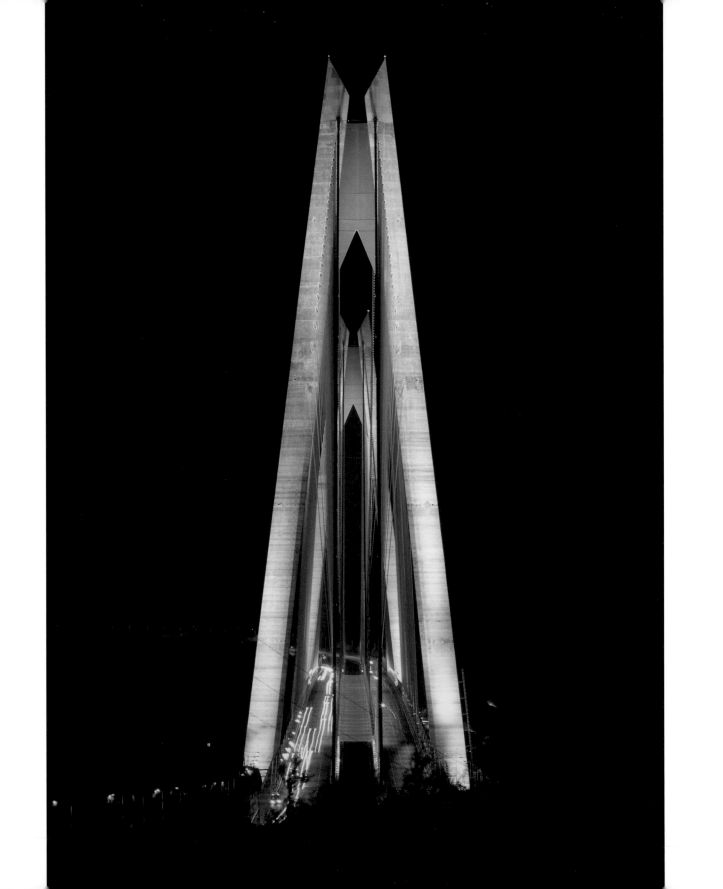

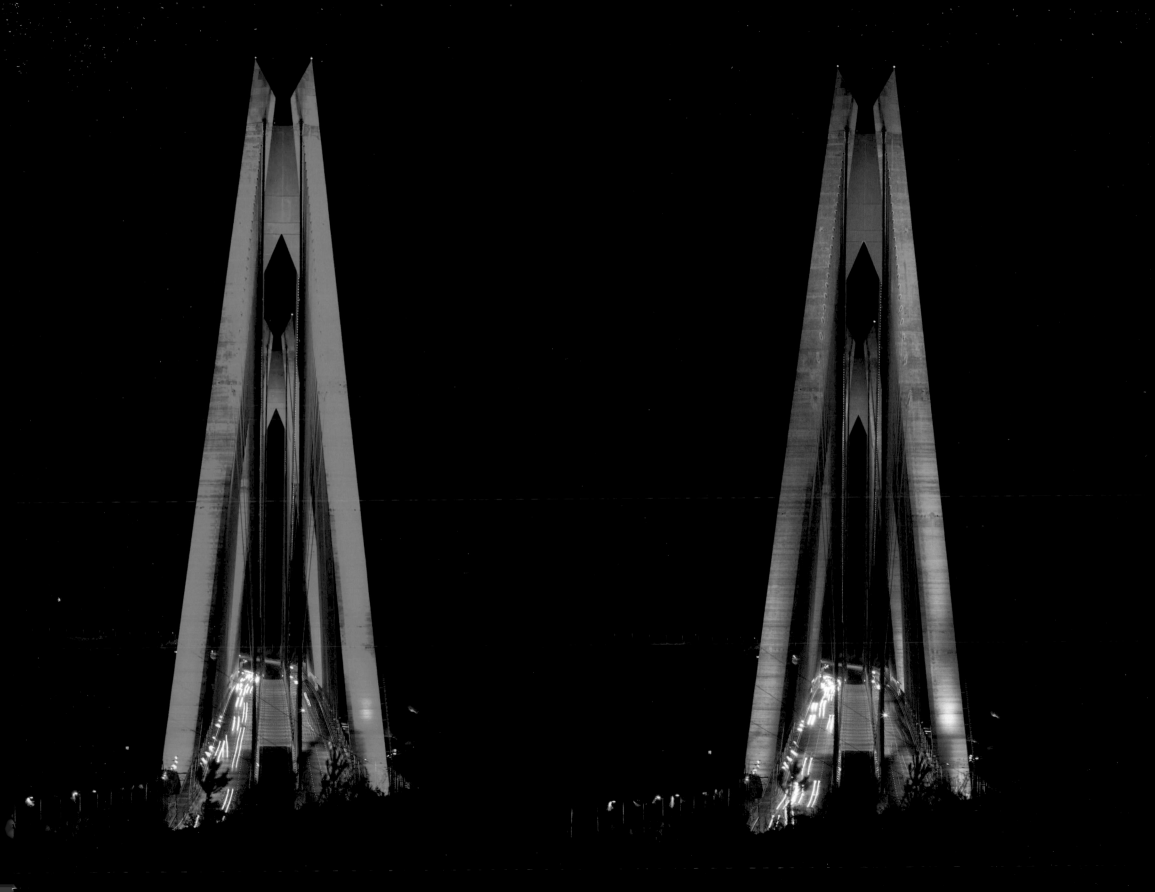

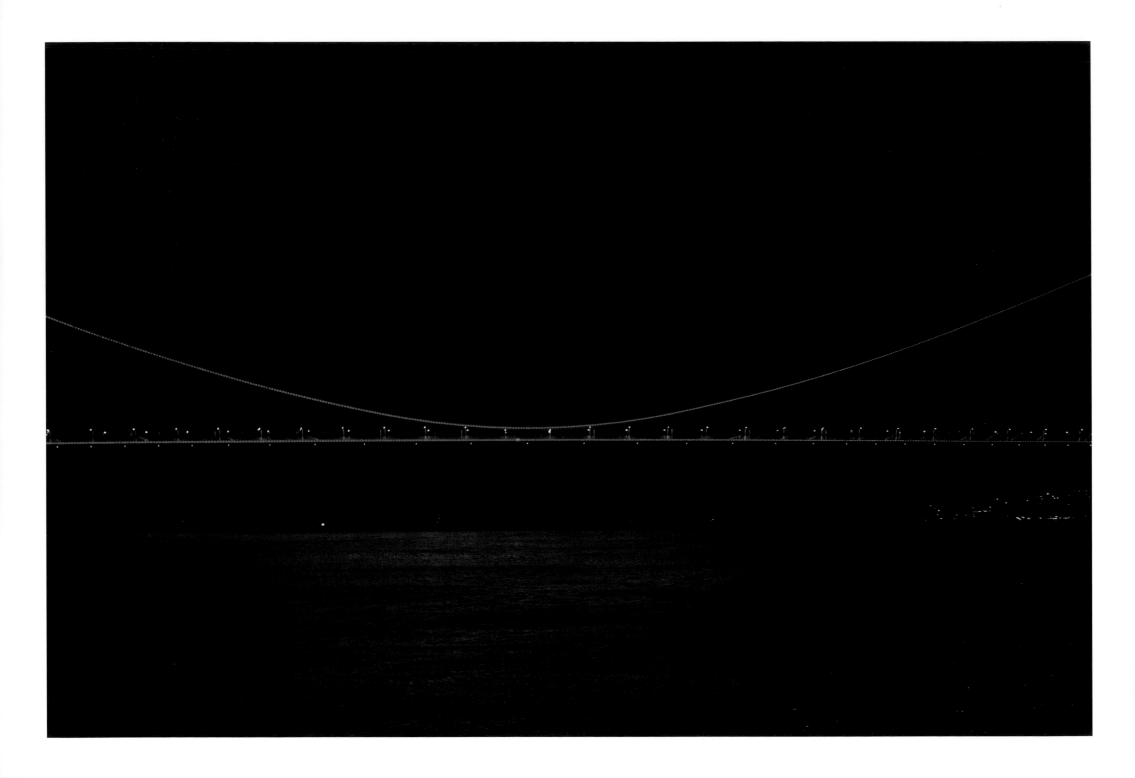

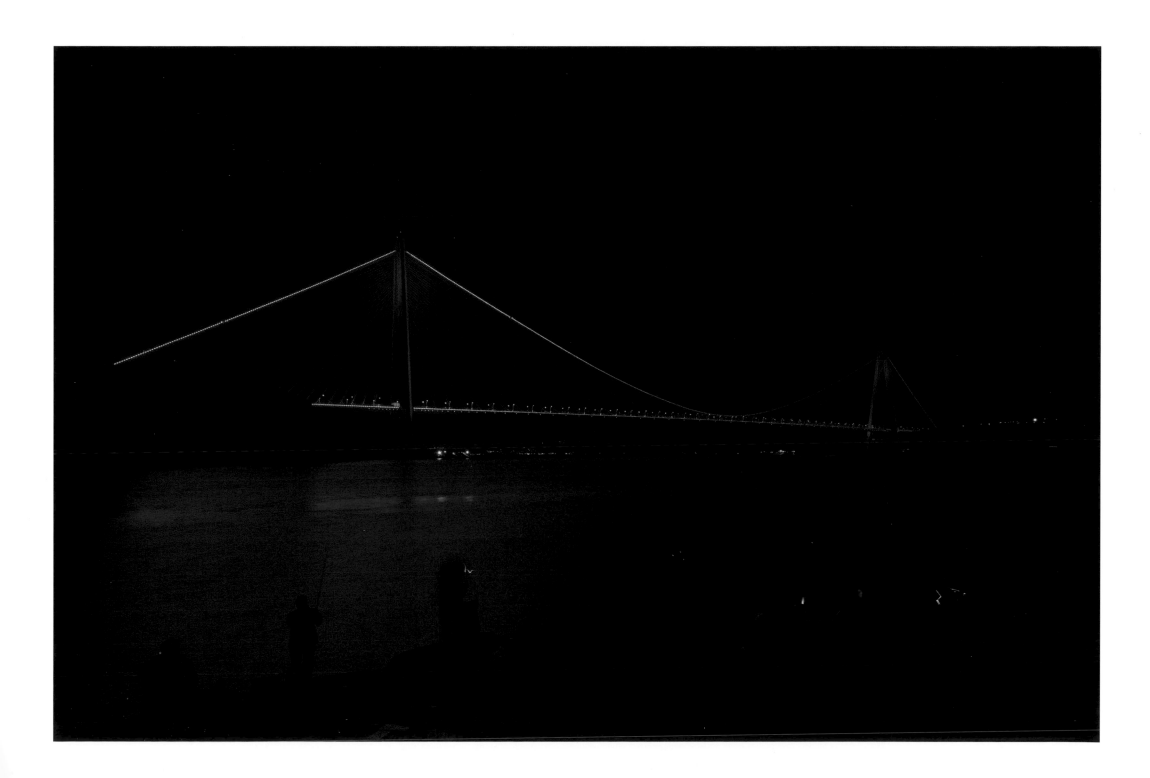

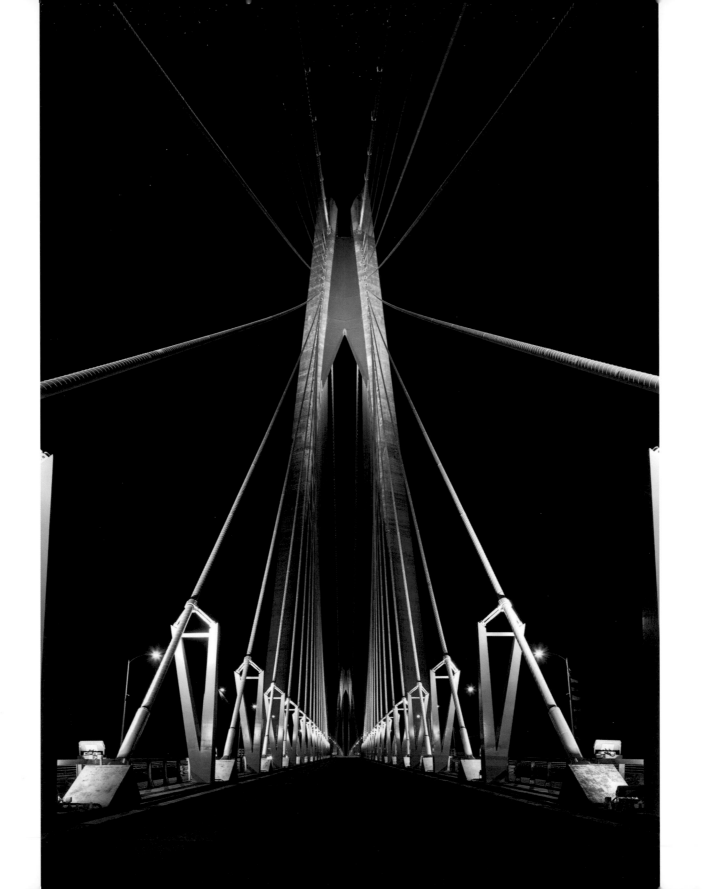

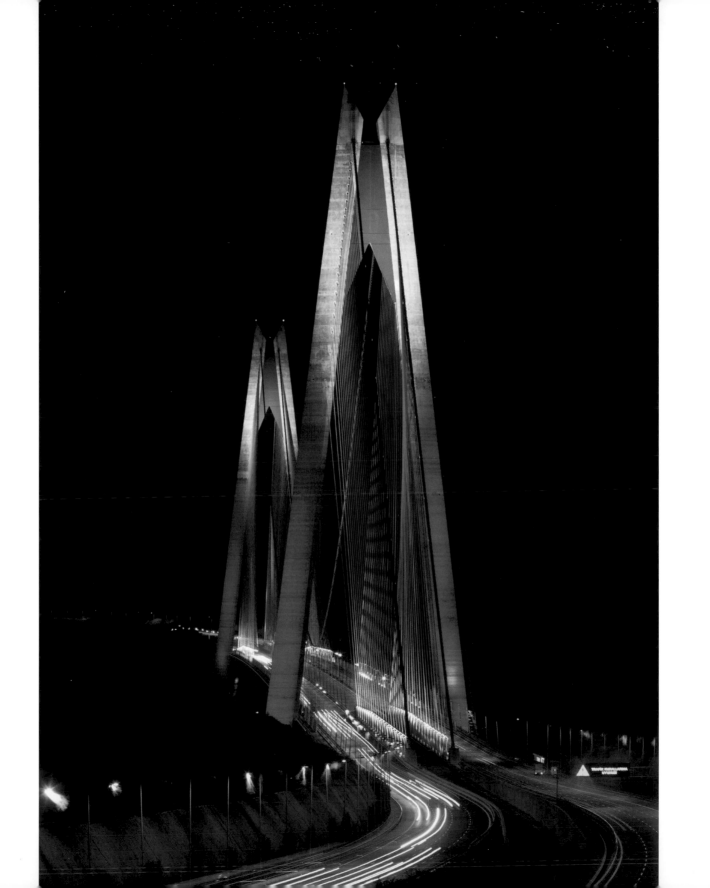

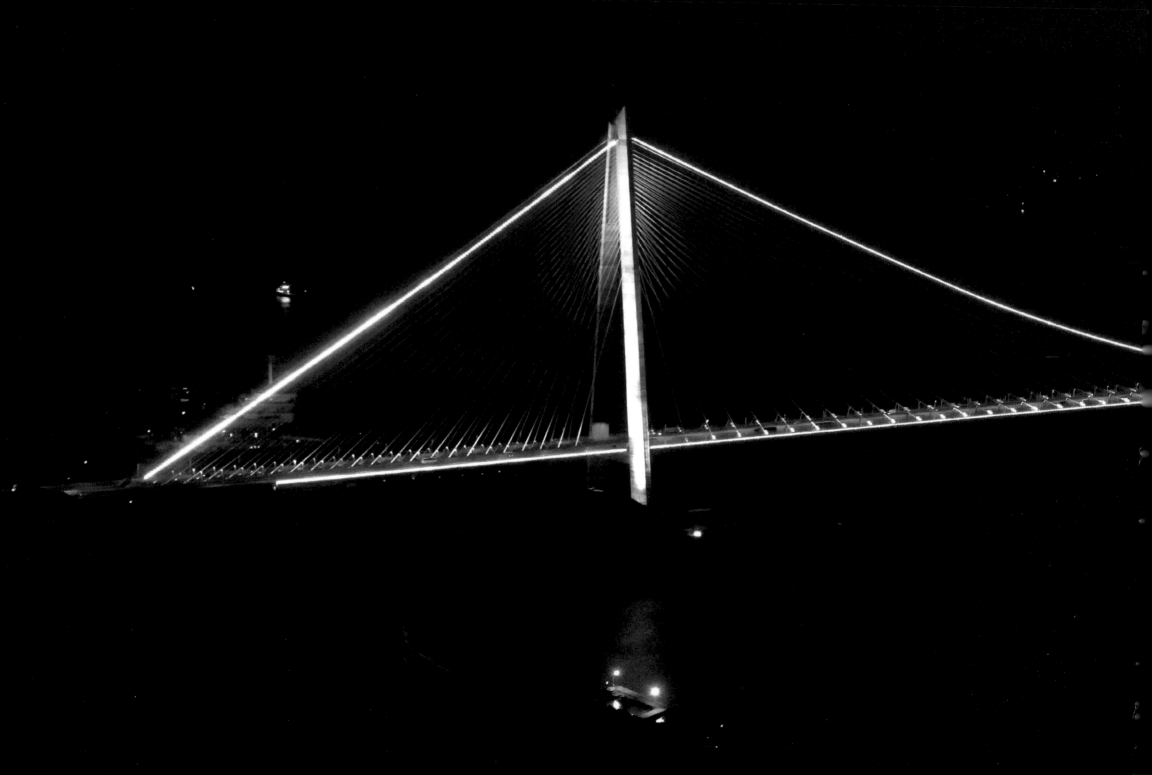

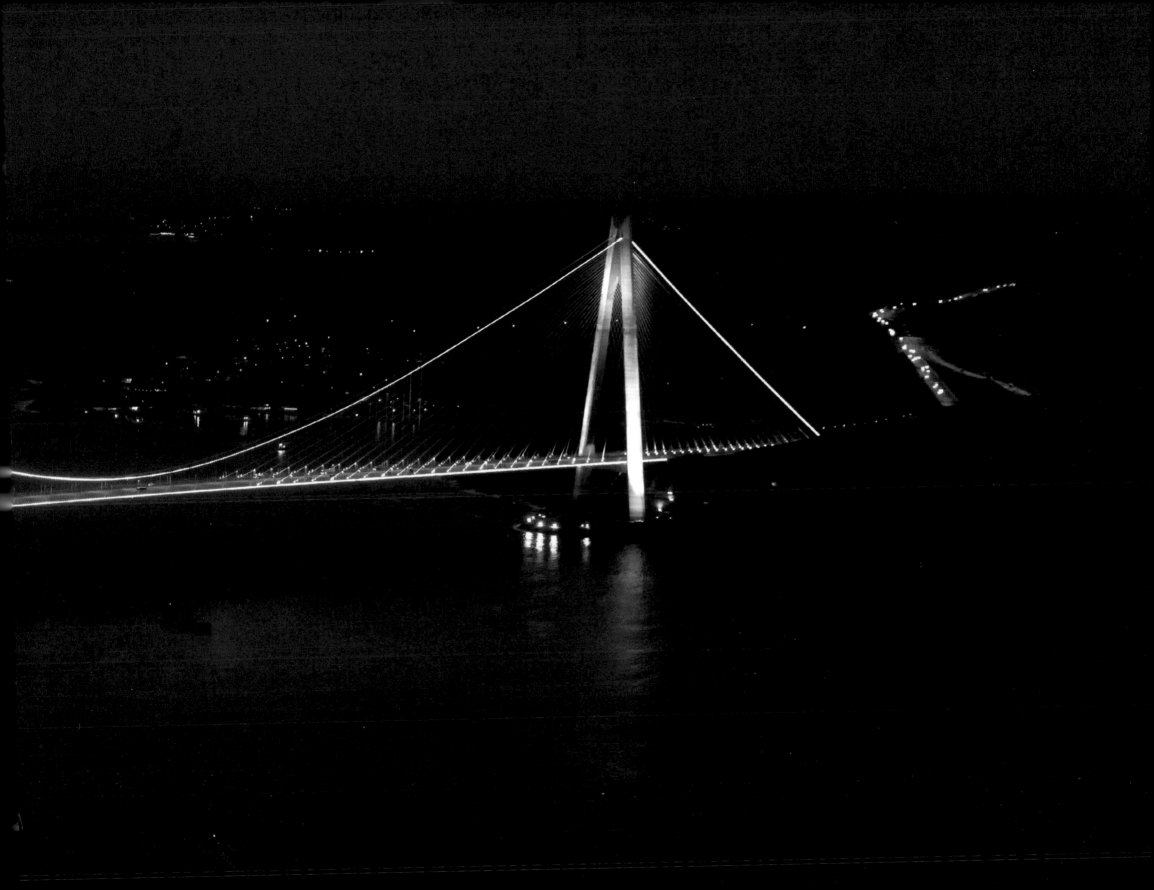

APPENDIX

ACKNOWLEDGEMENTS

We would like to extend our sincere gratitude to those who have been there for us with their continuous support and encouragement.

We would like to thank first and foremost, Our President Mr. R. Tayyip Erdoğan,
Our Prime Minister Mr. Binali Yıldırım,
Our Minister of Transport, Maritime Affairs and Communication Mr. Ahmet Arslan,
Our Director of General Directorate of Highways Mr. İsmail Kartal,
First Regional Directorate of Istanbul Highways and Northern Ring Motorway Inspection Authorities.

We would also like to thank our 10,000 employees, our advisors, financial providers, project managers, sub-contractors, consultants and hundreds of business partners for making it possible to complete this project of pride in a record three years.

YAVUZ SULTAN SELIM BRIDGE CREDITS

Client:
The Republic of Turkey
Minister of Transport, Maritime Affairs
and Communication
General Directorate of Highways

Client's Technical Consultant:
Yüksel Proje & Chodai Joint Venture

Lenders:
Investment Part: Garanti Bank, Halk Bank, İşbank,
Vakıf Bank, Yapı Kredi Bank, Ziraat Bank
EPC Part: Deniz Bank

Investor - SPV:
ICA İçtaş Astaldi Joint-Stock Company

**Engineering Procurement &
Construction (EPC) Contractor:**
ICA İçtaş Astaldi Joint Venture

Architectural Concept Design:
Michel Virlogeux & Jean-François Klein

Design:
T-Ingénierie, Greisch
Lombardi, Fugro Sial, CSTB, Politecnico di Milano,
Grid, Envico
Temelsu

Independent Design Checker:
Setec, BTC

Structural Geometry Control:
Cowi

EPC Subcontractor:
Hyundai E&C - SK E&C Joint Venture

Other Major Subcontractors:
Hyundai Engineering & Steel Industries, Korean
Erection Company, Freyssinet, H & K Engineering,
Endom, Davai, Intekno, Erse, İsfalt

Environmental Consultant:
AECOM

Lenders' Technical Advisor:
Mott MacDonald

Concrete Supplier:
Betonsa

Formwork Supplier:
Bygging-Uddemann & Peri

Tower Anchor Boxes Fabricator:
Sedef

Steel Deck Fabricator:
Gemak

Cable Suppliers:
Main Cable - Hyundai Engineering & Steel
Industries & Kiswire
Stiffening Cable - Freyssinet & Kiswire
Hanger Cable - OVM & Kiswire

Saddles Supplier: AFC
Expansion Joints Supplier: Maurer Söhne
Bearings Supplier: Mageba
Dehumidification System: Tetisan
Fire Fighting System: K2 Teknik
Monitoring equipment: Advitam
Electrical Works: Siemens
Architectural Lighting: Λ Group
Steel Deck Painting: Jotun

BIBLIOGRAPHY

Pertusier, Charles
*Picturesque promenades in and near Constantinople,
and on the waters of the Bosphorus* (1815). R. Phillips & Co.,
London 1820.

De Miranda, Fabrizio
"Il ponte strallato: soluzione attuale del problema delle grandi
luci," *Costruzioni Metalliche*, vol. 1/1971.

De Miranda, Fabrizio
*I ponti strallati di grande luce - fondamenti teorici, analisi
strutturale, criteri di progettazione, tecniche di costruzione,
5 esempi di realizzazioni.* Ed. Zanichelli, Bologna 1980.

Picon, Antoine
*L'Invention de l'ingénieur moderne: l'École des Ponts
et chaussées, 1747-1851.* Presses de l'École nationale
des ponts et chaussées, Paris 1992.

Freely, John
The Bosphorus. Redhouse Press, Istanbul 1993.

Klein, Jean-François
*Pont de Zaltbommel, Pays-Bas - Développement d'une
variante d'entreprise.* Presented at *Ponts suspendus
et à haubans. Cable-stayed and suspension bridges*,
International Seminar, Deauville, 12–15 October 1994.

Gokasan, Demirbag
"On the origin of the Bosphorus," *Bulletin annuel de l'AFGC*,
No. 1 , 1999.

Klein, Jean-François
Engineering and modern society – A tight mediation.
Presented at FIB Symposium, Avignon, 26–28 April 2004.

Cagatay, Irvali
"Late Pleistocene-Holocene history of the Golden Horn
Estuary, Istanbul," *Geo-Marine Letters*, June 2009.

Iori, Tullia; Marzo Magno, Alessandro, *150 anni di storia del
cemento in Italia.* Gangemi, Rome 2011.

Klein, Jean-François
Apologia for "Sculptural engineering". Presented at *Structural
Engineering: Providing Solutions to Global Challenges*, IABSE
Conference Geneva, September 2015.

Klein, Jean-François
*The behavior of the Third Bosporus Bridge related to wind
and railway loads.* Presented at *Structural Engineering:
Providing Solutions to Global Challenges*, IABSE Conference
Geneva, September 2015.

"Turchia, Astaldi inaugura il ponte dei record sul Bosforo:
8 corsie di autostrada e 2 linee ferroviarie," *La Repubblica*,
25 August 2016.

Vegezzi, Giovanni,
"Astaldi, via al maxi-ponte sul Bosforo," *Il Sole 24 ore*,
26 August 2016.

Basso, Francesca
"Turchia, il terzo ponte sul Bosforo inaugurato dal presidente
Erdogan," *Corriere della Sera*, 27 August 2016.

BOOK CREDITS

Printed in Italy